D0477023

...was awarded the Art Book Prize. He has collaborated with artists and curated exhibitions for many museums in Australia, New Zealand and the United Kingdom, including 'Skin Deep: A History of Tattooing' for the National Maritime Museum, London.

Thames & Hudson world of art

This famous series provides the widest available range of illustrated books on art in all its aspects.

To find out about all our publications, including other titles

idson.com.
wnload

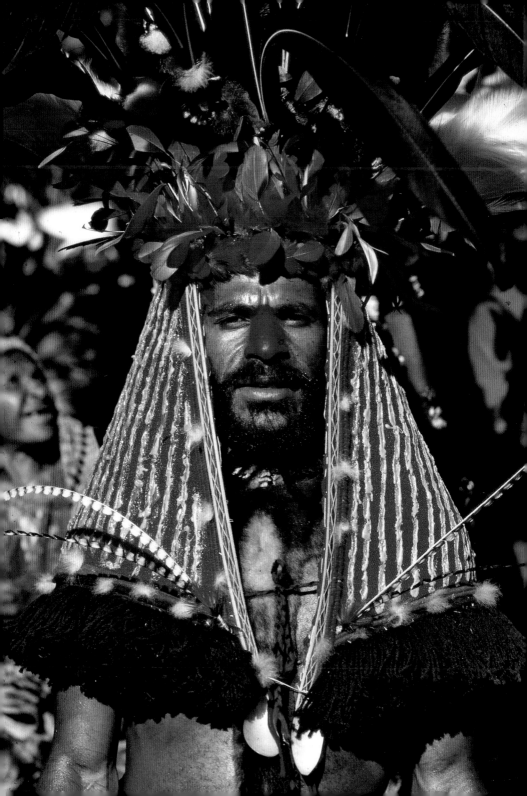

Nicholas Thomas

Body Art

186 illustrations, 143 in colour

Thames & Hudson world of art

For Mark Adams

Acknowledgments

This book is indebted above all to an anthropologist, Alfred Gell (1945–1997), and to a tattoo artist, Paulo Sulu'ape II (1950–1999). Mark Adams introduced me to Paulo in the early 1990s, and his photographs of Paulo's practice have empowered my understanding of body arts and their cross-cultural histories. I have also learned a great deal from my colleagues Anita Herle and Mark Elliott, who, together with Rebecca Empson, curated 'Assembling Bodies' at the Museum of Archaeology and Anthropology in Cambridge (2009–10); and from researchers involved in the 'Tatau/Tattoo' project funded by the Getty Foundation and the Arts and Humanities Research Council (2000–5): Peter Brunt, Anna Cole, Anne D'Alleva, Bronwen Douglas, Elena Govor, Makiko Kuwahara, Sean Mallon and Unasa Va'a.

The following people have been generous with their research, with images, with answers to questions and in other ways: Sally-Ann Ashton, Jocelyne Dudding, Richard Fardon, James Faris, Anna Felicity Friedman, Rachel Gadsden, Stephen Hugh-Jones, Jane Lydon, Howard Morphy, Andrew Mills, Michael O'Hanlon, Nicolas Peterson, Ruth Phillips, Carolyn Rasmussen, Ashley Savage, Marilyn Strathern, Sofia Tekela-Smith and Charlotte Townsend-Gault. Annie Coombes has, as always, been immensely helpful with advice and critique; special thanks again to her and to Nicky for their support and love.

Frontispiece
1 Michael O'Hanlon, Gilma, a Wahgi man, wears the long ceremonial wig worn by certain individuals during the Pig Festival, Western Highlands, Papua New Guinea, 1979.

First published in the United Kingdom in 2014 by
Thames & Hudson Ltd, 181A High Holborn, London WC1V 7QX

www.thamesandhudson.com

ISBN 978-0-500-20420-7

Printed and bound in China by Everbest Printing Co. Ltd

Contents

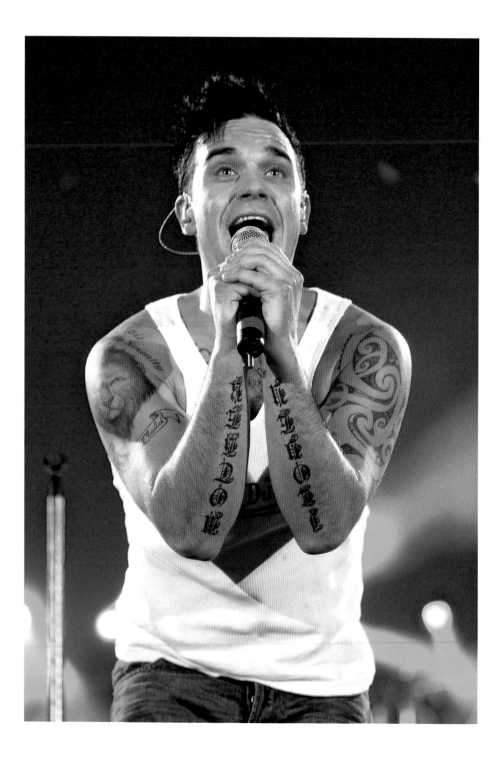

Introduction

If you get on a bus in London, San Francisco, Sydney or almost any other city in the world, and the weather is warm enough for summer clothes, you will encounter an anthology of body art. You may well bear some of it yourself. It will, most arrestingly, be a gallery that is not particular to a place and a time. You will see Maori tattoos on the shoulders of men in singlets. Or, more precisely, versions of those tattoos, historically inscribed on the faces and buttocks of warriors, and on the chins of women, now adapted for the shoulder, and created with an electric needle, rather than with the traditional bone needle or chisel. You will see a variety of piercings through ears and eyebrows. Intricate henna paintings are fading on the hands and feet of a woman who appears not to be of Asian descent. Diverse other tattoos are visible, some featuring Gothic script, skulls and flames, others the involuted designs of ancient Celtic art. The poor execution of figures and inscriptions on one man's neck is a pretty sure indication of time spent in prison. A thin ash-blonde in a silk shirt, who one cannot imagine serving on any kind of ship, bears a tea clipper in full sail on her upper arm, above a scroll that reads, 'Homeward Bound'. Another girl, in punk attire and an anti-capitalist T-shirt, carries a coloured tattoo of a woman in the style of a 1950s pin-up. This, we presume, is a knowing, politically motivated, ironic appropriation. But this bus full of people is a bus full of borrowings from world arts, from a host of Western subcultures, from histories of all sorts.

This book offers a survey of body art, a kind of art significant throughout history, and in all world cultures. Body art is the art form most intimately associated with human experience. It links the self, the senses and the social and the political; indeed, it may effect a painful imprinting of social distinctions on the skin, or on the person through other body modifications.

As our hypothetical bus suggests, there is something strange about offering this introduction at this particular moment in time, since there is a kind of survey of body art

2 Robbie Williams, 2003. Williams's tattoos were first revealed exuberantly on the cover of the October 2000 issue of *Vogue*, a sign of the new fashionability and acceptability of body art.

3 Ace Harlyn, 'Homeward Bound' tattooing flash, 1936. Harlyn was a significant tattooist working in New York City during the 1930s and 40s.

to be found in the streets, in our own experience, in popular culture. Such people as ourselves wear and exhibit body arts that for the most part are drawn from other places and times. From the start, we cannot but recognize a paradox: we think of the body art we choose to bear as an expression of our identity, yet the motifs and styles that we typically adopt are not anchored in the places and communities in which we have grown up. Rather, they are the products of more or less distant cultures and epochs. In some cases, such as the Gothic imagery associated with heavy-metal music, they have been embraced and revalued, not once but several times. If the young woman bearing the pin-up is playing with the patriarchal imagery of her grandparents' youth, or at least that of her grandparents' contemporaries in the United States, an appropriation as specific as that involves not only a leap back across a couple of generations, but also an introduction of past images and styles that is far less simple than it appears. We are all familiar with retro fashion in clothing, furniture and design, but it is important to remember that nothing can be the same as it was. The images that are being reintroduced, that abound in popular culture, that appear on the bodies of celebrities, may be old or second-hand, but their meanings and our motivations are new.

This book ranges widely around the world and across historic periods, but responds also to contemporary, pressing issues. Why have body arts proliferated in such a remarkable way, and why just recently? What is it exactly that new and borrowed body arts now *do*? A common-sense answer might be that what they do, their work, is to represent the identities of the people who bear them. Is this pertinent? If it is, what sorts of identity do they represent? What do body arts tell us about the global cultural order that we all now inhabit?

These questions presume that there is a profound difference between what we might call the postmodern body arts of the present, and past practices embedded in customary settings and particular traditions. If there has indeed been a sea change reflected in the modern globalization of body art, the distinction may nevertheless turn out to be too stark, since many supposedly traditional cultures were themselves innovative, engaged in multiple borrowings and the revaluation of practices adopted from the past or elsewhere. The ancient, complex and ongoing histories of henna painting among Hindu, Muslim and other populations in South Asia, the Middle East and north

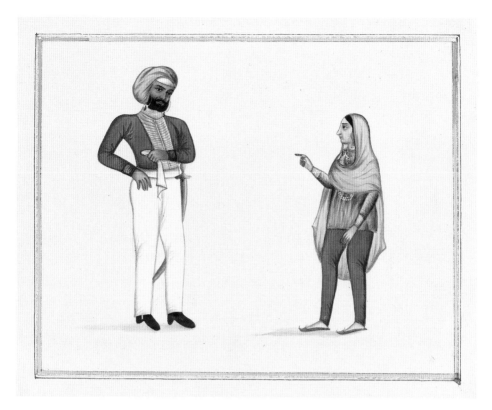

4 *Sikh Officer and Woman with Henna Painting on Her Hand* (detail), from an album containing watercolour paintings of Sikh rulers, architecture and trade, India, nineteenth century.

overleaf:
5 George Catlin, *The White Cloud, Head Chief of the Iowas*, 1844–45. The Iowa had to leave their territories, following the Indian Removal Act of 1830, for a small reservation in south-eastern Nebraska, where they suffered disease and poverty. In 1844 Chief White Cloud travelled to London with thirteen Iowa and spent a year with George Catlin's Indian Gallery, demonstrating their customs; this portrait, emphasizing the chief's status and his traditional body art, was painted during this time.

Africa would, for example, immediately belie any idea that there is something unprecedented about movements of body arts, across boundaries between societies, faiths and nations, that have spawned remarkable and diverse local expressions.

This book introduces a variety of historic world traditions, in part to enable us to understand better what is distinctive about the present. All cultures have employed body arts of some sort, and even if many are known only obliquely through archaeological evidence or incomplete historical records, such as inaccurate travellers' drawings or prints of various kinds derived from them, there is still a vast range of material to consider. This study can only be highly selective, of course, but it tries to be broadly representative, not only in aiming to present material from most regions of the world and from a range of periods in human history, but also by drawing attention to the different meanings and effects that body arts have had. As we will see, in some cases – in the context of initiation rites, for example – these focused on the creation

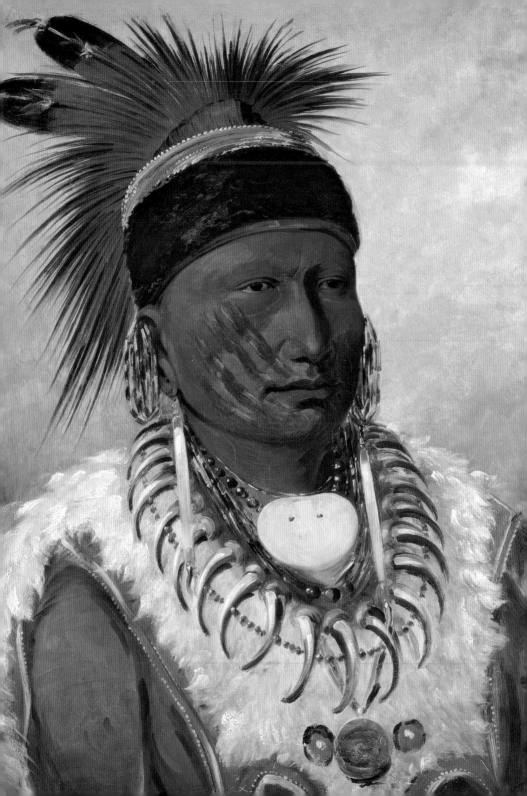

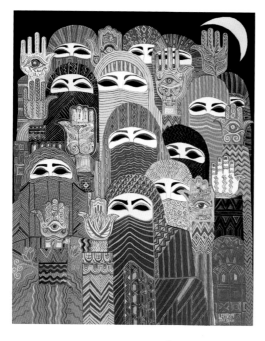

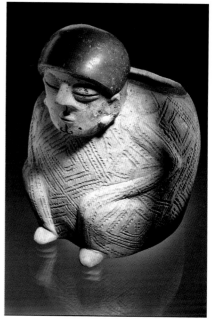

of a mature person. In others, the emphasis was on marking the body with signs of social and political affiliation. And in still others, body art was a project of beautification, or personal artistic experimentation. Or, indeed, some combination of these and other interests.

What is body art?

Where does this subject start and stop? If body art means the temporary or permanent aesthetic modification of the body, for some expressive or other purpose, the rubric ought strictly to embrace a range of practices that are mind-boggling in their variety. In addition to tattooing, body-painting and the decoration of oneself with ochres and such ornaments as feathers – the body arts that perhaps spring most readily to mind – the field should include dieting, sunbathing and fitness regimes intended to bring the body into conformity with an ideal. It is hard to make a sharp distinction between the use of ritual paints in an indigenous society and day-to-day adornment. The cosmetic creams, powders and scents (bearing in mind that art is sensory and possibly olfactory, as well as visual and material) that women and men in many societies make routine

above:
6 Laila Shawa, *Hands of Fatima*, 1989.
This painting by London-based Palestinian artist Shawa depicts women with upraised hands bearing henna painting containing signs against the evil eye.

7 Painted pottery vessel in the form of a tattooed man, Ecuador, probably Chorrera, 600 BCE– 1 CE.

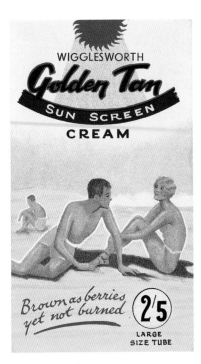

above:
8 Advertisement for
Wigglesworth 'Golden Tan'
sunscreen, 1930s.

9 Slate cosmetic palettes,
al-Amrah and Hierakonpolis,
Egypt, Predynastic period,
4000 –3100 BCE.
These were everyday objects,
used by ordinary people to grind
minerals for cosmetics such as
kohl, which was used by both men
and women as eyeliner, to protect
themselves from the intense
Egyptian sun as well as to beautify
themselves.

opposite:
10 Kenred Smith, scarification
near Bopoto, upper Congo River,
before 1905.

11 Unknown photographer, hair-
cutting, probably Congo, early
twentieth century.

use of are part of the story. Lipstick may be ubiquitous, but it has
a remarkable ancient history, extending back to Mesopotamia,
as well as a controversial one in modern times. If today it
is considered unremarkable, routine make-up, part of the
expression of a dignified and proper beauty, without a trace
of the nineteenth-century association with 'loose' women,
it is still accompanied by a potent colour code.

Modifications of finger- and toenails, haircuts, and shaving
are similarly practices that we would not think of as body arts,
but which certainly are, in that they involve interventions in the
normal growth of the body, albeit in relation to parts that we
consider distinct and disposable. Nails and hair are, unlike skin
and flesh, separable in this sense, and they are excluded from
the scope of the Human Tissue Act in the United Kingdom, and
from similar legislation in other countries. Yet hair is certainly
integral to the aesthetic presentation of the body and to the
arts of decoration and performance. Our habitual treatment of
it is a reminder that body art is an attribute not only of culture
but also of humanity itself, since there is virtually no part of the
world in which hair on the head and elsewhere on the body is
never cut, trimmed or shaved. To permit the hair to grow

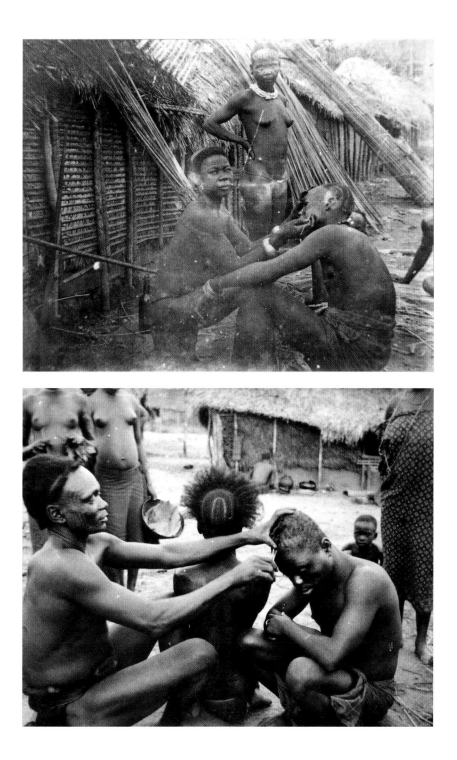

without restraint is thus a deliberate act, and one of an unusual kind – an aspect, for example, of a commitment to an ascetic religious identity.

Similarly, it is one of the great markers of the human condition that naturism, meaning nudism, is a misnomer. What is natural to humans throughout the world is to be clothed, however minimally, other than in more or less private or intimate spaces, or when washing. Nudity and nakedness are not natural, unmarked states but marked ones, not only and obviously when associated with sexual enticement, but also more extraordinarily, when people – generally women – whose dignity has been outraged have engaged in naked protest, known as *setshwetla* in South Africa, and staged at times during the struggle against apartheid as well as more recently. Given that body art is not only the creation of a state of being temporarily or permanently decorated but also a performance, both the covering of the body and its deliberate or dramatic exposure belong within the remarkable repertoire of body art's acts and offerings.

The arts of the body are about not only creating appearances but also seeking effects. We seek to impress, to render ourselves attractive, to give ourselves strength, assurance and poise. Some of us seek to daunt or intimidate others. In doing so we make use of technologies in which the body itself is the living form that lends vibrancy and effect to whatever decorations and enhancements it bears. In this sense the body is unlike any other medium. It is not only a surface that may be painted or inscribed, or a form that may be supplemented, with paint, clay, colour and clothing, or pierced, incised or subtracted from. It is also the substance of human life, the container of personal and collective existence, the bearer of vitality, of particular social identity and of personality alike.

'Self-decoration' is sometimes employed as a synonym for 'body art', but it really refers only to a subset of the arts of the body. In many instances it is not the self but another that is decorated, which is perhaps to split hairs. More importantly, the aim of adornment or modification is not necessarily to enhance the appearance or attractiveness of the individual, but a more profound transformation and empowerment. Among the most extraordinary archaeological relics yet discovered that are relevant to this subject are twenty-one stag headdresses, excavated from the Mesolithic site of Star Carr

12 Red-deer frontlet, Star Carr, Seamer, North Yorkshire, UK, Mesolithic, c. 9000 BCE.

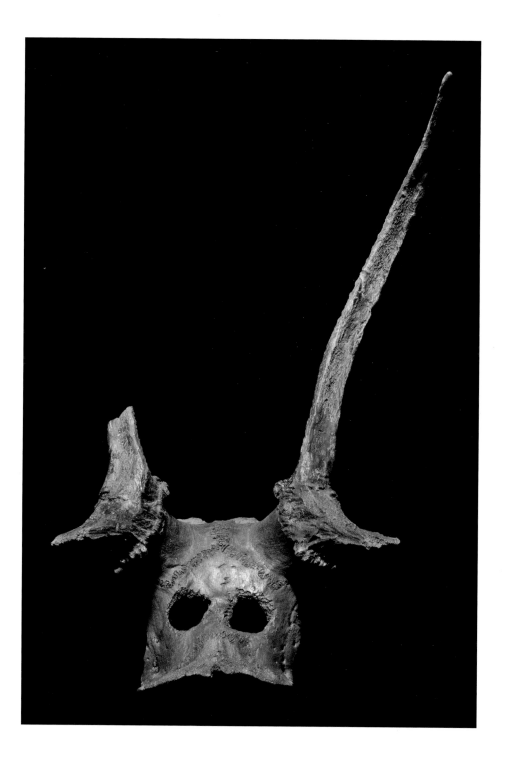

in North Yorkshire by Cambridge archaeologists in the early 1950s. Some 11,000 years old, these were made from the scraped-out skulls of red deer, with eyeholes bored into the top of each skull. They are exceptional discoveries: a few examples are known from sites in Europe, but no others have thus far been found in Britain. At this remove in time, their uses are unknown. But they were clearly made to be worn. The suggestion, advanced by some scholars, that they were used by hunters as part of a disguise (together, presumably, with some kind of deerskin costume) to aid the pursuit of deer is unconvincing. It is surely more likely that they were donned in the context of ritual. We know from historical and modern evidence that hunting peoples, like pastoralists, who depend

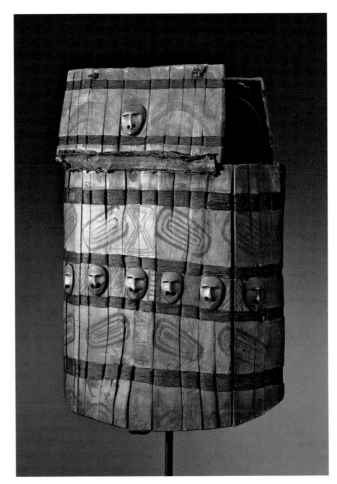

13 Wooden armoured shirt, Tlingit, Prince William Sound, Alaska, eighteenth century. This unique cuirass was acquired during Captain Cook's third voyage, which incorporated a short visit to Prince William Sound in May 1778. One of Cook's lieutenants wrote 'we also bought of them a kind of armour made of long slips of wood fastened together and curiously painted'. It would have been worn over a leather shirt by a warrior, who would additionally have been protected by a helmet.

on particular species, such as deer, not only develop profound practical understandings of animal behaviour, but also turn those animals into aesthetic and symbolic foci. In some sense, the Mesolithic hunters of Star Carr 'became' deer; they merged animal and human worlds, or crossed the boundaries that separated them.

Given all of this, 'body art' looks like a short title for an astonishingly long list of the ways in which people have changed their appearance: sometimes temporarily and spectacularly, for some exceptional purpose; sometimes permanently and meaningfully, with an arresting tattoo; and sometimes more routinely, in a day-to-day way we take for granted. Some of body art's manifestations are ancient, and require little other than a sharp knife or a palette for ochre. Others entail great skill. Even in the smallest of societies, the tattooist was a renowned specialist, in effect an individual priest or artist with a set of precision instruments, often the graduate of a customary school or guild — just as cosmetic surgery, a body art that over recent decades has been transformed from the privilege of an elite to a widespread lifestyle choice, is empowered by the most advanced medical science.

However long the list of body arts is, there is more that could be added to it. While tattoos are in some places considered to armour the body, actual armour is seldom purely functional, but has aesthetic and communicative aspects too. If shell and feather accoutrements are as essential to self-decoration in Melanesia as paint, wigs and oil, ornaments of all kinds — ranging from ear, arm, neck and ankle rings to necklaces, breastplates, pins and combs worn in the hair — may be integral to the arts of the body. And, as has already been noted, to be human is to be clothed, and clothing is similarly hard to separate from other techniques of adornment and

14 Body-painting pigment container, Papua New Guinea, probably nineteenth century. This incised bamboo tube contained a natural red pigment that was used to paint the body on ceremonial occasions.

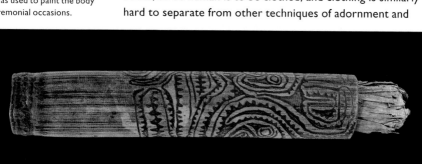

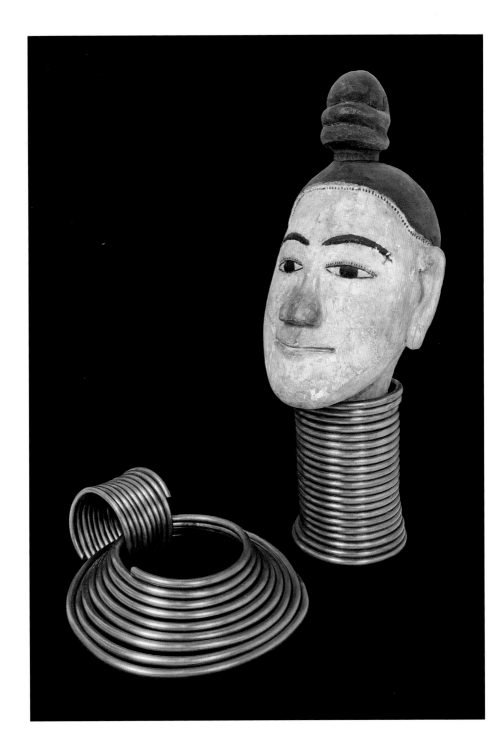

opposite:
15 Carved and painted wooden head of a woman wearing brass neck rings, Kayan Lawhi people, Myanmar (Burma), early twentieth century.

this page:
16 Set of girl's girdle-plates, which are worn from infancy until her first child is born, Adi people, Arunachal Pradesh, India, probably early twentieth century.

17–19 Three stamps, carved from old rubber flip-flop sandals, used for printing designs onto the body, Zinder, Niger, late twentieth century. These stamps come from a market stallholder in southern Niger. The stallholder was paid small change, mainly by children, to stamp designs onto their arms. The stamps, from left to right, depict: presidential candidate Mahamane Ousmane; a mosque; flowers.

self-transformation. The professionalization of self that many of us undergo, Monday to Friday, as we dress in a suit and tie or a jacket and skirt, or, more likely these days, some slightly less formal version of office uniform, is a banal example.

In no way ordinary, however, were the shamans' costumes of the Imin Numinchen people of Inner Mongolia. Among these people (and more widely in inner Asia and Siberia) shamans were prominent, renowned for their capacities to heal, to make predictions and to help people manage their relationships with their ancestors.

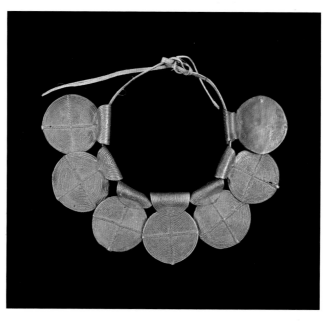

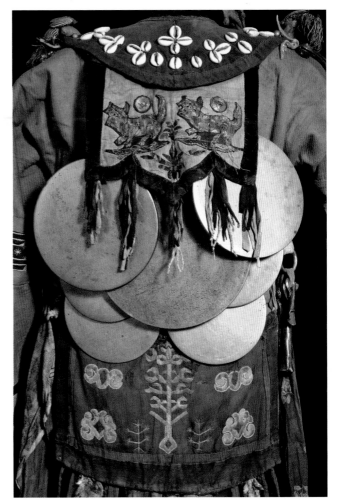

The costume illustrated here belonged to a woman who died in the 1930s, aged just twenty-five. No two costumes were the same, and each would have been added to and enhanced as the wearer became more accomplished; indeed, the costume was a sort of archive of personal connections and achievements. The main part of the garment is likely to have been made by Dagur craftsmen, skilled at embroidery. The brass mirrors came from Chinese merchants, and the embroidered lion on the back from the woman's father's Manchu military dress. The cowrie shells and brass plates would have reached the region through trade. Although it is missing in this case, a costume of this kind would have

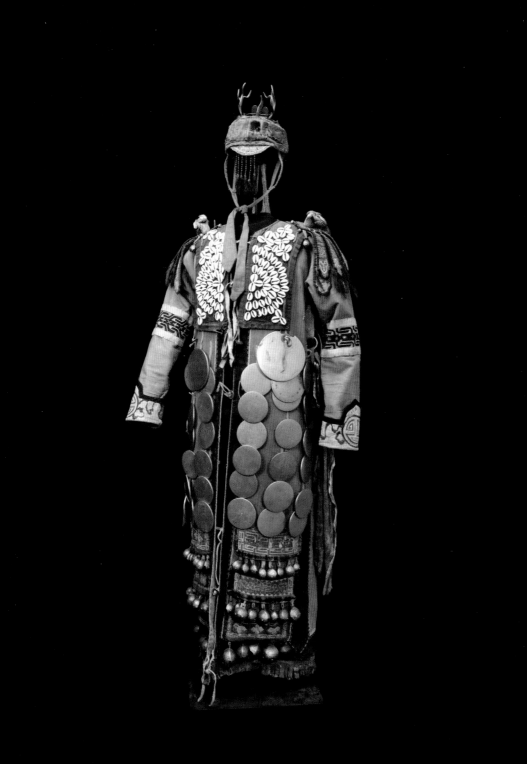

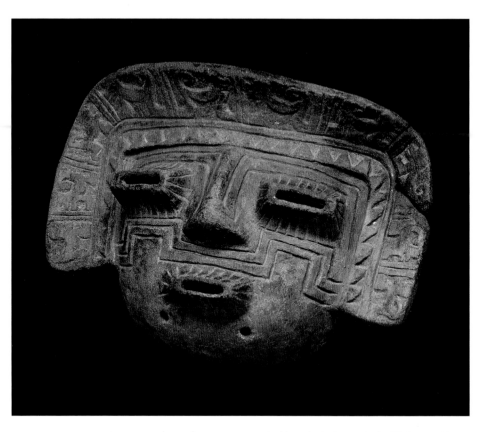

always been accompanied by a hat, decorated with iron antlers that evoked the reindeer of nearby woodlands. This was an apparatus, an empowering technology, that expressed the capacity of the shaman; it did what tattoos and amulets do for priests and healers in other cultures.

Body art's possibilities could be extended still further, if consideration were given to those arts that make use of whole deceased bodies, or parts thereof appropriated from enemies. Museum galleries can be and have been filled with embalmed and decorated mummies, funerary effigies of other kinds, commemorative ancestral heads, trophy heads and shrunken heads. Among the most impressive of such items are the *rambaramp*, the ancestral effigies made by the people of southern Malakula, an island now part of the South Pacific nation of Vanuatu, to commemorate the most prominent male members of the community. Societies of the region were hierarchical; status was gained through the exchange and

22 Ceramic funerary mask thought to depict facial tattoos, Columbia, c. 100 BCE–100 CE.

sacrifice of pigs, which themselves were not ordinary animals, but subjected to particular body modifications, with their upper incisors knocked out in order to allow their lower tusks to continue to grow, forming full circles. Only men who had achieved the highest status were represented through *rambaramp*. The effigies incorporated the deceased's skull, which was attached to a wooden 'skeleton' covered with tree-fern and clay; the whole was then painted and fashioned into a portrait of the man using a variety of ornaments, motifs and accoutrements that reflected particular accomplishments. The example illustrated here features model human heads with pigs' tusks, which together with the numerous tusks and

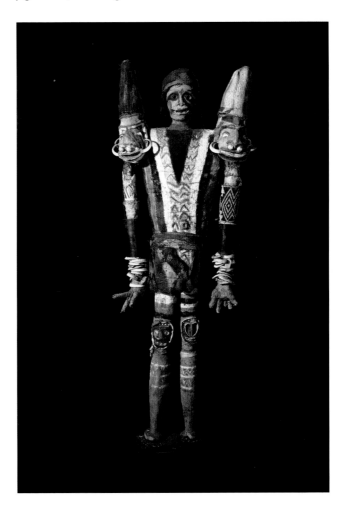

23 *Rambaramp* effigy of a prominent male ancestor, Malakula, Vanuatu, early twentieth century.

turtle-shell armlets around the wrists attest to the singular renown of the individual. These figures were preserved for a period in a men's house and commemorated from time to time; eventually, as the modelled face began to decay, the figure would be disassembled and the skull removed to the clan ossuary, the great man ceasing to be a named and remembered hero and becoming instead one among the group's ancestors.

The body and person could be diminished and negated as well as affirmed and commemorated. Given that body art is often as much a matter of process and performance as it is one of decoration – obtaining the tattoo being as important as bearing the finished design – public corporal punishment and executions are also relevant instances, theatrical stagings of the expression of social will on the bodies of offenders. If the lifestyle associations of body art today predispose us to think of body arts as the expression of personal choice, as modifications desired by the person whose body is in question, that has not always been true or typical. Body modifications have just as often been required by the community at large, and imposed injuriously on the bodies of reluctant bearers, or lethally on those considered enemies or appropriate targets for persecution. Conversely, political performance can hardly go beyond the theatrical destruction of the body through self-immolation. The person may hope that the virtue of the cause is reflected in the innocence of absolute self-sacrifice: the activist destroys what is most precious to him- or herself – body and life – but nothing other, nothing but the 'everything' that is lost to them alone. Hence the suicide bomber, unfortunately regarded by some as a martyr but more often than not the mere pawn of a callous terrorist commander, may act theatrically but cannot do so to the same moral effect in the eyes of anyone affected by the common humanity of the random victims of the typical bombing.

The open-ended character of the list implies that a survey of body art might need to embrace histories of dress, fashion, cosmetics and adornment, as well as those of diet, exercise, punishment and political violence. This would of course be impossible, and this book is for the most part focused on such art practices as tattooing, body-painting, scarification and other kinds of self-decoration that aesthetically transform the body. But it is vital to remember that this is not a formally defined genre or field, unlike textile arts or photography, say. If all

24 Marc Quinn, *Mirage*, 2009. Commemorating the abuse of Iraqi detainees by American servicemen in the Abu Ghraib prison over 2003–4, the artist created this bronze on the basis of a notorious snapshot, taken by a perpetrator and published on the cover of *The Economist* under the heading, 'Resign, Rumsfeld' (8 May 2004).

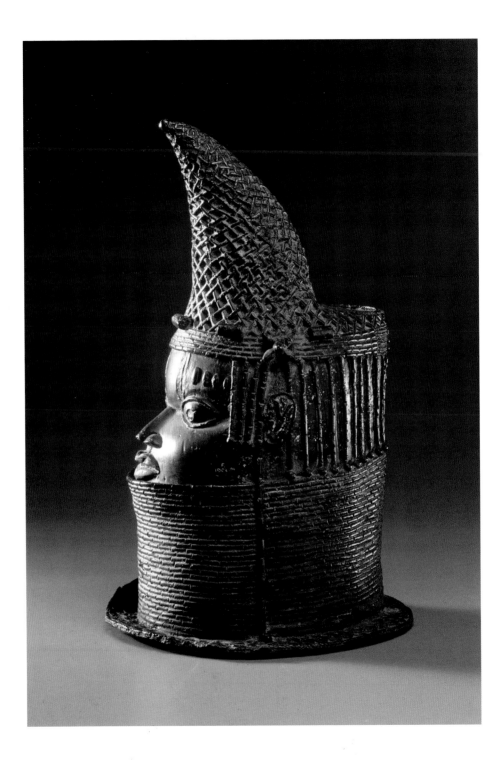

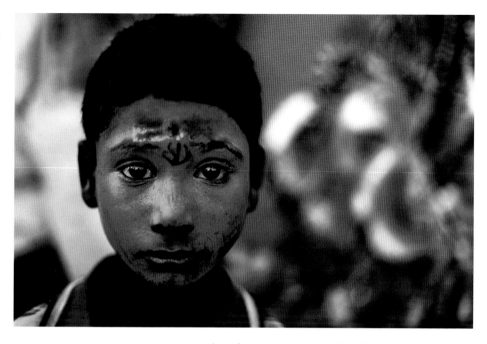

categories have fuzzy edges, and can therefore be more or less extended, this is true of the body and body arts in a more radical sense, because in one way or another the body is the vehicle or the subject of so much human action and art. Hence we also look at such practices as masking, which enable a person to assume and perform another identity – because identity, and the effort to enhance or transform it, is at the heart of body art. But beware. Identity in the contemporary understanding is itself a particular idea. At other times and in other places the aspects of being that body arts have refined or changed have been different. Thus, despite the popular interest today in borrowing on the body arts of the world, past and present, there is much in the history and variety of body arts that surprises us, that we are unprepared for. This book is dedicated to those surprises.

Thinking through the body

For much of the twentieth century, body art was a topic of specialist interest among anthropologists concerned with tribal traditions. Early on, designs were studied and compared in the hope of illuminating the migrations of native peoples, and for

opposite:
25 Bronze portrait bust of a queen mother, Benin, Nigeria, unknown date, collected 1897. The woman is depicted with four raised cicatrices over each eye.

above:
26 Indian boy with his face painted blue for the Ganesh Chaturthi festival, Allahabad, India, 2012.

27

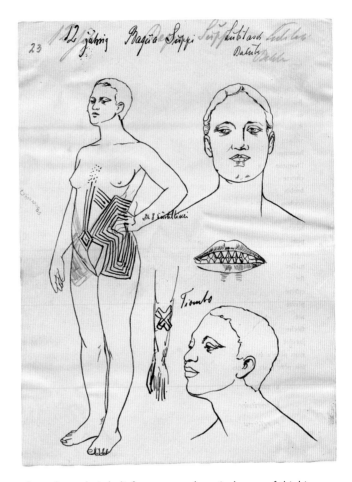

27 Field record of scarification marks and teeth filings of a Luba woman, on printed template, probably the work of German anthropologist Leo Frobenius (1873–1938), Congo, 1904–6. Ethnologists of the period took printed sheets of this type to the field to record various forms of body modification and adornment.

clues about their belief systems and magical ways of thinking. From the 1960s onwards, a rejuvenated discipline dedicated to the logic of culture and social relationships examined the meanings of body-art motifs, and the roles of art in initiation, ceremony and customary politics. Over the same period, the popular practice of Euro-American tattooing – stereotypically associated with sailors and prostitutes – was well known but little studied, though earlier, and notoriously, the criminologist Cesare Lombroso (1835–1909) had considered it symptomatic of a degenerate personality. As late as the 1980s, tattooing was being analysed by academics whose special field was known as the 'sociology of deviance'. A wider range of writing on the subject began to appear only towards the end of the twentieth century. A couple of landmark volumes in the late 1980s, such

as Arnold Rubin's *Marks of Civilization* (1988; see p. 40), paved the way for a literature that gained depth and momentum after 2000, with the emergence of a deeper range of studies of varied past and present body arts.

This wave of interest was in part a response to an unprecedented phenomenon of the 1990s. For the first time in the West, tattooing and piercing, among other body modifications, ceased to be the markers of subcultural and notably marginalized identities. They were widely adopted by middle-class youth, and prominently by such celebrities as the singer Robbie Williams and the footballer-cum-model David Beckham. The normalization of tattooing as part of mainstream fashion was for a few years a topic of frequent comment in the media. While tattoos on the neck or face, or others that might be prominent when normal clothing is worn, would still be unacceptable to most employers of white-collar workers, the notion that a professional man or woman might bear discreet tattoos is no longer at all remarkable.

The growth of thinking and writing about body arts was not only a response to this efflorescence, however. It also grew out of a longer and deeper trend. From the 1960s onwards,

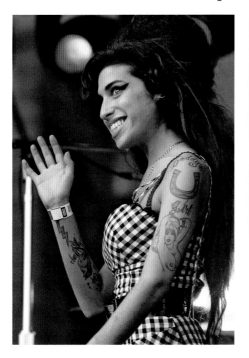
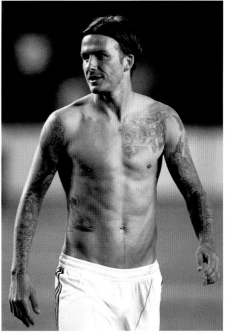

philosophers, anthropologists and feminists had questioned ideas of what was natural, more radically than ever before. Among the influential arguments of Michel Foucault (1926–1984) was his thesis that the body was subject to political and economic management, and a bearer of socially prescribed needs and desires. Historians inspired by feminism and by the anthropological interest in cultural difference began to argue that the body was not a natural constant but something that in each epoch was conceived of and valued differently; indeed, that 'nature' itself was not exactly natural. Once this was recognized, a proliferation of studies drew attention to different religious, medical, sexual and other ways of perceiving the body that had indeed undergone profound shifts over time, just as had conceptions of childhood, sexuality and death.

Over the same period, medical advances undermined the idea that the body was a self-subsistent and complete entity. Organ donation, the development of prostheses and varied medical implants, as well as the techniques of cosmetic surgery, already mentioned, eroded longstanding assumptions and fostered notions that were new in the West (although they had many precedents in other cultures) that the body was mutable, and susceptible to the addition or subtraction of some of its parts. In parallel, avant-garde artists began to explore the aesthetic possibilities of bodily rites and ordeals, and turned their own bodies or those of others into modified, often disturbing works of art. Thus, by the end of the millennium, the strange bedfellows of postmodern philosophy, biomedical science and performance art had conspired to overturn an understanding of the body as first and foremost a natural inheritance. What became natural, what entered common-sense ideas, was by contrast the notion that one's body was something one was at liberty – and indeed had a responsibility – to care for, shape, modify and re-create in ways appropriate to one's identity. This understanding carried its own assumptions, but they were new assumptions, and they provided ground for experimentation. This experimentation was the project not just of critics, theorists or adherents of esoteric minority art movements. Within no more than a generation, the new understanding of the body infiltrated what might loosely be called popular consciousness. It empowered experimentation not only among the middle-class youth of the West, who were supposedly getting pierced and tattooed for the first time, but also among people of diverse ages and classes around the world.

Methods and politics

What do we know of body art over the longer course of human history, and of the cultures of the world? The answer is a great deal, but much of the knowledge, much of the evidence, is uneven and in many ways unsatisfactory. For the more remote past, archaeological data is rich but also very patchy, and not always easy to interpret. Human remains bearing evidence of body modification have been extensively excavated, while designs on the bodies of ancient ceramic figures from various regions – South America, Japan and Egypt among them – are believed to represent tattoos or body-paintings; indeed, in some cases the motifs shown are consistent with those known from historic sources. Yet it is of course impossible to know what significance was attached to these modifications, and even to prove that motifs on figures represent those that actually appeared on the bodies of living people (except in the rare cases where mummified bodies, or bodies preserved in bogs, bearing marks have survived).

Different problems arise with respect to historic records. Many of the forms of body art encountered by European travellers among non-Europeans were and are spectacular.

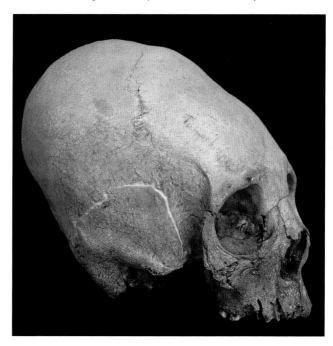

30 Woman's skull, elongated by head-binding, Peru, nineteenth century. Head-binding that resulted in elongation of the skull was historically practised in multiple regions worldwide, including parts of South America and Melanesia.

31

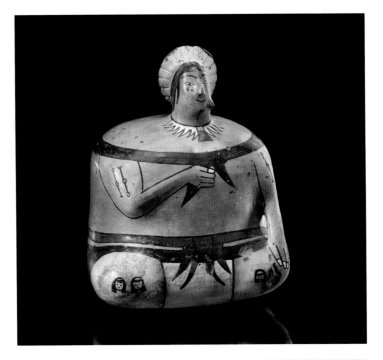

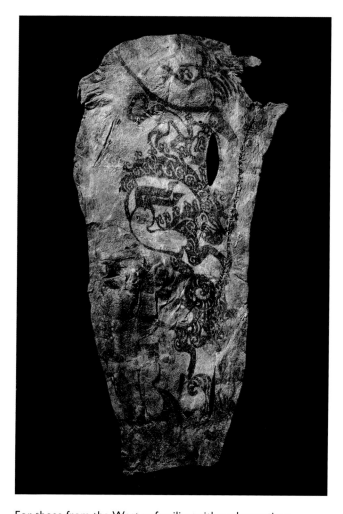

For those from the West unfamiliar with such practices – particularly those whose prejudices were shaped by Christian and aesthetic traditions that proscribed or stigmatized body modification – tattoos, scarifications and suchlike were striking; they provoked curiosity, they were in some cases alluring or awe-inspiring, but they were often also perceived as barbaric disfigurements. More enlightened observers and artists, over the centuries of exploration and empire, were genuinely curious, and tried to document techniques and motifs, but many were swift to dismiss customary arts as symptoms of one sort of savagery or another. Hence, although the array of relevant reports is massive, many are unreliable or at best

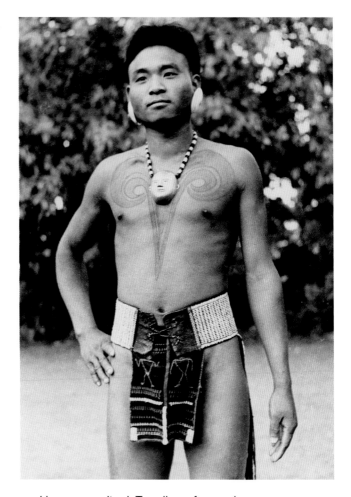

weakly contextualized. Travellers often made common-sense assumptions, stating for example that the most heavily tattooed men were those of the highest social status, or those who could boast particular achievements as warriors. Conversely, women were often said to be marked in order to make them more sexually attractive. These kinds of observation were in some cases simplistic or half-right, and in others just false, but they tended to gain currency as they were quoted, repeated and reproduced in encyclopaedic tomes that ostensibly described the peoples of the world.

Even seemingly well-qualified observers could misinterpret the significance of body-art practices. Paul Foelsche (1831–1914), the first police inspector to be put in charge of Australia's

above:
34 Verrier Elwin, 'Man, warrior, with mithun (wild cow) horns, chest tattoo and effigy head necklace indicating successful headhunting, and wearing ear plugs and cowrie shell belt', Naga people, India, 1954.

opposite:
35 J. H. Hutton (attrib.), 'Hamshen, man with tattoo (which can't be worn until enemy flesh has been touched) and in costume', Naga/Thado people, Assam, India, c. 1910–1930s.

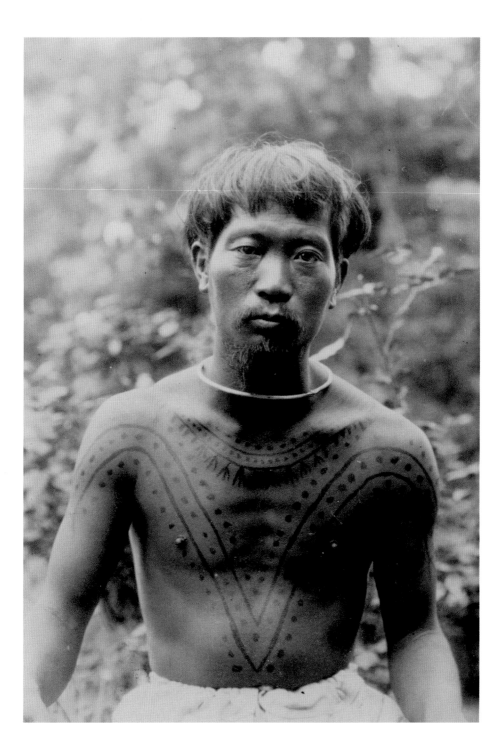

36 Paul Foelsche, Australian Aboriginal man thought to have been the Iwaidja elder Nullamaloo, also known as Bob White, with cicatrization marks, c. 1870s.

37 Paul Foelsche, twenty-three-year-old woman identified only as the wife of 'Charly', with cicatrization marks, Alligator River region, northern Australia, c. 1870s.

Northern Territory, worked extensively with Aboriginal people while leading the police force there between 1870 and 1904, and went on to become a highly respected photographer and amateur anthropologist. He reported that both men and women underwent scarification between the ages of about twelve and twenty, but that the practice was accompanied by no kind of ceremony. Although he acknowledged that some women had their backs incised when their husbands died, Foelsche believed that scarification was not prescribed at particular times; rather, it simply reflected the personal 'fancy' of the individual. The founding figures of central Australian anthropology, W. Baldwin Spencer (1860–1929) and F. J. Gillen (1855–1912), noted that cuts were generally more extensive on the bodies of men than on those of women, and consisted of a few bands on 'the scapular region' (that is, across the upper back) and on the front – typically, paired horizontal or vertical bands from chest to shoulder – as well as some lines on the arms. But they likewise rejected the idea that scarifications had ritual or any other significance, stating categorically that they were made simply for ornament, that they had 'no special meaning'.

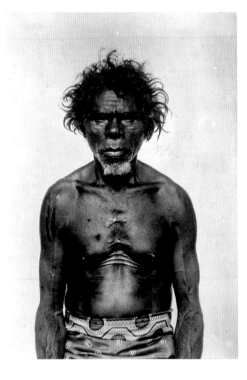

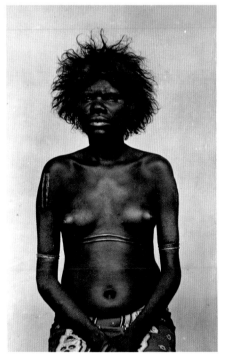

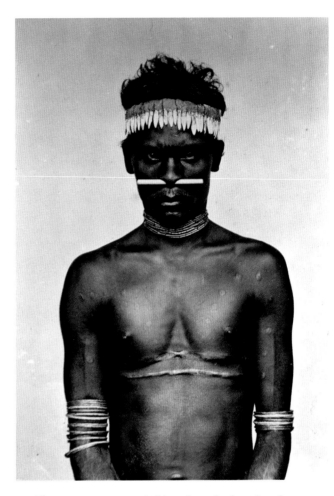

These statements probably reflect the fact that the fieldworkers, when they asked what scarifications indicated or were for, received no answers that made sense to them. But they were probably asking the wrong questions. Several of the early ethnographers were exercised by the question of whether patterns were used to distinguish between different tribes, and whether they were specific to exogamous (out-marrying) groups – it being presumed that it was vital that prospectively legitimate spouses were visually differentiated from those with whom sex would be taboo (because it would be equated with incest). The tendency to interpret body art as social marker or as coded information was typical of nineteenth-century anthropological thought, but overlooked the work that scars

38 Paul Foelsche, Daly River Aboriginal man wearing cane and leather armbands and a headband made out of crocodile teeth, c. 1870s.

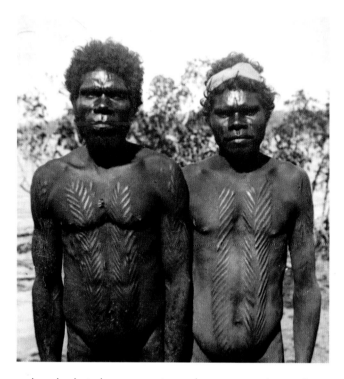

and marks do to bear memories, and to express values and relationships that may not be verbally articulated. In fact, the current understanding is that scarification in northern and central Australia was closely associated with the commemoration of the dead, and with major regional ceremonies. In at least some parts of the country it was considered a form of beautification; at any rate, those not bearing scars were thought unattractive. Among Tiwi Islanders, a dense, highly distinctive herringbone style of scarification appears to have been intended, in conjunction with a variety of ornaments worn on ceremonial occasions, to transform the appearance of the bearer, rendering them similar to *tutini*, the carved grave-posts used in the *pukamani* mourning ceremony. The designs employed in body art are frequently employed on forms other than the body, in customary paintings or on textiles, for example. This kind of crossing-over may reflect the sense in which both body and painting carry ancestral power, or the belief that a warrior's body and his shield are supposed to exhibit the same vigour and brilliance. In either case, the expectation that a particular kind of body art represents

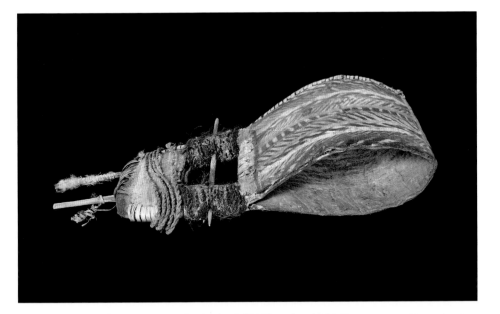

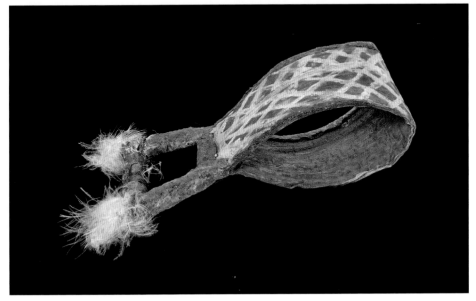

a social status, or membership of one group or another, is likely to be excessively literal and misleading.

The anthropology and history of indigenous art re-emerged as an area of serious scholarly interest in the 1960s, and stronger and more sympathetic studies emerged. Arnold Rubin's collaborative collection, *Marks of Civilization* (1988), which remains one of the most important modern anthologies on arts of the body worldwide, presented rich case studies that built on the more searching and sensitive ethnographic inquiries that were then emerging. But it left out whole regions, precisely because much of the data on which a global survey might have been based was, as Rubin was well aware, patchy and poor. Conscious that any overview risks lapsing into an anthology of disparate observations, this book tries to offer both depth and breadth by foregrounding particular histories and traditions, while ranging more widely, especially by using images to represent some cultures and practices that are not discussed in detail in the text.

There is a further issue that any book on this subject ought to address. Many of the practices that are relevant are known to us through the work of colonial photographers, who were concerned during the second half of the nineteenth century and the first decades of the twentieth with documenting peoples and ways of life that were often perceived as vanishing. Over the last twenty years or so, these visual records (and the sketches and paintings of colonial artist-travellers, the photographers' predecessors) have fallen into disrepute. They are seen not as neutral visual records of the ways of life of non-Europeans, but as a somewhat insidious demonstration of power, an expression of dominance in the field of visual culture, an anthology of stereotypes, an archive reflecting European racial ideologies and sexual voyeurism. Even modern curators and scholars involved in critically assessing colonial photography and art, it has been suggested, have subtly or not so subtly perpetuated this imperial culture and its values, by giving negative imagery further, unnecessary circulation. If this is a valid critique in general, it is of particular concern if our interest is in body arts, where the images under consideration often highlight the exotic markings of semi-clothed bodies.

It is certainly the case that colonial photos were both products and expressions of the culture that generated them (how could they not have been?). But the archive as a whole

is heterogeneous, and much of it does not amount to visual denigration, just as it is not devoid of documentary value. While studio photographs were frequently made to inform the metrics of physical anthropology and racial classification, and to feed popular appetites for picturesque images of folk types, or 'dusky maidens', images that were made in the field, in villages or otherwise in the normal environments of the people depicted are entirely different, and were typically motivated by more nuanced agendas. For native individuals and communities, photography was not necessarily experienced as an intrusion or oppression. On the contrary: it was sometimes actively appreciated. Some people were keen to be photographed, keen to have particular activities or subjects recorded, and keen to look at or to have copies of photos of themselves. If some individuals definitely were photographed under duress, or cajoled into being photographed, others were pleased to be, and appear to have felt as dignified by the process of being imaged on a *carte de visite* as any bourgeois European would have been. Which makes it unsurprising that in due course the technologies of photography were adopted by Asians and Africans themselves, and that Maori and indigenous Australian contemporary artists, among others, have gone back to the photographic archives and even to the casts made to serve physical anthropology, seeing value in bringing lost images into the light.

From the early nineteenth century onwards, heavily tattooed Europeans and native peoples were widely exhibited to the curious public, to those who visited fairs and sideshows of various kinds. These exhibitions represent an important chapter, one among the many histories that this book seeks to trace, but needless to say I aim to critically examine the spectacular and the spectacle, rather than reproduce the voyeurism that such shows invited and cultivated. Inevitably, readers of this book, people interested in this subject, in fact people everywhere, will look at pictures. Such looking is an expression of human curiosity that cannot and should not be censured or censored. This book tries to encourage and inform this looking, and tries also to look beyond images, to engage with the cultures that engendered body arts, and the people for whom they were and are meaningful.

With these issues in mind, I have avoided reproducing colonial or other photographs that seem patently offensive, that appear to exploit their subjects, but I do take colonial

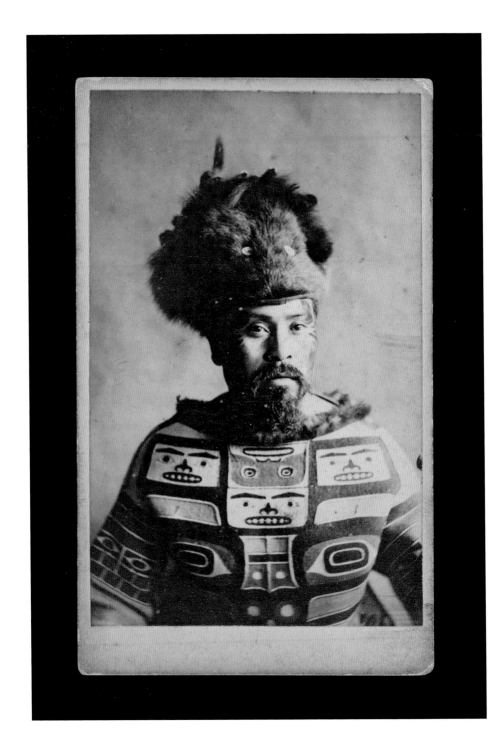

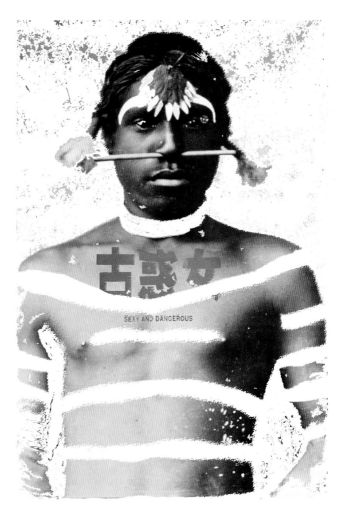

SEXY AND DANGEROUS

imagery to be too rich a resource to shy away from. This book aims to draw attention to the importance of archive and museum collections for those interested in the astonishing diversity of human creativity in both the past and the present. And the book balances these outsiders' images with the art forms that communities created themselves, that often gave scarifications, tattoos and body-painting the degree of prominence that was culturally appropriate. These art forms range from ancient ceramics to sculptures created over the last few centuries, and more recent paintings and other works of contemporary art. Some indigenous artists celebrate customary body arts that have been suppressed or abandoned.

right:
44 Marguerite Milward, *Portrait of Bendiri, A Tattooed Khond Woman,* c. 1938.
Trained in Paris and admired by Rodin, British sculptor Milward (1873–1953) created an extended series of Indian physical and social 'types'. Highly regarded at the time of their creation in the 1930s, her works are harder to assess today. They suffer from association with colonial racial categorization, but were also intimate portraits of named individuals.

opposite:
45 Fiona Pardington, *Portrait of a Life-Cast of Matua Tawai, Aotearoa/New Zealand,* from the series *Ahia: A Beautiful Hesitation,* 2010.
Pierre Marie Dumoutier, a phrenologist, travelled with Dumont d'Urville to the Pacific in 1837–40, and was perhaps the first scientific participant in a colonial expedition to be charged specifically with the study of physical anthropology. Pardington's photographs reinterpret Dumoutier's life-casts as monuments to her Maori ancestors.

Others celebrate practices that are very much alive, that have – unexpectedly and remarkably – become more potent and dynamic as a result of modernity and globalization. This is just another of the (too many) things that body art seems to mean: it is caught up with gain and loss. One of the fundamental questions of contemporary life is whether all the turbulence of modernization over recent decades and centuries has given us more, or less. What body arts do, and what body arts have become, exemplifies this issue, among others that are just as profound and controversial.

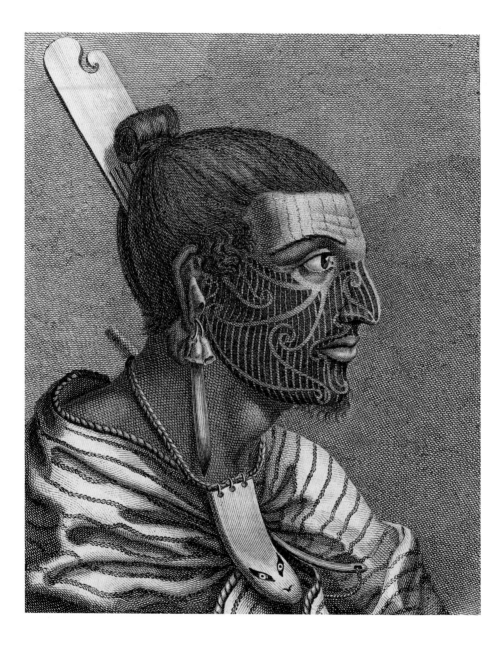

Chapter 1 Humanity

No action could be simpler, in a physical sense, than daubing some part of the body with paint, or using a quartz flake, a bamboo knife or some other kind of blade to cut open the skin. Yet in many parts of the world, painting and cutting the skin have been more than actions for millennia. They are what folklorists and anthropologists called 'customs': practices considered essential and important by particular peoples, necessary to the continuation of life and to social order. The idea of 'custom' is now dated, but our sense that peoples around the world sustain identities by sustaining certain practices, especially ones that shape the body, has renewed vitality in times of movement and global conflict.

To inflict a wound or smear paint is not simple but profound and paradoxical. Humanity itself is paradoxical, being both animalistic and civilized. At least, it appears that way, because we struggle to understand that it is always both, always hybrid. The conceptual dimensions of our identities – that you may be daughter, immigrant, businesswoman, citizen – are as vital to us as our organic make-up. And these paradoxes are encapsulated in the skin, which appears at once the expressive surface of inner personal identity, and the medium for society's inscriptions on the body, for the group's requirements of the person. People are nowhere supposed to behave like lone predators. Their acquiescence, their embrace of social values, is expressed through the management and modification of their bodies.

One of the most basic aspects of this is the maintenance of personal cleanliness. Hygiene means different things to different people, but has been universally important in the history of humankind. For the Kayapo of Amazonia, it was essential to bathe daily, and particularly to free the body of any traces of meat, animal residues or food. Carelessness and slovenliness were commonly regarded not merely as expressions of deficient character, but as antisocial behaviour, implying that the person himself or herself was wild and undomesticated.

46 Engraving after Sydney Parkinson, *The Head of a New Zealander*, from James Cook and John Hawksworth, *Account of the voyages undertaken by the order of His present Majesty, for making discoveries in the Southern Hemisphere* (London, 1773). Te Kuukuu, a chief's son who was shot in the thigh during a conflict between Captain Cook's men and Maori warriors in the Bay of Islands, was drawn by Sydney Parkinson in early December 1769. It is perhaps the single most extensively reproduced image from the entire visual archive of early European exploration and travel.

47 Engraving by Parfait Augrand after Jacques Arago, *Îles Sandwich, femme de l'île Mowi dansant,* from Louis de Freycinet, *Voyage autour du monde: Atlas historique* (Paris, 1822).
Hawaiian woman with extensive chest tattooing, depicted by an artist on an early nineteenth-century French voyage.

48 Engraving of Tahitian artefacts by John Record after John Frederick Miller, from James Cook and John Hawkesworth, *Account of the voyages undertaken by the order of His present Majesty, for making discoveries in the Southern Hemisphere* (London, 1773).
During Captain Cook's voyages, Europeans began to take an interest in Pacific arts and technologies and represent them in images of this kind. Together with adzes used to work wood, this engraving depicts (lower middle) three multi-pronged tattooing needles, and (right) the type of mallet with which they were struck.

However, if the term 'body modification' sounds like a neutral label for a set of practices, it implies one of the great binary oppositions on which Western thought is founded: that between nature and culture. It was once argued that this opposition was vital in all societies, that, like male and female, it formed a universal structure of thought and society. But that claim has long been considered untenable. For many peoples around the world, the cosmos is energized by spiritual forces, manifest equally in plant and animal life, in the elements and in human endeavour. The idea that culture is artifice, a system for action on a wholly separate natural realm, is not universal, but a hallmark of European thought during the modern era. For many peoples, body art is not just the fashioning of a properly social person out of a natural and potentially wild one, but also the creation of a fully human being.

For the peoples of Polynesia, the body was not a natural entity that a man or woman might choose to alter; rather, it was a bearer of a sacredness susceptible to transmission. This was the case particularly in the archipelagos of the east, in the Society Islands, Hawaii **[47]**, the Marquesas, and the related cultures of the Maori of New Zealand **[46]**. Europeans first visited Tahiti and the neighbouring islands in the 1760s. The explorers found the environment, the people and the islanders'

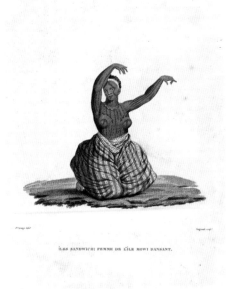

ÎLES SANDWICH: FEMME DE L'ÎLE MOWI DANSANT.

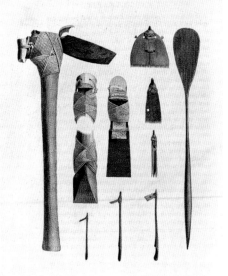

way of life aesthetically pleasing, and saw the Tahitians not as savages but as people who were partially civilized. Among the Tahitian customs that intrigued and impressed the explorers was that of tattooing **[48, 49]**. Joseph Banks (1743–1820), the aristocrat and natural historian who accompanied Captain James Cook on his first voyage around the world, was astonished by the practice, and particularly by the preparedness of young women to submit to what was evidently an exceptionally painful process. As he noted in his journal:

> The colour they use is lamp black wich they prepare from the smoak of a kind of oily nutts usd by them instead of candles; this is kept in cocoa nut shells and mixt with water occasionaly for use. Their instruments for pricking this under the skin are made of Bone or shell, flat, the lower part of this is cut into sharp teeth from 3 to 20 according to the purposes it is to be usd for and the upper fastned to a handle. These teeth are dippd into the black liquor and then drove by quick sharp blows struck upon the handle with a stick for that purpose into the skin so deep that every stroke is followd by a small quantity of Blood . . . and the part so markd remains sore for many days before it heals.
>
> I saw this operation performd on the 5th of July [1769] on the buttocks of a girl about 14 years of age; for some time she bore it with great resolution but afterwards began to complain and in a little time grew

49 Sydney Parkinson, studies of Tahitian tattoos, 1771.

so outrageous that all the threats and force her friends could use could hardly oblige her [to] indure it.

It is done between the ages of 14 and 18 and so essential it is that I have never seen one single person of years of maturity without it. What can be a sufficient inducement to suffer so much pain is difficult to say; not one Indian (tho I have askd hundreds) would ever give me the least reason for it.

It is notable that both Banks and Cook himself wrote about tattooing as though they had no knowledge of any similar art. Johann Reinhold Forster (1729–1798), the scientist on Cook's second voyage, was more widely read, indeed exceptionally so, and when he remarked on tattooing in his own voyage reflections, a decade later, he noted in passing that the custom was also reported among the Tungus of Siberia, Native Americans, the Bedouin of Tunisia, Palestinian women, other 'Arabians' and 'Greenlanders'. The tattoo was indeed highly significant among these peoples, and for some of them, such as the circumpolar Inuit, it remained so well into the twentieth century **[50–52]**. Forster was thus well aware of the distribution of the practice around the world, although the only Europeans he mentioned were the 'ancient Huns'.

Through extraordinary coincidence, tattooing was also conspicuous in one of the most famous paintings of the time. In 1770 the history painter Benjamin West (1738–1820) completed *The Death of General Wolfe*, which created a sensation when

opposite:
50 Arnaqu Ashevak, *Tattooed Women*, 2008.

above:
51 Jessie Oonark, *Tattooed Faces*, 1960.
Inuit artists such as Oonark and Arnaqu Ashevak have commemorated the tattoo tradition that declined over the course of the twentieth century, following pressure from Christian missions and colonial agencies.

right:
52 Thomas Paterson, Inuit woman in front of a building, probably the Roman Catholic church at Repulse Bay, Nunavut, northern Canada, 29 August 1947.
This Inuit woman has traditional facial tattoos and wears a caribou-skin jacket. Paterson was an archaeologist who undertook several fieldwork trips to the Arctic from 1934 onwards.

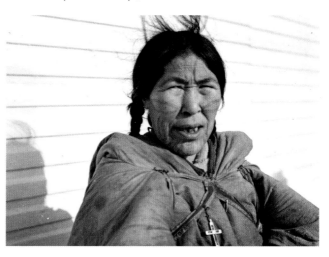

53 Benjamin West, *The Death of General Wolfe* (detail), 1770. This work famously broke new ground in bringing the conventions of historical painting to a contemporary event. Its claims to authenticity were underscored by the apparently careful depiction of the tattoos worn by the Native American in the foreground, anticipating the striking representations of tattoos in the Cook voyage engravings by only a few years. Both expressed the renewed interests and anxieties surrounding questions of national identity and cultural difference in Britain during the 1770s.

shown the following year at the Royal Academy in London **[53]**. Among those tending to the fallen hero of the Battle of the Plains of Abraham (1759) in Quebec is a Native American warrior with a carefully delineated tattoo. The man's various other accoutrements and ornaments are similarly accurately depicted, probably on the basis of objects in the painter's own collection, items that were later donated to the British Museum by his descendants. The visual source for the body art is, however, unclear. Although West had been born in Pennsylvania, and had lived there until his early twenties before travelling to Italy and subsequently settling in England, it appears unlikely that he was simply reproducing tattoos that he had seen on indigenous men in his youth. He may rather have worked from sketches of tattoos that he had made much earlier, before leaving North America, or he may have encountered a Native American visiting London. In any case, the tattoo is an arresting feature of the painting, and the presence of the character is vital to the overall effect. A Native American, marked with what would have been seen as an expression of barbarity, is nevertheless shown in the company of the British army (the viewer presumes that he has served

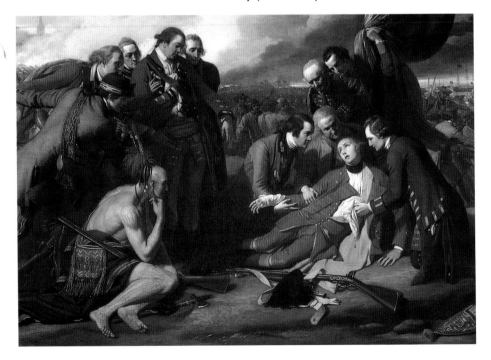

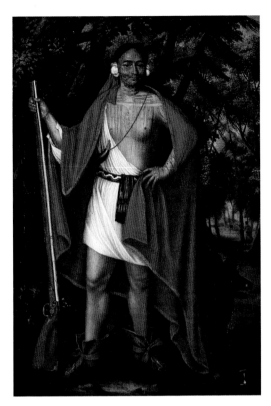

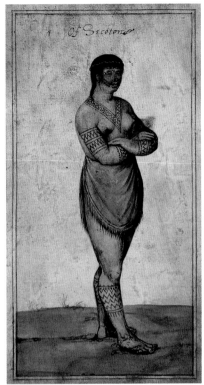

54 Jan Verelst, *Sagayenkwaraton (baptized Brant), Named Sa Ga Yeath Qua Pieth Tow, King of the Maquas (Mohawk)*, 1710.
This man was one of four Native American leaders – three Mohawk from the Iroquois Confederacy and one Algonquian – who travelled to Britain in 1710 to negotiate a military alliance against the French. Queen Anne commissioned portraits of all four.

55 After John White, *The Wife of a 'Werowance' or Chief of Secotan*, 1585–93.
This tattooed woman is said to be a Secotan from the coast of what is now North Carolina. White, subsequently governor of Roanoke Colony, was the first British artist to paint Native Americans.

as a scout or local auxiliary of some kind). Moreover, he is pictured among those not only paying their respects but also empathetically engaged in the general's plight; he is a full member of the cast, as it were, in an imperial and patriotic scene that circulated widely through printed engravings.

What was usually referred to as the 'puncturing' or 'marking' of the skin was thus known at least by savants and travellers of this period to be culturally widespread, and to be a conspicuous practice among the Native Americans with whom both the British and the French had close dealings as a result of North America becoming a theatre of imperial conflict in the late eighteenth century **[54, 55]**. Yet Cook, Banks and their sailors, in the Pacific at the very time West was working on his great painting, made none of these associations. Rather, they were fascinated and awed by the practice before them, which affected them as though unique, as though unprecedented among travellers' discoveries, which of course it was not. Captivated, they made note of the Tahitian word *tatau* and

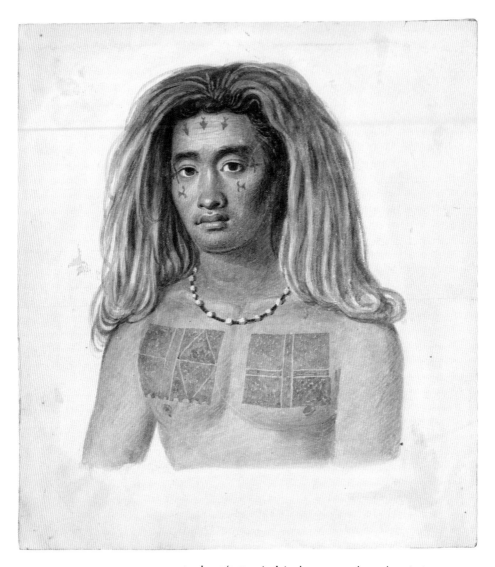

56 Augustus Earle, *A native of the Island of Tucopea (Tikopia), c.* 1827. Earle was an especially interested and sensitive artist in portraying Pacific Islanders and their cultures. The sitter's rectangular chest tattoos may well have emulated the flags of sailing ships, which were symbols of power and considered prestigious textiles by indigenous people.

wrote about 'tattowing'; in due course these descriptions were published in voyage narratives that became best-sellers, not least because they tantalized European readers with curiosities and customs of this sort [56–59]. The word was not only anglicized but also entered all the other European languages into which these popular accounts of exotic adventure were swiftly translated. Soon, 'tattooing', 'tatouage' and equivalents thereof replaced 'marking' and 'puncturing' to become the familiar word for the permanent marking of the skin with ink or dye.

As Joseph Banks readily acknowledged, the Tahitian practice was not one that early European visitors could understand. They witnessed something of Tahitian life and gained some familiarity with the language. But the concepts that empowered the Tahitian understanding of the world and that motivated this treatment of the body were only documented much later, as knowledge concerning the Tahitian's beliefs and rites was salvaged in the wake of their conversion to Christianity. The information that was gathered is not in itself easy to interpret, but does suggest that Polynesian culture possessed its own, very powerful binary opposition: a juxtaposition between this world, the world of the living and of light, *ao*, and the other world of darkness, of before and afterlife, *po*. While many cultures posit spirit worlds and afterworlds, the Polynesian beliefs were distinctive. The *po* was a realm of primal energy, of an unconstrained life force that constituted the sole source of energy, fertility and life in the world that humanity inhabited. The force was vital and necessary to procreation, sustenance, growth and everyday life, but also dangerous. It could cause illness, infertility or death if it

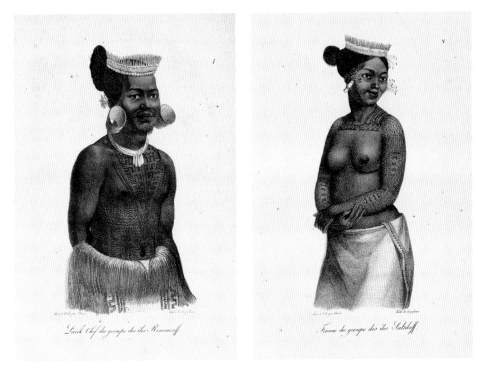

Larik Chef du groupe des îles Romanzoff

Femme du groupe des îles Saltikoff

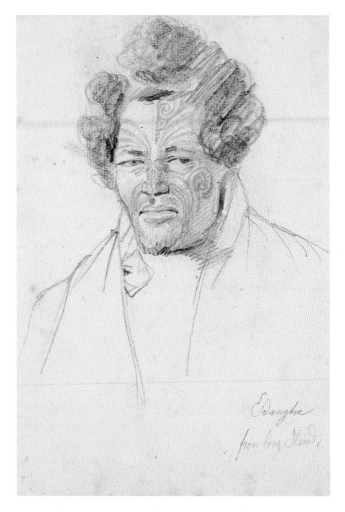

Edanghe
from Long Island

appeared in an uncontained or unconstrained manner. Its appearance and its channelling thus had to be carefully managed. Human orifices represented passages between *ao* and *po*, and food and menstrual blood thus had to be kept separate, insulated from less charged substances that might transmit their energy.

The newborn emerged directly from the *po* and were thus intensely and threateningly *tapu*. They therefore underwent rites that diminished this powerful and dangerous sacredness and made ordinary interaction between themselves and others (including their parents) safe. In Tahiti, this was made possible by blood-letting and mixing: the child's blood was intermingled

59 Charles Rodius, *Edanghe from Long Island*, 1834–35.
This man was from Long Island in the Marlborough Sounds, at the top of New Zealand's South Island. Probably an active trader, he was sketched by a convict artist while visiting Sydney in 1834–35. It is unclear whether his asymmetrical moko was just incomplete, as it may well have been, or deliberately intended.

with that of less sacred persons, and thereby rendered less contagious. This was not a one-off ritual but an operation that was performed on a number of occasions over the course of childhood, presumably because sanctity was too intense to be effectively removed on a single occasion. Until the whole sequence of rites had been completed, the child remained threatening to its parents in various ways, and could not eat with them or touch their food without rendering it *tapu* and therefore dangerous to them. Many rituals, in fact, were

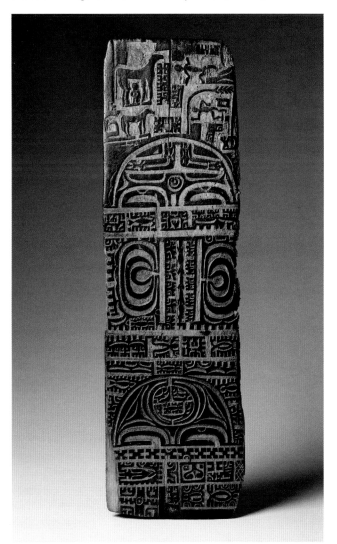

60 Tattoo template or signboard, Marquesas Islands, late nineteenth century.
This Marquesan carving, of a very rare type, is essentially an illustration of designs typically tattooed on the legs and arms, though the human and animal figures shown did not feature in Marquesan tattoo, so far as is known. The board may have been created on commission for an interested European visitor, but this is far from certain.

directed at the removal of *tapu*; their effect was relative and contextual, and some persons of high rank were permanently *tapu* to a greater degree than others.

The tattooing operation witnessed by Joseph Banks, among other early travellers, was one such technique of de-sanctification. It redressed the problematic permeability of the body, its instability and its capacity to threaten others. The tattooist, a specialized priest, wounded the skin under controlled circumstances, permitted blood to flow, and hammered the plant-derived dye into the epidermis. The operation, which was centred on the buttocks, fixed and sealed the body's surface, imprinting it with arched motifs recalling the sculpted faces of deities, perhaps to give the person the form of a Janus, or two-headed, figure (such doubling was ubiquitous in Oceanic art, and is generally associated with empowerment). This form of tattooing was thus vital to the constitution of the mature, sociable person, and so far as can be established, Banks was correct to observe that everyone was tattooed in this manner. Once it was finished, a small and easily visible tattoo on the arm marked the completion of the de-sanctification rites and the non-contagious character of the individual.

In Tahiti, tattooing did not necessarily end with this essential operation, which belonged more to a ritual–medical tradition than to an artistic or decorative one. Many men and women obtained additional tattoos – on their arms, shoulders and thighs – and customary designs seem swiftly to have diversified, with the stimulus of European contact and the novel artefacts and motifs that outsiders introduced. But these tattoos appear to have been adopted (or not) out of personal choice. They were neither ritually nor socially required, and they reflect the sense in which 'body art' in Tahiti was not defined by a single cultural or ritual regime. Just as body arts among much larger and more complex populations are eclectic, the upshot of both tradition and personal taste, Tahitian practice was defined both by a religious order and by idiosyncrasies.

The necessary role of tattooing in the creation of a living human, in the Polynesian understanding, is further illustrated by the remarkable Marquesan practice of removing the skin of heavily tattooed warriors upon death **[60, 61]**. Marquesans believed in an afterworld divided into a gloomy realm occupied by former servants and common people, and a paradise presided over by the goddess Opuu, into which the spirits

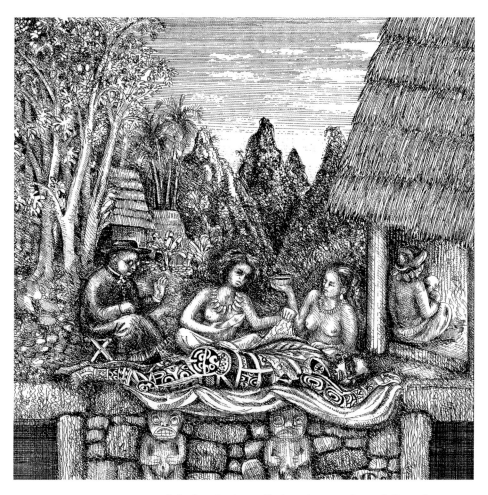

61 Alfred Gell, *The Flaying of Iotete, c.* 1990. Gell made this drawing, after a description of the flaying of the chief Iotete in a missionary letter, while researching and writing his influential study of Polynesian tattooing, *Wrapping in Images* (1993).

of chiefs and others of high rank were admitted. Opuu, however, was said to be disgusted by tattooing, and certain ferocious deities were believed to be waiting for the dead at the entrance to the afterworld, ready to tear apart anyone who arrived with any trace of it. The logic behind the flaying was the unsealing of the body, such that the man might recover the absolute disembodied sacredness that characterized immortality in the other world. Consequently, the wife or relatives of a tattooed man were obliged painstakingly to rub away the corpse's skin and all tattooing with it, over a period of months. Once the process was complete, the body, which had now recovered its infant nudity, as it were, was placed in sacred ground, from which the spirit was later understood to depart by canoe for

62 Raymond Amisongmeli, Luke Kamangari, James Lanjinmeli, Albert Lumutbange, Ben Mafa and David Yamanafi, sculpture depicting an initiate during the process of scarification, Kanganamun, Papua New Guinea, 2001–2.

This Iatmul sculpture was commissioned by the Papua New Guinean anthropologist Andrew Moutu, who undertook fieldwork in 2001–2 in Kanganamun, the village that had been Gregory Bateson's fieldwork base.

the underworld. Just as men had created warrior personalities for the present world through the addition of tattoos – multiple and artificial skins – so women created a person for the next world by undoing those skins, by stripping away the warrior's armour. The life cycle was thus not a natural process; rather, the human had to be actively made and unmade, the warrior's death not just a sad event, but also a process that needed to be crafted, a work of body art in itself.

In the Sepik region of Papua New Guinea, body arts were similarly vital to the creation of the adult human, but in the context of initiation ceremonies intended to rupture the bonds between sons and mothers, in the creation of young adult men. According to Gregory Bateson, the distinguished

anthropologist who studied the Iatmul in the late 1920s and 1930s, certain male relatives, *wasu*, acted as the 'mothers' of initiates and behaved in the manner of a comforting parent, particularly during the traumatic early stages of the process, when boys were carried past their actual mothers, as well as their sisters and other kin, en route to an enclosure within which they were to undergo scarification. Inside this enclosure was a canoe, on which the *wasu* or notional mother would sit upright, initially cradling the boy as cuts were made across his chest. The boy then had to turn over, lying with his head in the lap of his *wasu* while the much more painful cutting of the back got underway **[62, 63]**. While this was taking place – and with the initiate probably crying out in pain – the men undertaking the cutting and those standing around might joke or chat in an offhand way, as if unconcerned by the ordeal the boy was suffering. Only the *wasu* would offer any reassurance, and once the pattern of incisions had been completed, he would carry him off on his back, first to have the blood washed away, and then to the ceremonial house, where the wounds were treated with oils, and the initiate permitted to recover. Yet this represented just the beginning of a whole series

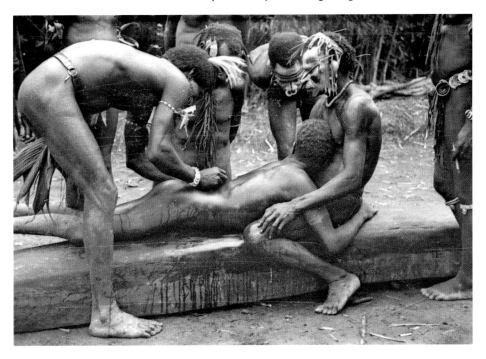

63 Gregory Bateson, Iatmul initiate being scarified, Kanganamun, Papua New Guinea, 1932.

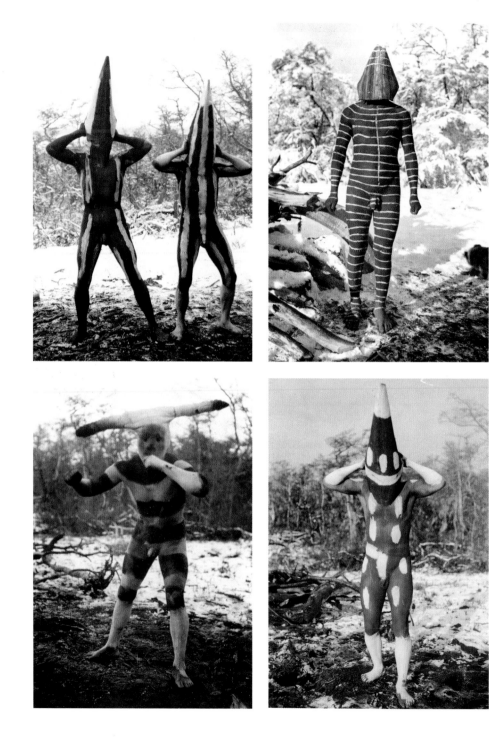

of ordeals and humiliations that would continue for six weeks or so.

During this period, secret and sacred knowledge would be imparted to the initiate. At the very time cuts were being made on his back, he would be given a secret name associated with his mother's brothers. These aspects of the rites would not be known to the Iatmul population in general, or at least not ostensibly or publically. From their perspective the visible aspect of this maturation would be the acquisition of the scarifications. These were understood locally through the metaphor of a crocodile eating, and then giving birth to, the initiates. Once the senior men controlling the initiation considered that all that was necessary had been done, and that the initiates were ready to rejoin the community, they would be provided with a feast, and then permitted to leave the men's ceremonial house. Girls also underwent scarification and a form of initiation, but Bateson, as a male ethnographer, had no direct access to such practices.

Initiation has been studied worldwide, and commonly entails the features so prominent in Bateson's analysis: the separation of the young person from society, an ordeal at the hands of elders in seclusion, and reincorporation. Among the Selk'nam and Haush of Tierra del Fuego, the Hain, the initiation cycle, featured performances by painted characters. Charles Darwin had encountered Fuegian body-painting during the second voyage of the *Beagle*, although it had disturbed him. 'All painted white red & black they looked like so many demoniacs', he wrote on 23 January 1833. But the arresting photographs taken by the missionary and anthropologist Martin Gusinde during a 1924 field trip make it apparent that this was a truly amazing body-art tradition **[64–67]**. Not because it was elaborate; it was not. Rather, varied and powerful forms were created out of such simple elements as lines and circles, and out of red, grey–black and white tints, made from ochre, prepared charcoal (ranging from light grey to black), and chalk or bone; the most elaborate forms were intended to impersonate spirits. At the core of the Hain was the deception, or rather the ostensible deception, of women. The great secret taught to initiates was that the beings who terrified them during various rites were simply masked men. The ideology was that women, who had originally ruled and oppressed men, could be kept in their place only if they believed in and feared

64–67 Martin Gusinde, Selk'nam body-painting, Tierra del Fuego, 1924.
For those interested in the native people of Tierra del Fuego, Gusinde's photographs have acquired an iconic status, and have inspired artists including Elaine Reichek, who created knitted versions of the figures, commemorating the missionary imposition of clothing and the colonial transmission of disease.

68 Headdress, Kalash people, Pakistan, made before 1983.

the spirits. Although the men were utterly serious in asserting the vital importance of maintaining this secrecy on which social order supposedly rested, and although it is hard to know for sure who understood what, in the time before missions and colonialism disrupted all these beliefs, it is highly likely that women understood the truth of the cult all along. Among the Selk'nam, the creation of the initiated adult male was also the reproduction of a gender hierarchy: body art was part of a drama that made mature men and constructed a gender hierarchy, seen as vital to social order, at the same time.

While some aspects of the trauma of initiation remained secret or private, the body would also bear permanent or temporary marks that would make the change of status and the drama around it publically visible and visually powerful. Among the Kikuyu of Kenya, circumcision took place in the context of a cycle of ceremonies known as *irua*, featuring body-painting and dance, in which the initiates carried specially decorated shields designed to complement and underscore the vigorous linear designs on their bodies. Some ornaments, such as reed necklaces, worn by uncircumcised boys were discarded at this time and replaced by others. Among the Kalash of the Hindu Kush, the *kupas*, a woven and decorated headdress, was worn by girls from the age of around five onwards **[68]**. This was the age at which they were seen no longer as infants, but as those on a path towards puberty and eventually adulthood; they also began to plait and decorate their hair in appropriate ways. The embroidered headdress was highly valued, worn during

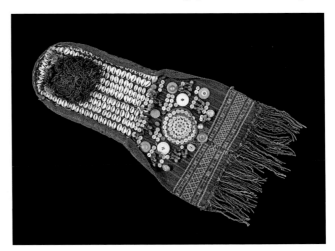

festivals, and decorated with cowrie shells as well as varied beads, buttons, pendants and other objects. The cowries reached these communities, far from the coast and far from urban markets, through extended trade networks and thus expressed not only maturity but also wealth.

In the context of initiation and maturation, body art is not concerned with creating a product or a finished appearance. The initiate is scarified or circumcised in the course of a ritually managed ordeal, and it is this *process* that is the work of art – the work of body art – for these societies **[69]**. That trauma is proportionate to the perceived need to produce and mark the passage from childhood to adulthood; this is not something that happens simply organically and progressively to the growing human, but something that needs to be effected. During the period of crisis and forced maturation, the initiate suffers great pain, and acquires secret and sacred knowledge. The aim of the effort is not to beautify the body, although some people, or all people locally, may consider the scarified body (or circumcised genitalia) aesthetically attractive, just as the new ornaments or decorations that an initiated or mature man or woman may bear are beautiful and arresting. For the initiate him- or herself, scarifications or other modifications are expressions of what the body and the person have undergone, of the self's distance from what it was. Just as people in general 'feel their age', in the sense that they are conscious of inhabiting a youthful or an aging body, so scarification or circumcision, and such age-appropriate accoutrements as *kupas*, enabled Iatmul or Kikuyu young men and Kalash girls and young women to have an implicit and ever-present sense of themselves as maturing or initiated beings with commensurate capacities, responsibilities and status. The effect of body art was thus the transformation of inner being, of the individual's personal identity. What may appear abstract and exterior, a matter of social classification, is rendered internal, an aspect of everyday being.

Too often in life, the body and the person are at risk. The issue is not the assurance of mature being or the enhancement of the person, but the nearness of death and the question of survival. Varied body arts take the form of charms and prophylactics, thus supposedly reinforcing the body's resistance to illness or evil. Formerly, if a child was sickly among the Tewa people of New Mexico, a ring made from the hair of a parent was perceived to offer strength, to imply the presence of the

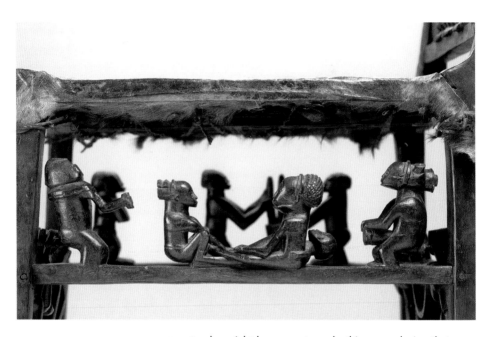

parent, who might be away at work; this was a device that transferred vitality from one person to another. Among the Baule people of Ghana and Côte d'Ivoire, adults were scarified, but not children, unless there was a particular medical issue or need. If a woman's child died in infancy, those born subsequently were given marks known as *kanga*, three lines radiating away from the corners of the mouth, like a fan extending to the ears and hairline **[70]**. These were said to make the child ugly, and therefore less attractive to death. Other cuts – also in a cluster of three – were sometimes made on the chest. Local toxins were rubbed into the cuts, hence the procedure may have been understood as offering protection against poison, analogous to an innoculation.

Such practices and arts acknowledge the body's vulnerability and its propensity to be overtaken by suffering. Yet the body is also the bearer of hope and the will to live. In some contexts, this tension at the heart of humanity has motivated remarkable forms of body art, at once profoundly personal and explicit about social and political aims. In South Africa, the early years of the new millennium were momentous ones for those living with HIV/AIDS and for the activists who campaigned on their behalf. Members of the South African government notoriously refused to accept the scientific consensus regarding the causes

69 Chief's seat (detail), featuring a circumcision operation, Chokwe, Congo, late nineteenth century.

of the syndrome, and advocated folk remedies lacking medical credibility. The Treatment Action Campaign called for the state to provide the life-saving medications that were being routinely prescribed elsewhere in the world. As the campaign reached its peak, a small project based in Khayelitsha, a vast township on the outskirts of Cape Town, resulted in an extraordinary series of self-portraits, or 'body maps', documenting the lives of those members of the Bambanani Women's Group (and one male activist) with HIV/AIDS who were given access to antiretroviral drug therapies **[70, 71]**. The body maps are life-sized images that identify the virus and relate individuals' stories. The shadowy forms of the people who supported the subjects hover behind each portrait, pointing to the crucial support

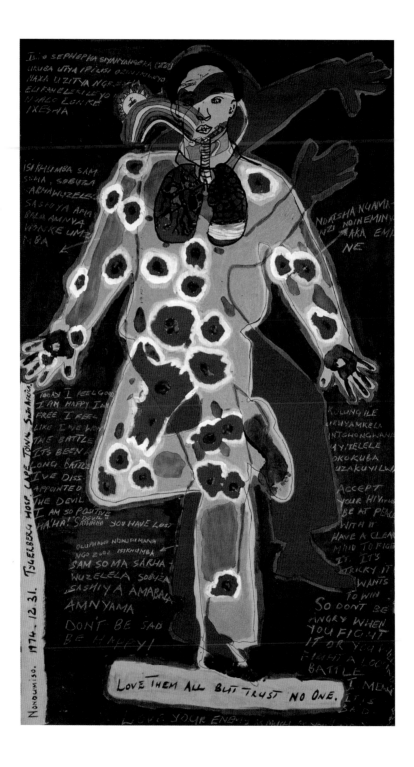

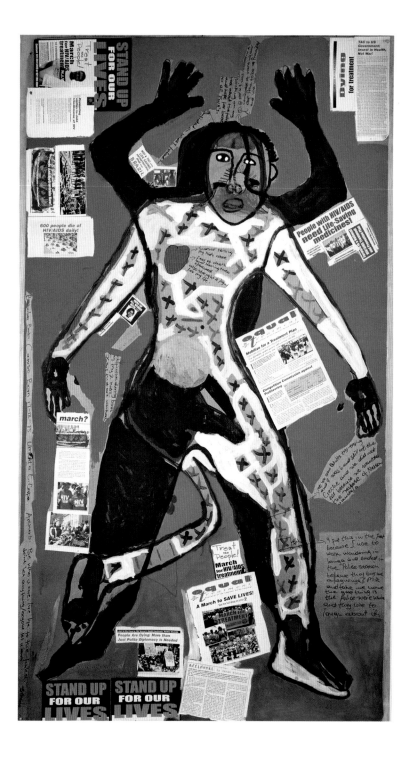

each person received from others. Biomedical science, religious beliefs, familial attachments, political claims and moral values are interconnected in these remarkable images of self, caught between the fear of death and the hope of survival.

The body maps not only sustained the members of the collective that produced them, but also became ambassadors for the community and the cause. Digital copies have been shown in museums in the United Kingdom and Canada, with the UK exhibition leading to an additional project. Part of the London 2012 Cultural Olympiad, Unlimited Global Alchemy was a partnership between members of the Bambanani group and Rachel Gadsden, a British artist who also suffers from a debilitating and life-threatening condition [73, 74]. They jointly produced new work that embraced tributes to those who had died (not all members of the collective survived), but which highlighted the struggle to live, the experience of risk and vulnerability that links people from across the world, and life's richness and fragility. The programme culminated in a performance in which dancers Freddie Opoku-Addaie and Sarah Chin (who is also a physician) explored both the possibilities and the limitations of life with HIV/AIDS against a background of Gadsden's drawings. The pace of this work, and the abrupt and almost brutal movements that punctuated it, communicated the necessity of creativity and the importance of living in the moment. Perhaps the most vital message of the project as a whole was that of the body's fragility. As Gadsden put it in an interview, even those who are fortunate to lead long and healthy lives 'have some form of disability towards the end. We all become more fragile.' Whatever we make of the body, through our lives and through art, it is in the end undone.

73, 74 UGA (Unlimited Global Alchemy) performance, Southbank Centre, London, September 2012.

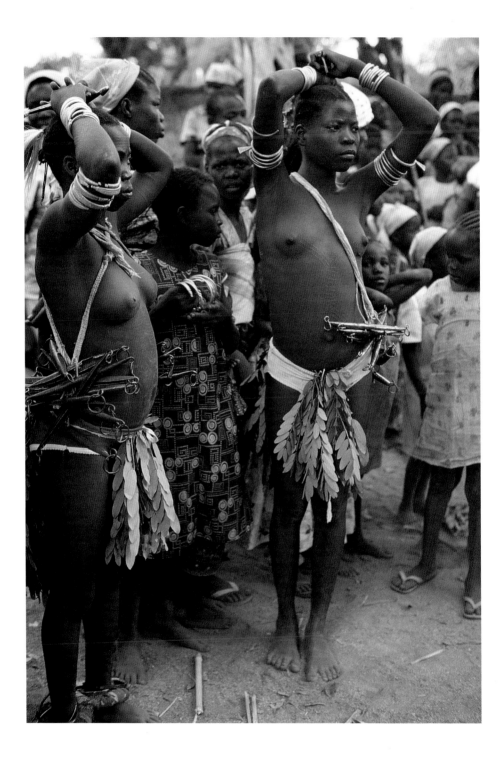

Chapter 2 Society

We are accustomed to interpreting contemporary body art as the expression of personal identity, and customary body art as a symbolic and ritual affair. Yet in both 'traditional' and 'modern' societies, body arts are often profoundly political. In and on people's bodies, they define a social order, inscribe status or reflect a mode of government. Body arts express dominant values and also opposition to those values. People may use their own bodies to challenge and reshape society and systems of governance.

For the Ga'anda people of the country to the north of the Benue River in north-eastern Nigeria, customary politics centred on marriage. Social networks were created through polygamous alliances that gave families reach across various groups of kin, who did not necessarily live in close geographic proximity to one another. While prospective marriages were contracted during infancy, betrothals initiated long-term obligations that imposed considerable demands long before marriage actually took place. Young men, or rather their families, had to gift ceramics, gourds and iron hoe blades, items that used to be rare and prestigious imports, to the bride's people. Equally vital to the progression of the relationship,

opposite:
75 Marla C. Berns, new Ga'anda brides being presented to the community, Ga'anda Town, north-eastern Nigeria, November 1980.
New Ga'anda brides (*perra*) were presented to the community during the annual post-harvest festivities. These two young women had not completed the full program of body scarification (*Thleta*), formerly prescribed as a requirement for marriage, because *Thleta* had been outlawed in 1978 by local government authorities. However, the central torso motif, *njoxtimeta* (stage five of a six-stage process), is just visible.

right:
76 Marla C. Berns, cicatrization marks on the torso of a Bena woman, Riji Village, Nigeria,1981. Cicatrized incisions heal as a pattern of subtle raised bumps on the torso of a Bena woman. The same texture is present on the skin of Ga'anda and Yungur women who have undergone scarification.

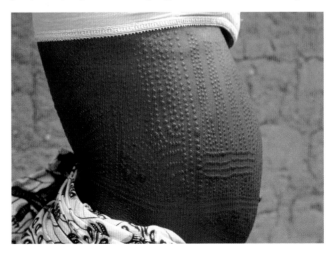

however, was the extensive scarification of girls **[75, 76]**. Undertaken in stages, it focused first on the stomach and forehead, then on the neck and arms, and subsequently on various areas on the thighs and chest, around the navel, and on the back. Each stage was accompanied by ceremonies and presentations from the girl's prospective husband. The designs were uniform, not personally adapted; inflicted by older, expert women, they linked the identity of the woman with her role as wife, and defined the wife as an agent of social solidarity, as the person who embodied the necessity of the domestic unit and the constitution of wider social networks via links between extended families. Whatever else she was, the scarified woman was an embodiment of the Ga'anda way of life, of conformity to its order – albeit an order that began changing in the 1950s and did so more decisively from the 1970s onwards, when scarification was outlawed by a government sensitive to a different ideology, that of modernization.

Body arts do more than reflect the realities of a political regime: they may also play a vital role in constituting it. They are not just signs but also tools of society. This is so, in part because what is often most vital in body art is, as we have already seen, not the product but the process. It is less the scar, the shaped foot or the completed tattoo, and more the careful violence and controlled harm of cutting, binding or inking. It is the production of pain, and the business of undergoing necessary suffering, under dramatic and extraordinary ritual circumstances, that is powerful and cathartic. This is not always true, and certainly there are contexts in which one simply gets the work done, in order to exhibit the result. But it is often the case that what the marks speak is the experience of the body and the transformation of the person – for social ends.

Nowhere was the creation of art on the body perhaps more essential to the creation of a political order, and to the dramatization of that order, than in historic Samoa **[79–81]**. Like Tahitians, Samoan males were tattooed around the lower torso, buttocks and thighs, but the Samoan designs were considerably fuller and more elaborate, and were commonly said to give the naked man an appearance of being clothed, of wearing a pair of breeches **[77, 78]**. This male tattoo form is known as the *pe'a*; girls received a less extensive set of marks known as the *malu*.

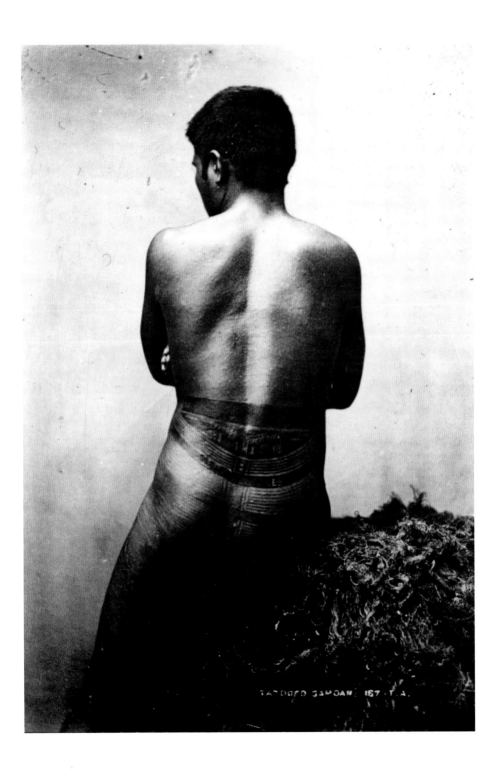

TATTOOED SAMOAN 167 T.A.

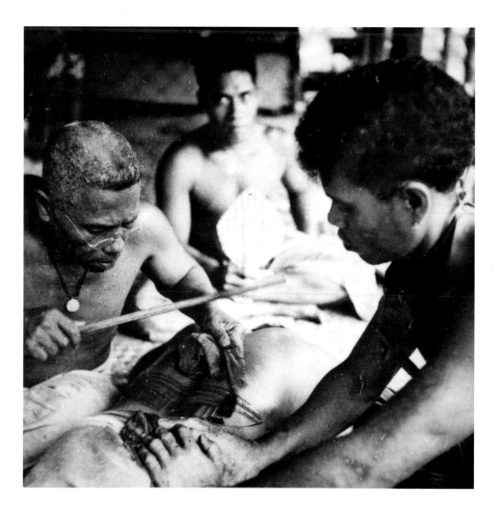

The missionary John Stair was the best early observer of Samoan *tatau*, and provided an extensive description based on what he witnessed during the 1840s. He believed that all adolescent boys were tattooed, but Victorian society's attention was captivated by the tattooing of boys from higher-status families. 'Great preparations were made', including for feasts, and gifts were gathered together for kin and to pay the tattoo artists, or rather the 'priests of tattooing' (*tufuga ta tatau*), who constituted a sort of guild, renowned for their particular art and expertise. A higher-status boy was not tattooed alone, but with a gang of his peers, who were there to support him and share his pain, although they themselves were said to receive somewhat cursory or careless versions of the tattoos. Proportionate to the importance of the families involved, a major gathering took place around the tattoo process, which would involve a number of practitioners, last for four to six or more weeks, and be attended by a good part of the population of a district. Some might stay close to the youth being tattooed, holding and comforting him during the most painful periods, otherwise chatting and playing music; the wider crowd would play games, dance and feast, enjoying the largesse of the host family while celebrating the great passage being undergone by the son.

If all went well, and the youth was brave, progress on the *pe'a* would be sustained. But it was not uncommon for the work to cause inflammations or infections, which would require periods of rest. As all this went on, people would continue to

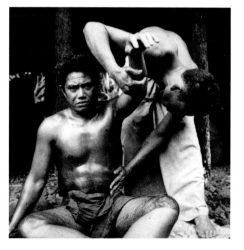
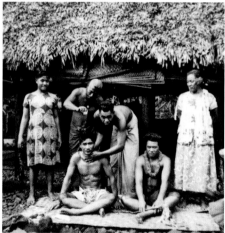

party and perform. The tattoo finally complete, massive presentations and payments would be made, consisting of hundreds of the intricately woven mats that were among the supreme gifts of the Samoans, a kind of currency that expressed debts between families and clans, around the vital events of birth, marriage and death.

The key to the drama of the Samoan tattoo ceremony lies in the singular nature of the Samoan polity. Europeans generally saw the people of the Pacific as inhabiting either relatively egalitarian societies in which there were men of status but no hereditary chiefs, or those in which there was some form of more institutionalized leadership, which in some cases they equated with kingship. However, the various regimes were in fact all very different. The Samoan system was bewilderingly complex, and provided not for a class of chiefs or kings but for a dispersed structure of chiefly titles that were ranked, some carrying authority over a group as small as a household, others over districts and successively greater and more inclusive entities. A title-holder or chief (*matai*) was owed loyalty and service by subordinate *matai* within his domain, while he in turn would have to serve greater title-holders above him.

Titles, most crucially, were not inherited. Rather, one became a *matai* by being elected at a *fono*, a formal gathering of chiefs within a given domain. An aspiring *matai* had to win the support of as many chiefs as he could, partly through advantageous marriage and partly through serving those well-placed chiefs whom he wished to ingratiate. One title was not held for life: a chief holding a lesser title would continue to work and position himself for more senior titles as they became vacant. Women appear formally to have been in the background, and did not generally speak at *fono*, but they were frequently pulling the strings and were influential at multiple levels.

In all societies there are tensions between conformity and individual ambition, but the Samoan structure exacerbated these profoundly. The great social prizes of rank and status were constantly in play, and those who were ambitious had to work tirelessly and consistently to attract favour. The centrality of carefully strategized marriage (a man would always seek a wife of higher rank than himself, to advance his position and opportunities, rather than merely substantiate what status he already had) intensified the demand to submit and conform on the one hand and, on the other, to advance and transgress.

This dialectic is perfectly captured in the play of power that constitutes the great Samoan tattoo ceremony. This was, as the social anthropologist Alfred Gell has pointed out, a form of initiation in all but name. The novice and his companions were secluded; they suffered an ordeal that featured the mutilation of the body; and the climax of this was a pseudo-death (on completion, lights were formerly put out, a vessel broken, and water sprinkled over those whose *pe'a* was complete) that was succeeded by reintegration into society and the celebration of the newly adult initiates. The key fact here is that the young man being tattooed was *subjected* to the operation. The pre-eminent figure of modern Samoan tattooing, Paulo Sulu'ape (1950–1999), used to refer casually to those he worked on as his 'victims', and his dry humour captures an essential aspect of the historic Samoan practice. To be tattooed was an act of submission; it was something that senior men required youths to go through. It was a manifestation, or rather – given the pain and drama involved – *the* manifestation, of the authority, central to Samoan society, of the power of chiefs and elders. That power was written into the body of the youth through the rite, while the *pe'a* itself exhibited his labour, his suffering, his obedience and his respect for his elders, his chiefs and the system. Even today, Samoan men discussing the *pe'a* will often make a direct connection between the pain of childbirth that women must endure and the pain they have to suffer in receiving the *pe'a*. This is to suggest that the two acts of suffering are equally essential, one to the reproduction of human life, the other to the reproduction of Samoan society.

Yet the ceremony had of course another side to it. The acquisition of the tattoo – like the scarification of the Ga'anda girl and similar practices in many other societies – was an act of heroism. It empowered the youth and elevated him to the cadres of junior adult men, who might aspire to secure a beneficial marriage, to achieve great things as traders or in battle, and to acquire titles and wealth. Such socially mandated body arts were therefore works of not only subjection but also empowerment. They at once affirmed a hegemony of statuses and relationships, and enabled the young to push themselves forward and begin making their own presumptions and claims.

Elsewhere, tattooing has been understood in warlike societies as a form of armour. Polynesians generally understood it as a potent form of wrapping, which effectively sealed the

Guerrier sandwichien

82 Engraving by N. Maurin after Jacques Arago, *Guerrier sandwichien*, from Jacques Arago, *Promenades autour du monde* (Paris, 1822).
While representational designs may have featured among pre-contact tattoo motifs, they are more likely to have been an aspect of post-European contact innovation, notable particularly in Tahitian and Hawaiian tattoo.

skin, reinforcing the body's carapace. Here, the wounding of the tattoo process also anticipated the wounds that the warrior would likely receive in battle [82]. It prefigured the delicate management of the warrior, required at once to be aggressive towards enemies yet obedient before his own superiors and chiefs. In the Samoan case, body art lay at the heart of the effort to negotiate this great contradiction, which has destabilized martial societies around the world and throughout history.

Among the native peoples of Amazonia, body art signified a social being, but in different ways. When dances took place on ceremonial occasions, men wore feather-based decorations, more or less elaborate depending on their seniority. Younger men wore a basketry crown incorporating red and yellow

toucan feathers and those of macaws, which were closely associated with humans, spirits and ancestors. Their seniors might also wear a plume of egret feathers on a human- and monkey-hair support, jaguar bone and hair, hanks of string made from monkey and sloth hair, rattles made from snail shell and beetle wings, a belt of jaguar teeth and a bark-cloth apron. All of these artefacts and accoutrements were clan-owned collective property, but individuals also bore personal accessories, such as quartz pendants, strings of beads and tooth necklaces that had either been made by the owner or acquired through trade. This range of objects reflected the interplay between human and animal bodies, the dependence of people on animals and birds that were routinely hunted. Shamans performed a rite enabling the flesh of these creatures to be safely consumed, whereas hair or feather had to be burned, properly returned to the 'houses' that constituted the spirit worlds of these creatures, or converted into human identities through the creation of ornaments. Social anthropologist Stephen Hugh-Jones has argued that in north-west Amazonia, creatures were seen to possess identities in their surface decoration, in their colour, clothing and capacities; they were also understood to entail armour, design, identity and power. This is to underscore how profoundly misleading the Western notion of ornament as superficial enhancement has been, relative to the body-art traditions of many indigenous peoples. In Amazonia, as elsewhere, bright colours are associated with the sun, energy and vitality, dark with night and death, and decorations are neither pretty nor merely eye-catching things but means of appropriating the predatory and spiritual powers of the creatures that make up the animal world [83]. The relationship between humans and various animals was not one of species differentiation but something more like analogy. Body arts were techniques to bring spiritual affinities to life, to empower people, if only temporarily, with extraordinary powers.

Some of the most remarkable forms of adornment created by human beings in any part of the world are still employed on ceremonial occasions by the large populations of the New Guinea Highlands. Across this region, spanning the Indonesian-controlled territory of West Papua and the independent nation of Papua New Guinea, intensive horticulture and pig husbandry have supported large populations, with some language groups numbering many tens of thousands. The pidgin English term

'sing-sing' has been employed generically by travellers, colonial administrators and tour operators to refer to a range of these ceremonies, but gives no sense of the profound importance of such occasions, which historically have involved grand presentations of treasured ornaments, cooked pigs and other valuables, which today include cash **[84]**.

Unlike Samoans, Highlands peoples were not organized into chiefdoms of any kind, but rather in descent groups, clans and tribes. These constituted collectives, and were therefore not subject to formal political leadership. Tribes were not necessarily fully unified, and their subgroups might declare war on one another. Within them, the clan was the key unit: its members married out, hence clansmen were all theoretically 'brothers', who might occasionally brawl but who never warred with one another. Wives were both given to and taken from other clans, but these inter-clan relationships were precarious; they were the foci of competition and rivalry that periodically erupted into full-scale war. Among the Wahgi of the Western Highlands, studied by the social anthropologist Michael O'Hanlon, individuals have complex relationships with their wives' kin: they must make periodic payments in return for the

woman they have received. If these debts are not recognized and respected, in-laws may do spiritual harm, bringing about infertility, illness and death. Conversely, if relations are good, they may be benevolent, fostering the health of both the family and the community. The balance is complex, particularly for ambitious men who seek to be leaders and must take several wives — not least in order to build up a domestic workforce to garden and take care of the pigs — but who thereby risk losing the support of some kin while favouring others. Their political work entails not only the manipulation of reciprocity and the display of largesse, but also, above all, effective performance. Men and their clans gain renown by presenting themselves, and by staging events that capture the attention and admiration of the communities, neighbours, strangers and opponents who gather to encounter them as visitors and guests.

Groups that are friendly towards one another periodically and alternately make presentations of food, which are typically accompanied by dance performances. Such events acknowledge common origins and relatedness, recognize friendships between male leaders, and repay previous gifts. They allow allied groups to impress through their capacity to offer considerable

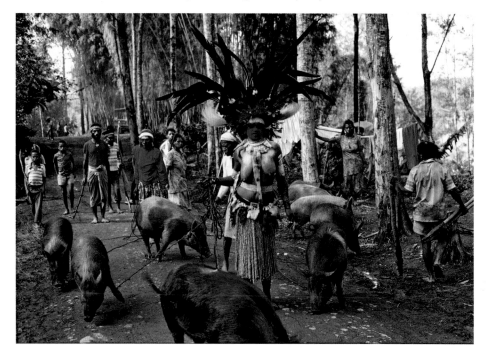

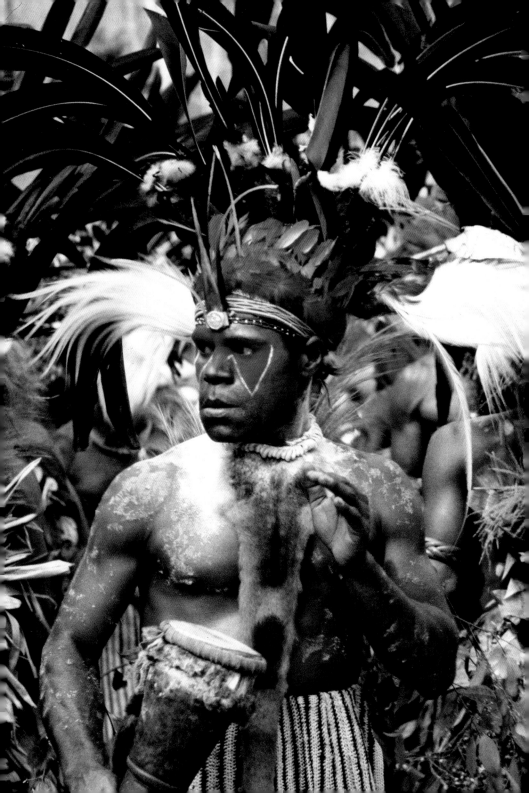

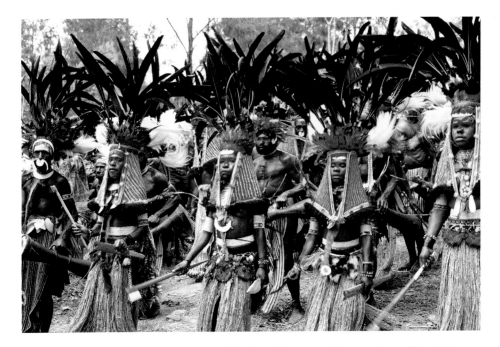

quantities of food, and those receiving to show off their dances. These events are smaller-scale expressions of the highest form of Wahgi ceremony, the pig festival, which a clan mounted only very rarely – perhaps once in a generation – and which entailed a massive commitment of resources **[85–88]**. The pig festival was not a single event, but rather a cycle of performances, rites and gifts that culminated in the killing of the bulk of a clan's pigs, which were then gifted to kin, those related through marriage, and trade and exchange partners. Although a given clan mounted its own pig festival very occasionally, its members would be guests and dancers at the pig festivals of other clans. The event had many dimensions, including the incessant playing of sacred flutes, which were perceived to have magical effects and, in particular, to enhance the growth of the pigs, the most desired and valued of the customary foods. Men, moreover, had to dedicate great energy to procuring the ornaments that would be worn and danced with. These were diverse, and men might have to call on friends from far and wide to secure them against promises of pork, gifts and support. The objects especially sought after were the long black tail feathers of the black sicklebill and Princess Stephanie's astrapia; a standard costume might incorporate twenty or more of these.

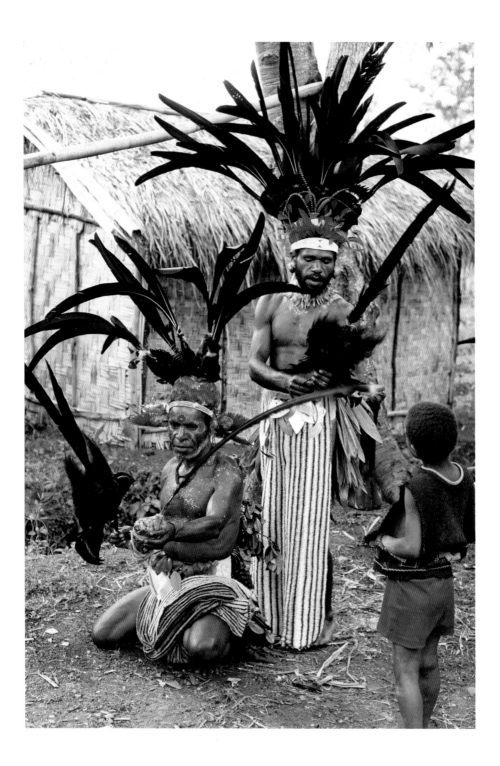

Preparations for the festival included the setting out of a ceremonial ground and the building of houses; once the ground was ready, men would dance every day for several months, while expeditions took place into higher-altitude bush to secure various forest products considered necessary for the appropriate presentation of rituals and pigs. The pigs were killed in stages, cooked in earth ovens, presented to the thousands of guests and spectators, and carried away. The event was, above all, a celebration of a clan and its prosperity and fertility. The spectacularly, and broadly uniformly, decorated bodies of the men were an integral part of this celebration.

Among the Wahgi – and indeed among most Highlands peoples – there were other sorts of meetings between groups at which men and sometimes women were likewise decorated. Intergroup relationships were marked by feuding as well as friendly exchange, and clans sometimes made payments to warriors who had killed enemies on their behalf. Groups also made payments for help during times of fighting, and offered compensation for killings, for example when a man from an allied group had been killed. From the 1970s onwards, as trucks and four-wheel drives came into increasing use in the region, groups also made payments when the clan was blamed for a road death.

In all cases these compensation payments were intended to prevent further violence. In some cases they were swift responses to regretted events, while in others they were aimed at redressing wrongs that had occurred a generation or more ago. Although in some instances the specific rationale for compensation was perhaps less important than the opportunity to reveal and demonstrate the clan's vitality through a gift or performance, Wahgi, and many other Highlands populations, were anxious to maintain a sense that the clan's debts were balanced and not disproportionate. This was a moral matter, a manifestation of the clan's inner vitality or weakness.

On all such occasions men would self-decorate, with a lesser or greater degree of preparation and care, depending on the importance of the event. The *gol* dances that featured in the lead-up to the pig festival were also overtly intended to attract women [87]. Married men who hoped to secure further wives underwent a variety of cleansing operations to loosen the hold that their existing wives had on them, and to render ineffective any spells those wives might have cast on them to diminish

their attractiveness. In the lead-up to a dance, men filled a head-net with soft moss to provide a bed into which the ends of their feathers could be inserted; they also put on a bark belt, an apron and some cordyline leaves, and rubbed their bodies with pork fat to make them shine. Other ornaments included shell breastplates and necklaces of marsupial jawbones, or bought ornaments and medals. After perhaps sprinkling talcum powder – also obtained from local trade stores – over their shoulders, they would paint their faces. Finally, another man would assist with the mounting of large black plumes in a broad fan emanating from the top of the head **[88]**.

Wahgi men decorated themselves in a strikingly different manner not only when going to war but also in a variety of other antagonistic contexts, for example when making compensatory payments **[89, 90]**. This set of decorations could involve coverings made of dried grasses and a cassowary headdress, which was considered intimidating and frightening; most importantly, however, it featured charcoal. Men covered themselves from head to foot in it, and were thought thereby to invoke the support of ancestral ghosts. Charcoal was associated with war magic; it was considered a fearsome substance, and warriors bearing it were presumed to be mobilizing the spiritual power of ancestors. The uniformity it bestowed was felt to dissolve the individuality of warriors into the petrifying mass of a united clan, the decoration manifestly a technique of psychological warfare in itself.

This body-art system created both alluring and fearsome bodies, but what was of fundamental importance was what their beauty or terror was taken to mean. Those who witnessed groups of decorated men and women displaying themselves and dancing were constantly in judgment. For Highlands viewers, these performances were not vibrant or colourful or picturesque, as they would have seemed to foreign observers. Rather, the qualities that such displays exhibited were considered expressions of other states; as Michael O'Hanlon has put it, they were seen as 'an external reflection of [the performers'] inner moral condition'. The lustre and brilliance of a group, the form and quality of their decorations, their shine, were all read in relation to such issues as whether the performers concealed anger, perhaps a desire to revenge some past transgression; whether they were capable of betrayal; the state of their reciprocal obligations; their loyalty

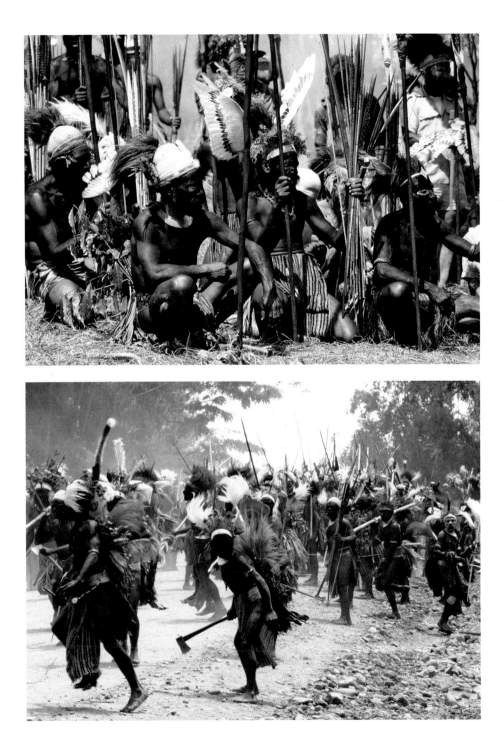

to friends and allies; and their acknowledgment of long-standing relationships. In the turbulent social environment of the Highlands, compelling displays were reckoned to act as a deterrent to the ambitions of rival and enemy clans. More than that, they were considered to provide a truthful account – in a world in which rumour and rival accounts were rife – as to the state of clan unity or the balance of reciprocity between clans. But however consummate a performance, rivals would do their best to find fault, to identify an inferior aspect of the display, which they would interpret in relation to some culpability or group weakness. In sum, Highlands body art was not merely expressive or symbolic; rather, it was at the very centre of the political process, the negotiation of group unity and dissent, strength and weakness, success and failure.

The *unadorned* body as well could be central to a project at once aesthetic and political. Nudism has not always been a minority lifestyle choice; it also has a history as a more overtly ideological movement. In Germany, naturism attracted diverse groups from the end of the nineteenth century onwards, some of whom associated secular ideals, exposure to sunlight and healthy lifestyles with progress towards a classless utopia, conceived in socialist terms **[91]**. While the practice was attacked by moralists, and considered by many on the political right to be part and parcel of the degeneracy of the liberal Weimar period, its advocates were often also eugenicists who believed in reinvigorating the German body. Their ideas anticipated, and were wholly compatible with, Nazi ideology, but the Nazi party responded in a contradictory manner, some members deploring what they considered the moral threat, others applauding the commitment to gymnastics and fitness regimes – in effect, naturism's performance of racial purity through the exposure of the (notionally) perfect, vigorous and youthful body. Naturism was officially embraced, albeit ambivalently, from 1934 when official Nazi nudist clubs were established. While this appears to have nothing to do with body art in the conventional sense, the political imperative was to exhibit the power and virtue of a 'race' through a body aestheticized in a particular manner, presented in this case via dramatic photography. This presentation of collective power is also what the Wahgi and other Highlands peoples accomplished, but in a more artful and magnificent fashion.

89 Michael O'Hanlon, men who have offered compensation for a death in a road accident, Wahgi people, Western Highlands, Papua New Guinea, 1986. The men who have offered compensation wait to learn whether their gifts are considered sufficient. They carry weapons and many wear cassowary plumes.

90 Michael O'Hanlon, an aggressive payment of compensation, Wahgi people, Western Highlands, Papua New Guinea, 1980. Watched by spectators, men from one clan, in warrior adornment, advance upon those to whom they are making a payment.

Art on, of and via the body has mediated political ideologies and revolutionary gestures in a variety of ways and in different places and times **[92]**. Public executions, such as those involving the guillotine in revolutionary France, amounted to profoundly shocking but also peculiarly absorbing performances – at worst horrific entertainments – for massed spectators. Their staging, as Michel Foucault influentially argued, far and away exceeded what was practically required by the legal sentence. If the modern, bureaucratic and ostensibly rational state 'reformed' capital punishment by carrying it out away from public view, in the presence of only selected witnesses, such regimes as Stalin's and Pinochet's used secrecy to create a more pervasive terror. In Chile, people were not acknowledged to have been executed; rather, they were simply 'disappeared', made to vanish. Decades later, families search for bones in remote mountainous areas where bodies may have been dumped. Their archaeology uses the traces of bodies to delineate past atrocities. To keep trying to recover even fragments of the people killed in brutal obscurity is a way

opposite:
91 Hans Surén, nude couple playing ball, from his *Mensch und Sonne* (1936).
Surén (1885–1972) was one of the most influential advocates of naturism in the interwar period. Not initially a Nazi, he joined the party in 1933 (and later the SS) and revised his best-selling, often-republished *Der Mensch und die Sonne* (Man and Sunlight), originally published in 1924, to be more consistent with Nazi ideology.

right:
92 A man painted in the colours of presidential candidate Soumaila Cisse's URD party watches Cisse speak at a campaign rally in Bamako, Mali, 20 July 2013.

of honouring those who were lost, a stubborn refusal to allow a historical wound to heal and be forgotten.

One of the most shocking works of performance art of the early 1970s was Chris Burden's *Shoot* **[93, 94]**. On 19 November 1971, in F Space, a gallery in Santa Ana, California, Burden was shot in the upper part of his left arm by a friend with a .22 rifle. 'In this instant I was sculpture', Burden subsequently claimed. Inspired by Marcel Duchamp, he went on to stage a variety of similarly disturbing and dangerous performances, considered attention-seeking by detractors, and acclaimed for breaking new ground by supporters. *Shoot*, at least, was more than a stunt. The debate at the time was not the one we are now familiar with, concerning the proliferation of guns and gun-related violence in the United States. Instead, it was about Vietnam, about the fact that, as Burden saw it, young men were being shot every day in combat while Americans were entertaining themselves by watching such fictional characters as gangsters and soldiers being shot on television. 'So, what does it mean *not* to avoid being shot, that is, by staying home or avoiding the war, but to face it head on?' he asked.

93, 94 Chris Burden, *Shoot*, F Space, Santa Ana, California, 19 November 1971.
'At 7:45 p.m., I was shot in the left arm by a friend. The bullet was copper-jacketed .22 Long Rifle calibre. My friend was standing about 15 feet from me.'

In the contemporary art world, the careful staging of violence
to the body has been a subversive gambit, or at least one that
aspired to subversive effect. But throughout the world, and
throughout human history, ritual violence, carefully enacted,
has not undermined social orders but created them. Both the
permanent arts of tattooing and scarification and temporary
transformations through paint and adornment have created and
reinforced political relationships; they have made the person
an embodiment of the polity.

Chapter 3 Theatricality

Body art is often a work of transformation: the creation of a human being, or, in the case of the ritual arts that mark passages in the life cycle, the creation of an adult man or woman. But transformation may also be a matter of temporary impersonation, the assumption of a character or role to dramatize cosmology or myth, to narrate a history, or for sheer entertainment.

In many parts of West Africa, ceremony took the form of masquerade **[95]**. The significance of dramatic performances involving masked or costumed performers was apparent to outsiders as early as 1730, when the geographer Francis Moore, an agent of the Royal African Company, reported seeing near the Gambia River 'a Mumbo-Jumbo' or 'Idol' in the form of a bark-cloth coat eight or nine feet high, which made a 'dismal' noise and played the part of a 'Wild Man'. For anyone who did not already know that a man was inside the apparatus, the effect was, he thought, totally convincing. Moore took it that the performance was supposed to keep women in awe, as did the traveller Mungo Park, who made similar observations in late 1795, concerning 'a sort of masquerade habit ... which belonged to Mumbo Jumbo ... much employed by the Pagan natives in keeping their women in subjection'. Indeed, Park understood that the costume was employed specifically on occasions when a woman had committed an offence or caused some form of conflict. The figure was supposed to carry a rod, to be heard in the bush outside the town, then make an appearance; people would gather, sing and dance, and finally, at about midnight, the 'Mumbo Jumbo' would pick out the offender and beat her with the rod.

In many parts of West Africa and the Congo, masquerades are still performed widely, although they are not primarily concerned with disciplining women, as these colonial accounts suggest. Historically, their key feature was disguise. The identities of the actors were concealed; they were possessed by spirits, or at any rate became spirits or characters, whose personalities were defined by the features of the performers' costumes, as well as by particular gestures and actions.

95 Gwilym (G. I.) Jones, Otill, a character in the *Okwanku* masquerade, Igbo people (detail), Akanu, Cross River, eastern Nigeria, 1932–39.

Masquerades were staged for diverse occasions, and generally by secret societies, which brought status to members (mostly men but sometimes women), were themselves divided into status grades, and which created social networks and political links; indeed, they sometimes engaged in activities other than performance. Masquerades also had significant ritual dimensions. With the emergence of Christianity, the performances were in many regions maintained but their significance altered, ostensibly to reduce the role of the characters specifically associated with the animist beliefs that the evangelical missions (and, in other regions, proponents of Islam) were trying to combat.

Typically, a masquerade did not consist of a single narrative drama but a set of performances or sketches, involving singing, dance and miming. The South African anthropologist G. I. Jones, who observed and photographed masquerades in various parts of southern Nigeria in the 1930s, described one that took place in a northern Edo village **[96, 97]**. A parody of the colonial regime and its representatives on the ground, it began with the appearance of a hooded, faceless character called 'Government', who was wearing a homburg. 'An elephant tusk

96 Gwilym (G. I.) Jones, Onye ocha or Oybio, masquerade character representing a white man, Igbo people, eastern Nigeria, 1932–39.

horn, a symbol of authority, was laid on the ground in front of him and he read in ghostly gibberish from an important-looking document', noted Jones. Next appeared a parade of ghostly policemen and court messengers, who wore mock uniforms and cloth masks. They went through a vigorous drill and were then posted among the crowd, as if to maintain order. Then came 'a supercilious white-faced sun-helmeted figure in white drill jacket and trousers', a white man who went through the motions of inspecting the crowd before taking his place in the area reserved for the most distinguished guests. A variety of other characters then appeared, some impersonating male and female spirits (black- and white-faced, respectively), others people from the village or animals such as antelopes. The size of these masquerades varied, and while some were mounted by just one secret society, others were put on by many, with each contributing their own particular characters and sketches. Some were primarily comic, and others had more serious ritual ends.

The Chamba people of the middle reaches of the Benue River Valley in Nigeria used unusual hybrid masks **[98, 99]**.

97 Gwilym (G. I.) Jones, masquerade character called 'Government' and attendant, Igbo people, eastern Nigeria, 1932–39.

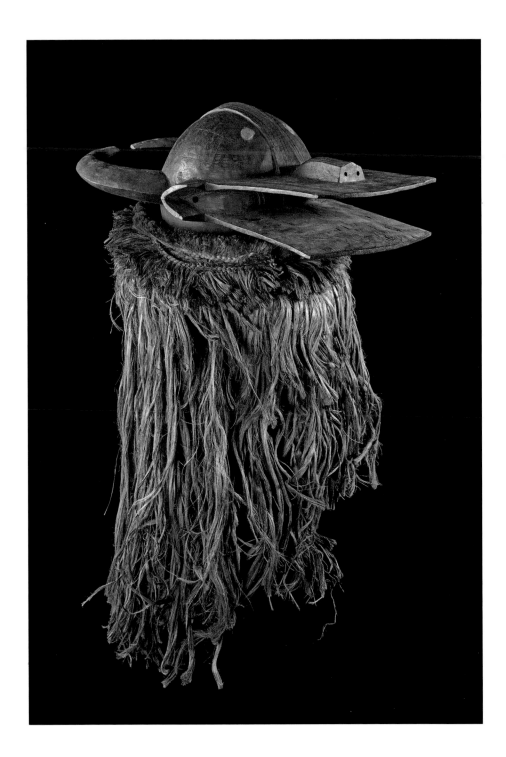

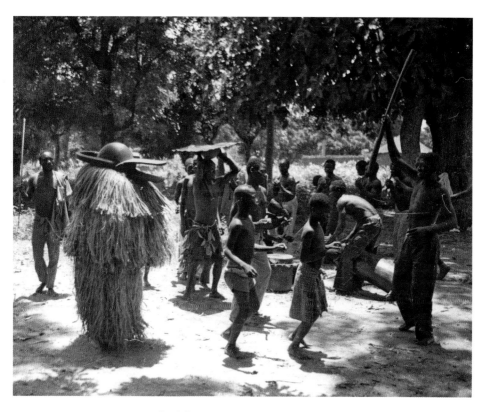

Both human and animal-like, they incorporated the horns of the bush cow, or dwarf buffalo, and stylized representations of the human head, complete with nose, eyes and ears. Some such masks were transformational, in that they appeared more human in one orientation and more animal in another. The fusion of human and animal traits did not represent compound or hybrid spirits, but reflected the significance of fusion within Chamba thought and cosmology: the movement between the wild and the domestic, between animal and human worlds, was central to many myths and understandings surrounding the management and ordering of life forces.

Among the Mende people of Sierra Leone, public masquerades were vital to the celebration of the rituals that transformed the status of community members. The Mende sustained a whole set of distinct masquerades: some were associated with particular spirits or with grades of more or less powerful spirits; some were specifically parodic, featuring much-loved male and female clowns; others revolved around

opposite:
98 Juju mask, Chamba Daka people, Muri, Nigeria, *c.* 1921.

above:
99 Richard Fardon, Chamba masquerade of *nam gbalang* during a secondary mortuary ritual, Mapeo, Nigeria, 1977.

nature spirits. Some masquerades were understood essentially in festive terms, while others were more associated with ritual and with the power of particular medicines. Old masquerades were from time to time adapted or allowed to rest for a while if it was felt that no one possessed the expertise needed to recreate and restage them. Entirely novel masquerades were invented or imported from neighbouring populations. One such masquerade was owned by a Kissi herbalist named Lamin Kortu, who lived in the city of Bo in Sierra Leone during the 1970s. It had been brought, he claimed, from Liberia in the 1920s by his brother, and it featured a headpiece based closely on a Poro mask from the Loma or Bandi people of Liberia. This masquerade was offered for private purposes, as a potent medicine that could be used to hunt witches or be directed against a purchaser's enemies.

The masquerades of the Sande society, a women's association of the Mende people, are renowned for being the most important mounted by the Mende, and for being managed and performed by women who wear beautifully sculpted wooden masks – well represented in museum collections, and possessed of iconic status – together with full-body fibre and fabric costumes [100–107]. Historically, all Mende women were members of the Sande society; indeed, to be a woman was to be identified with it. Its practice revolved around maintaining the symbolism of the initiation ceremony, which included a form of cliteridectomy, a procedure widely denounced by feminists and human rights activists in the West, but in the past considered essential by the Mende, who believed that children (female and male alike) possessed inchoate and ambiguous sexualities. Without the appropriate form of circumcision, it was impossible, the people understood, to create mature heterosexual adults. As was the case in New Guinea and elsewhere, the rites and ordeals of the initiation cycle were vital periods in which knowledge essential to a competent adult was imparted. Moreover, initiates were required to serve older women, thus learning the fundamental importance of respect towards those who were senior, of diligence and of modesty. Membership of the society did not end with the completion of initiation rites, however. Women remained members throughout their lives, and some inherited particular titles and statuses, while others were elected as leaders by particular families or clans of high status. These

100–105 Lansana Jo, drawings of Mende masks, 1972. A selection of the eleven masks drawn by Jo, an elderly Mende man in Sierra Leone, in response to a request from art historian Ruth Phillips to depict all the masks he had seen. Four of them – gbini, sowei (top left and right), nafali and gongoli (centre left and right) – are common in Mendeland, while fakoli and landa (bottom left and right) are performed in neighbouring areas and would have been interestingly exotic for Mende viewers.

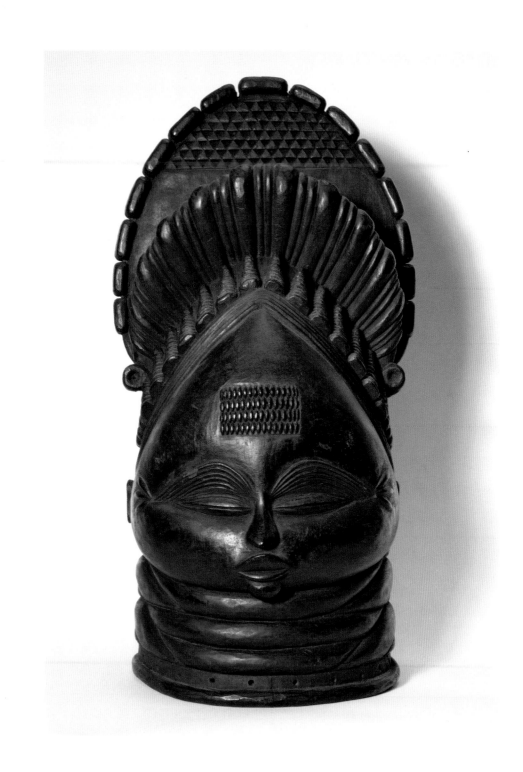

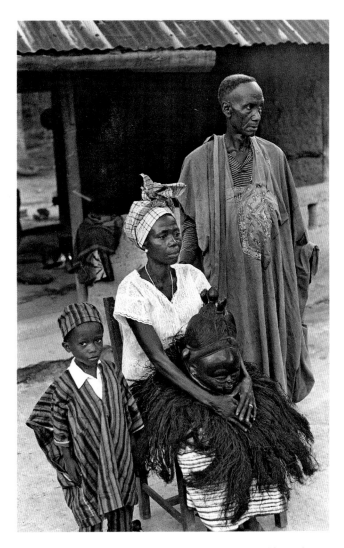

leaders maintained custody of sacred medicines and kept the masks within special enclosures known as *kundei*.

The women of highest rank in the society were called Sowei. Sowei personified medicines and spirits, and were seen as experts in the history and wisdom of the Sande. They – and the masks they bore – exemplified an ideal of feminine beauty. For outsiders, Sande art is above all one of sculpture, assemblage and performance, but as art historian Ruth Phillips, who studied the Sande in the early 1970s, reveals, language and naming were centrally important to it. Masks were given

names, which were announced by attendants or heralds, who vaunted those ancestors or living people after whom many of the assemblages were named, or cited the qualities and values that other names referred to. The Mende were intensely interested in these names, some of which referred to money, status and beauty, and indeed the strong associations between these terms. But humour was never far away, and other names referred to laughter – not to imply that the mask itself was funny, but that the performance associated with it created laughter and joy among assembled spectators.

The carved wooden components of Sande masks are exquisite; the propensity of both locals and Western connoisseurs to celebrate their artistry is completely understandable. The masquerades in which they featured were symbolically rich and nuanced performances: expressions of women's beauty and authority, mediations of the complex reciprocities and asymmetries that joined men and women, theatres for the celebration of ancestors and renowned Mende of both sexes, and, more overtly, occasions to parade and inculcate Mende morality, social orthodoxy and knowledge. Yet all this was powerful because it absorbed audiences, because the dancing and shaking bodies of the bearers of these remarkable assemblages would be both witnessed by spectators and felt by them. Not only movement and music but also pain and poignancy have contagious qualities; the effects of these arts are not only visual but also corporeal, and this is why body arts and performances have been so potent throughout human history. Many kinds of image can be powerful, but images of and on the body, and the body in performance have the capacity to reach us and seize us viscerally in ways that no other arts do.

In many societies, festivals take place from time to time that are marked by a transgender performance of some kind. In various parts of the Pacific, the festivities around weddings include clowning, generally by women dressed as men, who act outrageously, exhibiting sexual desires in a manner that would normally be highly inappropriate. Clowns often also make fun of male pomposity and habits, and take greater risks in sending up the behaviour of chiefs. Men and women of rank – the local aristocracy – are generally venerated, their persons highly respected, and behaviour around them subject to manifold taboos and observances. Yet individual chiefs, particularly

108 Men in suits of tree lichen celebrating *Schleicherlaufen*, Telfs, Austria, 2005.
Varied masquerades have long been been staged in many parts of Europe at certain times of the year. Processions of wild men, sometimes marking the transition from winter to spring, have been associated with a march of the dead, or a hunt, in Switzerland, Austria and Eastern Europe.

those seen to look after themselves rather than their people, may be discreetly but frankly resented. In the mid-twentieth century, social anthropologists and sociologists who saw society in functional terms regarded these occasional theatrical transgressions and subversions as 'safety valves', as opportunities for communities to express the frustrations engendered by society's boundaries and hierarchies without fundamentally undermining their stability. The West African performances described by G. I. Jones, among many other anthropologists, encourage us to think in more dynamic terms. Masquerades were about a great deal more than the regulation of a customary regime. They expressed and celebrated engagements with nature and cross-species relationships, as well as village life and colonial institutions. In the particular case he described, they enabled people to laugh at the colonial types who intruded into their lives and oppressed them. But the fact that they could laugh did not mean that everything then went on as before. Performances highlighted aspects of life and the world that were changing. Thirty years after Jones's observations, Europeans still featured in masquerades, and no doubt they still do today. But by the

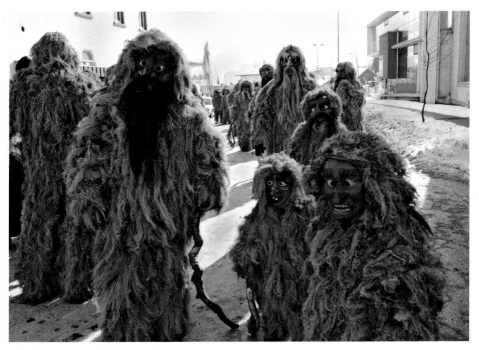

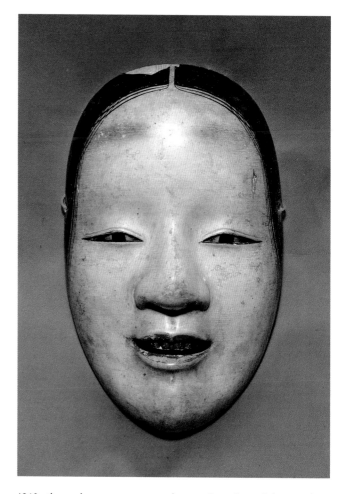

1960s these characters were no longer the rulers of the people
who mimicked their costumes and mocked their foibles.

While we commonly associate masks with exuberance,
courtly societies have used them in traditions marked by
austerity, by the aesthetic criteria of an elite. In Japan, masks
date back to the prehistoric period, and have been used in
various forms in shamanic rites, planting and harvesting
ceremonies, Buddhist performances and popular drama for
centuries. The Japanese form of tragic theatre known as Noh
emerged in the fourteenth century under the patronage of
Ashikaga Yoshimitsu (1358–1408), third shogun of the Ashikaga
shogunate **[109, 110]**. The performer and theorist Zeami
Motokiyo laid out the principles of this Zen theatre, which

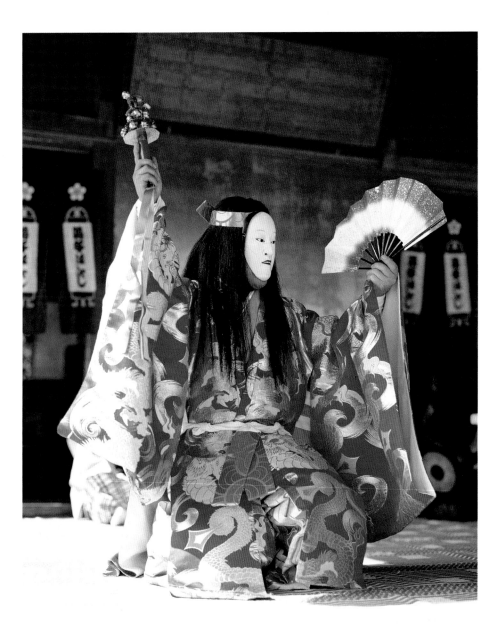

was characterized by subtlety and restraint. Although Noh evolved and suffered periods of decline and revival throughout its history, it remained an official, courtly art – seldom accessible to common people, and typically austere and solemn – until after the Second World War. Whether performed indoors or in the open air, musicians and actors had fixed positions on stage, stage furniture was minimal, and only a few specific characters were masked. Drama types included plays dealing with battles, romances and struggles with demons, and while the stories were important, they provided the context for finely choreographed dances, some restrained and exquisite, others, such as those involving supernatural beings, more dramatic and even frenetic.

The focus of an aristocratic audience's attention was the virtuosity of the performer. Actors were elaborately costumed, but the masks, carved from Japanese cypress, painted with gesso and delicately sanded and painted, were famously neutral. The mouth could appear either to frown or to smile, depending on the angle at which the face was presented, and the performer's skill resided in convincingly embracing the male or female character – although all actors were men – and in delicate shifts of poise that suggested the character's changing moods and responses to events.

The sense that masquerade and related forms of performance entail risk and experiment, rather than merely a kind of collective cultural reassurance, is underscored by the international, and particularly the North American, history of drag balls and related transgender performances. In Harlem and elsewhere in New York City, these events have a much longer history than might commonly be assumed [111]. One of the first is believed to have taken place in 1869, and a tradition was well established by the 1920s, when spectacular masquerade parties with thousands of participants were taking place annually, and at such prestigious and publically visible venues as the Astor Hotel and Madison Square Garden. The parties featured parades of drag stars and pseudo-heterosexual dances, in which lesbians dressed as men and gay men dressed as women partnered feminine women and butch men, respectively. While a clampdown took place during the 1930s, and activities of this kind retreated into semi-private clubs and such counter-cultural ghettoes as Greenwich Village, the scene began to re-emerge in the post-war decades, which were also

111 Chantal Regnault, Tina Montana at the Avis Pendavis Ball at Red Zone, New York City, 1990.

marked by the divergence of white and black drag cultures. During the 1960s, a new excess and extravagance in dresses, accoutrements, props and performances also became apparent: those who were mostly denigrated and on the margins of society were investing heavily in the signs and theatre of glamour and stardom.

In 1972 the first of what would come to be called 'houses' were founded. These predominantly black gay, drag and transgender social groups invoked the idea of the iconic fashion houses, after which many of them named themselves. They were empowered by the advances of both the civil rights and, subsequently, the gay liberation movements. Yet black, working-class drag queens tended to be shunned by communities and excluded from mainstream political organizations. Their 'houses' were thus intended to be shelters: they were presided over by a 'mother' or 'father', they created alternative spaces for socializing, and they even began to function as orphanages for young gay people and those for whom emerging transgender identities led them to be excluded from their families. They also enabled participants to prepare for and to host balls. During the 1980s events at which houses competed became increasingly frequent, and new houses proliferated. The nature of performance became more nuanced and specialized, with the stereotypical drag act being replaced by specific 'categories' of performance and display. Initially these included such broad subjects as 'butch realness', but went on to embrace the styles associated with business executives, Hollywood evening wear, the mode of shopping associated with a particular Manhattan avenue, and so on. The upshot was a diversified and fantastic re-enactment of a host of idealized experiences and lifestyles.

Over the same period – the late 1970s and early 1980s – a distinctive style of performance and dance known as 'voguing' appeared [112]. Apparently derived from the pages of *Vogue* magazine, this practice of striking or throwing poses centred on the creation of a highly glamorous image or spectacle. The practice was overtly competitive, both in the sense that balls featured competitions at which prizes were awarded, and in the sense that there were great rivalries between different performers. Although the balls attracted a variety of participants, many were drug addicts and street prostitutes. Poor and highly vulnerable, they paraded their own 'lifestyle

112 Chantal Regnault, Willie Ninja, New York City, 1989. To 'vogue' was to strike an arresting pose, confronting one's audience while ostensibly being indifferent to them, evoking the glamour associated with the fashion magazine in the context of competitive performance.

of the rich and famous', making a form of celebrity status momentarily real. Given the propensities of fashion and music to appropriate the visceral energies and genuinely risky experiments of diverse outsiders and subcultures, it is not surprising that fantasy underwent a partial and limited transformation into actuality.

At the end of the 1980s the real fashion houses began to give voguers opportunities on the catwalks, and the long-standing fashion potential of gender-inversion and gender-ambiguity was revived and exploited. This culminated in 1990 with the video for Madonna's song 'Vogue', but the fame that the scene gained was soon overshadowed by the HIV/AIDS epidemic. The celebrated documentary *Paris Is Burning* (1990) featured a voguing prostitute hoping to save money for a sex-change operation [113]. Venus Xtravaganza fantasized on camera about being able to turn herself into a 'spoiled, rich white girl living in the suburbs' (implying a passage across not only gender but also ethnic and class boundaries), but was later found murdered in a New York hotel room. Given the growing carnage of AIDS among the voguing community at that time, the documentary's mood was perhaps understandably elegiac. However, the practice remained vital, and still has its adherents today.

The old sociological questions concerning seemingly subversive performance were recast when the influential feminist philosopher Judith Butler responded to *Paris Is Burning*, questioning whether the extravagant subversion of gender and sexuality that voguers performed actually resulted in any effective displacement of dominant norms. Evidently it did not: what was dominant remains dominant, and voguing was all too obviously marked by an ambiguous combination of parody and fetishism. The scene certainly enacted an audacious appropriation of the distinctive body arts of celebrity performance, which most ordinary people can access only through *Vogue*, through Hollywood films, and otherwise through the media and consumption. They were no ordinary 'fashion victims', yet their appropriation was also fully and, in the end, uncritically committed to the values of glamour, beauty and femininity. If it was radical to insist that people could have and be what it was impossible for them to have and be, this radicalism inspired projects of personal identity that were at once brave, perilous and destined to fail. Yet, as the writer

113 Film still from *Paris Is Burning*, directed by Jennie Livingston, 1990.

114 William Yang, Sydney Gay and Lesbian Mardi Gras, 1993.

Tim Lawrence has argued, the queens of the voguing scene shared few illusions. They did not actually expect to become fabulously wealthy celebrity models. They were committed simply to socializing, having fun and being who they were.

Drag performance is of course a feature of many other gay and transgender cultures, from Brazil to Australia. The Sydney Mardi Gras grew out of the gay rights marches of the late 1970s – which were initially met with hostility from both the public and the police – and has developed into one of the biggest parades and gay pride events in the world [114, 115]. Indeed, it now has considerable official and corporate sponsorship, makes a major contribution to the tourist industry, and even has its own museum. Not only do the police no longer harass participants, but also gay and lesbian police officers march in substantial numbers as part of the parade.

The Australian photographer William Yang documented 'sleaze balls' in the 1980s and the Mardi Gras over succeeding years. The flamboyance and transgender dimension of this exuberant event echo the New York houses and similar scenes; the Sisters of Perpetual Indulgence, a San Francisco-based group of male activists who dress as nuns, have had a strong

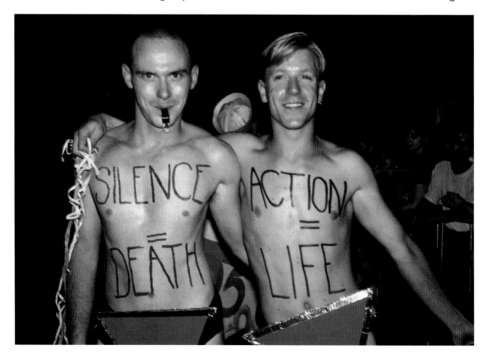

presence. Body paint and bananas have been used to joyfully outrageous effect. Yet Sydney has long exhibited a more diverse range of performances and identities, many with an overt political orientation and a politics that ranges beyond questions of sexuality. In 1988, in a parade to mark the bicentenary of white settlement in Australia, gay members of the Aboriginal community entered a ship-shaped float in which they dressed up as the heroes of British exploration and colonization. At first glance, this masquerade and those of Nigeria may appear a world apart, the one embedded in local secret societies, the other in a cosmopolitan movement for sexual liberation. Yet in both cases, body arts enabled people not only to empower themselves by taking on other identities, but also to parody colonial hegemonies, among others, and laugh at them.

115 William Yang, Aboriginal Bicentennial float, Sydney Gay and Lesbian Mardi Gras, 1988.

Chapter 4 Beauty

It is commonly assumed that indigenous body arts, and indigenous arts in general, are entirely different in their values and contexts from the arts people associate with the West. In Western civilization, 'art' is or was supposed to be about aesthetics; among native peoples, and in small-scale societies, generations of anthropologists, among other commentators, have emphasized that Western categories are inappropriate, and that arts possess social and religious significance and therefore need to be understood 'in context'. These views are typically well intentioned but misleading. While the ostensible aim is to break from some kind of ethnocentrism, the effect is to diminish the range and impact of both Western and indigenous conceptions, valuations and uses of art. All art will be understood more richly if it is understood in cultural, social and historical context. Such understanding is not at odds with the recognition of aesthetic effect. On the contrary: an effort to grasp the aesthetic dimensions of an expression or performance of body art may be crucial to its contextual understanding.

Likewise, what may broadly be called indigenous arts are not one-dimensional. They do not necessarily focus on ritual or spiritual ends or expressions of social status. Rather, they may convey historical imaginings, they may be intended to be comic, or they may, above all, be intended to depict or enhance beauty. Teeth may be filed, neck- or earrings worn, and labrets (lip plates or discs) inserted **[116, 117]**. Indeed, these modifications were typically associated with such stages

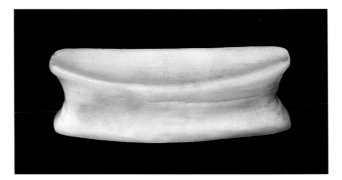

right:
116 Labret (lip-plug), Haida people, Haida Gwaii, British Columbia, Canada, nineteenth century. Native North American lip-plugs were made from wood, bone or ceramic.

opposite:
117 Mask of an older female wearing a labret on lower lip, Haida Gwaii, British Columbia, Canada, before 1868. This Haida mask is an individualized portrait of the sculptor's wife.

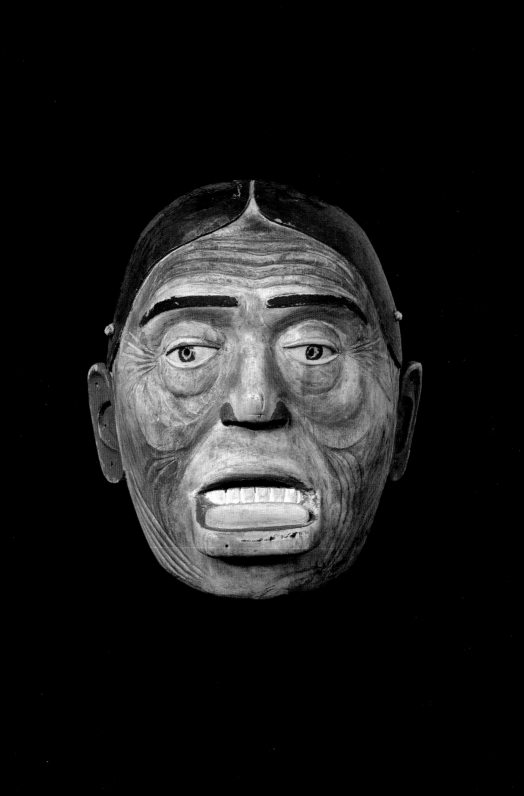

in the life cycle as maturity, and hence sexual or marital availability, but they also invited attention, heightened allure, drew the eye to the face, or specifically the mouth, and in some cases associated the person with shimmering metal or finely polished precious stones.

In Sudan, the body-painting traditions of the south-eastern Nuba – formerly a small, somewhat isolated and relatively egalitarian society of mountain agriculturalists and hunters – were famously studied by the anthropologist James Faris in the 1960s [118–21], and subsequently popularized by Leni Riefenstahl, the German film-maker, photographer, actress and dancer best known for directing the Nazi propaganda film *Triumph of the Will* (1935). These remarkable, rich and diverse traditions were essentially decorative, essentially aesthetic. Although the Nuba also practised scarification, particularly to mark stages in the life cycles of girls and women, the body art that was most representative of the population made use of oil and ochre. The most commonly employed process entailed the oiling of the body and the addition of ground-up colour extracted from local deposits. Decoration was practised from birth. A baby would be oiled and its head coloured with a red or yellow representative of its particular clan affiliation; once it had hair, this would generally be cut in a form also associated with the descent group. From around the age of eight or nine, boys and girls would cut their hair differently, would fully begin

right:
118 James Faris, non-representational body and facial design and stamped body design, south-eastern Nuba, Sudan, 1966–69.
James Faris's landmark study *Nuba Personal Art* (1972) exemplified a new sophistication in the study of body art. Nuba designs were both representational and non-representational; this man's adornment is of the latter type.

opposite:
119 James Faris, *turka tera* body design, south-eastern Nuba, Sudan, 1966–69.
A male of the second (mature) age set, bearing a design representing a leopard; the headdress incorporates an ostrich plume.

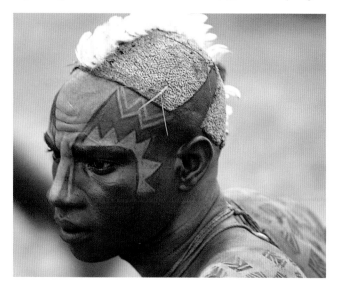

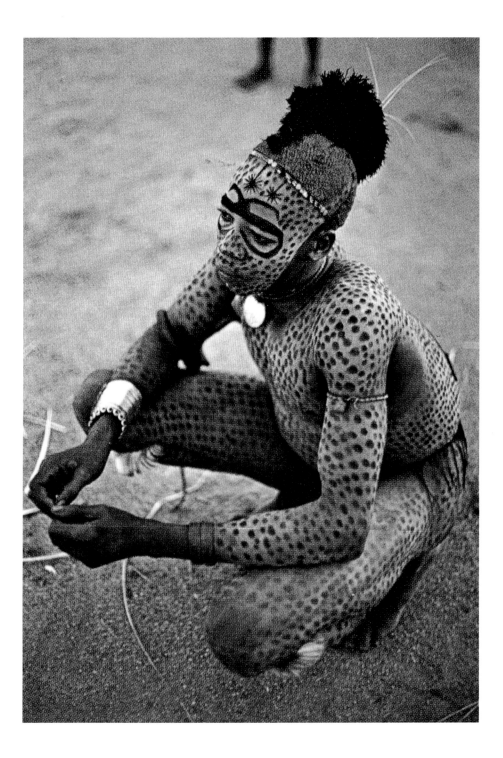

to oil and paint their bodies on a daily basis, and were scarified. Boys received facial cuts around puberty, while girls were given both face and more elaborate body scars over successive stages. Such marks were considered beautifying.

The body-painting of girls and young women was sustained until pregnancy and then resumed after the first child had been weaned, at which time a fresh set of scars was also applied; these too were considered beautifying, as well as indications of renewed sexual availability. The male passage through life was more complex, beginning at around the age of eight and involving a series of stages, each lasting some three years: the first three stages formed one grade, the next five a second grade, and two further a last grade associated with full maturity and older age. The grades reflected involvement in different activities over different phases of life, as well as participation in different tribal sports.

The initial stages were also associated with simple body decoration, at first with red ochre and grey–white; then, from around seventeen, with both red and yellow; and finally, from around twenty-three, with black too. Over the course of these stages, a hair 'cap' was successively enlarged, and more elaborate and arresting designs were produced. If a youth started to embrace colours before he ought to do so, he would be cautioned by elders, who would warn that sickness might follow, or that an excessively flamboyant appearance might attract resentment on the part of rivals, who might use sorcery or other means to harm the young man concerned. The use of a

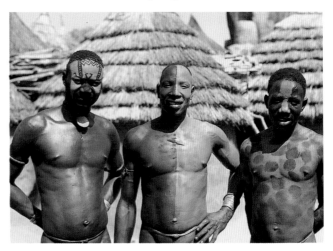

120 James Faris, body designs, south-eastern Nuba, Sudan, 1966 69.
The man in the middle bears a standard type of *tore* design, structured around a vertical axis; the figure on the right is decorated with the *krendelnya* design associated with the giraffe.

rich black ochre was identified with maturity, at which time the man would enter his first orchestrated fight, and, after this fight, would for the first time be formally praised in song. It was during such praise-song dances that young men aimed to appear most beautiful, since they were being shown off to eligible young women. As men became older, they decorated themselves less: their bodies were no longer considered strong, youthful or handsome, so beautification became less appropriate.

Nuba body imagery embraced a remarkable diversity of both representational and non-representational designs. Many of the former featured animals, although not, as Faris stressed, because those animals possessed particular qualities that were relevant to the decorated individual at a given time. That is, they were selected neither because they were totems nor for magical or symbolic reasons. They were chosen, rather, because their representation was considered aesthetically effective because their design complemented or worked on the body in an appealing and impressive manner, either through an image of the animal as a whole, or through some aspect of its appearance, such as leopard-like spots. Essential to a composition were such aesthetic qualities as balance or an acceptable and attractive asymmetry.

To be beautiful the body had to be in the right condition, and prepared in the right manner, prior to the application of ochre. Any man who was unwell or injured would wear clothing of some kind, rather than decorate himself. A healthy man had to be washed clean, carefully shaven and properly oiled. Oil was perceived, in fact, to be a form of dress; if one lacked oil, one would wear clothes until it could be obtained. Moreover, oil kept the skin in a dark, shiny and aesthetically attractive state; dry, flaky and lighter-coloured skin was considered ugly. Oil was therefore considered a vital gift, and men who were betrothed, and had to work for their in-laws over an extended period of service ahead of marriage, would present their future wives with ochre and oil every day.

The availability of new colours, such as a blue obtained through Arab merchants during the twentieth century, had already stimulated change. The arrival of Faris and his family among the relatively small south-eastern Nuba population (some 2,500 at the time the fieldwork was conducted) also introduced new visual stimuli. The Middle Eastern skyline that

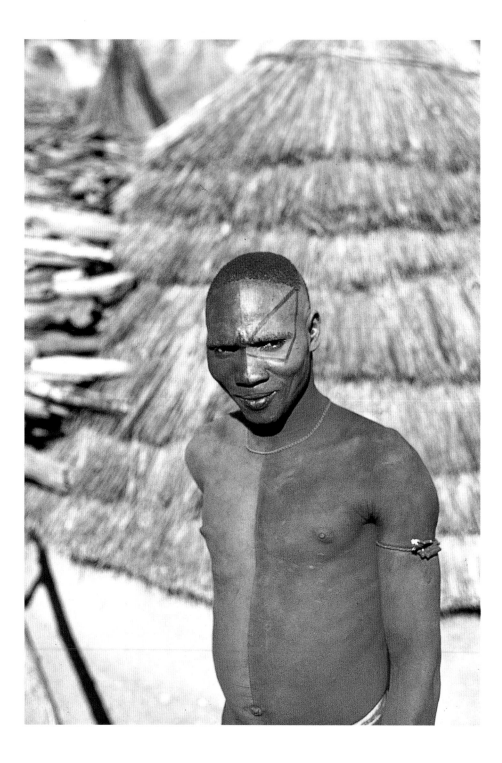

featured on the Camel cigarette packet of the period was precisely reproduced on a young man's back, as were words and phrases taken from cartons of tinned food. Relative to what was to follow, however, these were incidental innovations. Leni Riefenstahl began working in East Africa in the 1960s. She became aware of the south-eastern Nuba, she claimed, through a dream, but more likely through Faris's 1972 book, *Nuba Personal Art*. She had already published one photo-essay on another Sudanese population, but went on to produce *The People of Kau* (1976). Both titles were commercially successful, widely celebrated, and resulted in exhibitions of Riefenstahl's photographs at various prestigious institutions. They were, however, conventionally primitivist, in the sense that the Nuba were idealized as wild, passionate, savage and noble. The American intellectual Susan Sontag considered the imagery consistent with the 'fascist aesthetics' of Riefenstahl's earlier work. It also had the effect of attracting tourists to Nuba territory, with visitors paying men to decorate themselves and be photographed and filmed. Although Riefenstahl had lamented the intrusive impact of the outside world on the supposedly pristine population, her work turned body art into a commodity and a spectacle.

Tourism, however, need not mean the end of the world for native cultures, and in some regions tourist patronage has arguably helped sustain practices that might not otherwise have survived. It may be that among the Nuba some compromise could have been found between customary life and performance for cash. We shall never know, because the region was soon caught up in a wider conflict. In 1989 an Islamist government took control in Khartoum, and the Nuba mountains became a buffer against rebel armies in the south. The people either converted voluntarily to Islam or were forced to do so; life was disrupted by rebel raids, body decoration was formally banned, and the people adopted the sorts of clothing worn by the population of Sudan as a whole. By the second decade of the twenty-first century, a generation had grown up that had not known the body-art traditions of its ancestors.

Personal beautification has had diverse expressions throughout the world and throughout history. It has, for example, embraced body shape and size. In Polynesia, among other places, fattening was prescribed, especially among aristocrats whose bodies ideally exemplified the prosperity

121 James Faris, *tore* design in red and yellow, south-eastern Nuba, Sudan, 1966–69.

of their people. More familiar today is the reverse aesthetic, reflected in the notorious celebration of under-nourished models and the associated incidence of such eating disorders as anorexia. The alteration of skin colour and the enhancement of skin quality are frequently the ends of dermatological treatments and more routine cosmetics. In France, in particular, the variety of products that purportedly help retain a youthful appearance is mind-boggling.

In many ways, hair has been an aesthetic focus throughout the world [122]. While those who share neighbourhoods with African and Afro-Caribbean migrants in Europe or elsewhere might presume that the proliferation of hair (and nail) studios reflects comparatively recent interests in style and fashion, both archaeological evidence and historic photos make it clear that hair has been carefully attended to, and cut, braided, knotted and styled in an extraordinary variety of ways, probably for millennia. Diverse styles of comb have been traced over space and time, archaeologically and through the historical record [124, 125]. Ethnographers such as Northcote W. Thomas – the first government anthropologist in both Nigeria

right:
122 James Barnor, *Eva*, London, c. 1965.
Long-standing West African concerns with hairstyling were sustained by the Ghanaians and Nigerians who migrated to the United Kingdom from the 1950s and 1960s onward. Accra-born photographer Barnor documented black British style in London during this period.

opposite:
123 Northcote W. Thomas, young Igbo woman with coiled hair, photographed as part of a survey of southern Nigerian peoples, c. 1910.

124 Ivory comb with a bird crest. Egypt, pre-dynastic period (4000–3500 BCE).

125 Wooden comb, Asante people, Ghana, mid-twentieth century.

126 Page from one of Northcote
W. Thomas's Nigerian photograph
albums, c. 1909–10.
Thomas was one of the first
government anthropologists in
the British colonial service. He
took thousands of photographs
in Nigeria and Sierra Leone,
documenting many aspects of
local life including hairdressing
and hair styles.

and Sierra Leone, who also helped set a new standard in the thorough documentation of local ways of life – photographed a singular variety of styles [123, 126].

While forms of beautification have had different values and lives within a particular society, they have also differentiated entire peoples and nations from one another. Difference is known and felt through different approaches to body art; people learn to find a particular practice and appearance sensual, and at the same time learn to find another off-putting, even disgusting. The historic body arts of non-Europeans can be hard to understand and interpret because we know them via the reports of prejudiced Europeans, who reacted viscerally, considering labrets, tattoos and piercings, among other modifications, to be disfigurements. Such ethnocentrism Is now well understood, but the intersection of beauty and modernity throws up different and more complex issues. Around the world, from the nineteenth century onward, in response to colonialism, modernization and nationalism, the divisions within all societies assume new forms, like the shimmering elements of a turning kaleidoscope. Some people affirm the importance of local customs and traditions, while others seek to modernize themselves and turn their backs on the arts of their ancestors. Indeed, the repudiation of customary body arts may be equated with modernization, just as religious conversion is often marked by the adoption of new clothes.

Probably no practice has been more controversial over such a long period of time as foot binding in China [127–29]. To almost any modern mind, it was nothing more than barbaric oppression, a shocking instance of the sufferings imposed on vast numbers of women by men, and by social regimes that effectively contrived the disability of women, and celebrated it: a woman barely able to walk could not work in the fields (although many in fact did), but was the ideal of an elegant lady. The facts of the practice remain shocking. Between the ages of two and five, the feet of Chinese girls were successively bathed, soaked, massaged, bent, broken and wrapped. Specifically, the toe bones and those that created the foot's arch were broken, foreshortening the foot so that it would eventually fit, preferably, within a three-inch shoe.

The practice was an ancient one. Archaeological finds from Fuzhou in Fujian Province, including skeletal remains and grave goods, indicate that it was carried out as early as 1243 CE, and it

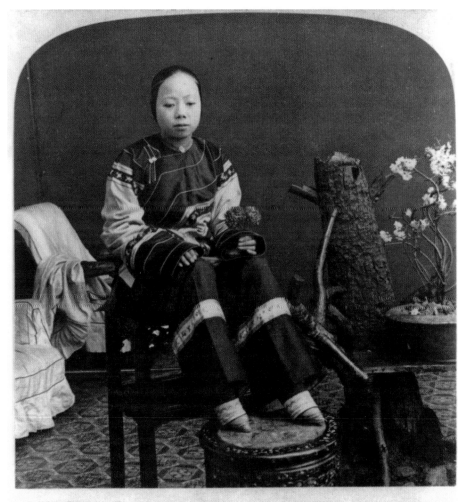

A "Lily Footed" Woman of China—this outrage against Nature has been in vogue 900 years.

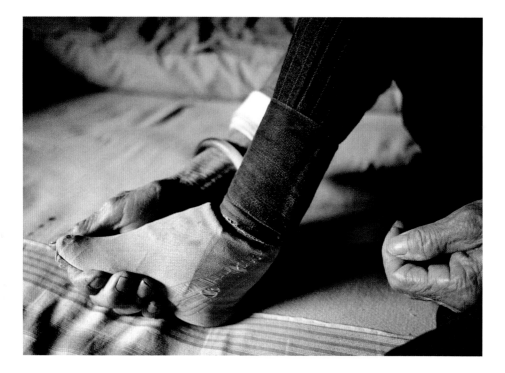

is suggested that it may have originated even earlier, during the Tang dynasty (618–906 CE), when it was intended to enhance the delicacy of a dancer's movements. Subsequently, it was associated with higher-status families, but remained ambiguous in its values, signalling at once erotic appeal and virtue, and understood at times perhaps by women themselves (whose pre-modern perceptions of the practice are virtually impossible to access or understand) as a celebration of womanhood and motherhood. From the thirteenth to the fifteenth centuries, foot binding was seen to enhance a daughter's marriage prospects. It continued to be the mark of rank and privilege, but then became progressively more common, especially among the eldest daughters of peasant families, for whom advantageous marriages were sought.

Whatever values the practice had were transformed, however, as a result of the efforts of British missionaries in China. Although evangelists did not succeed in converting elites or the society as a whole, as they appear to have done in many parts of sub-Saharan Africa, the Pacific and elsewhere, their impact on social and political debate in China was

128 An elderly woman holds her bound foot, China, 1998.

134 A tattooed Atayal woman
from northern Formosa
(Taiwan), wearing bamboo
earplugs and a cloth cape and
headscarf, late nineteenth or
early twentieth century.

above:
135 Hollow clay *dogu* figure,
Chobonaino, Hokkaido, Japan,
Late Jomon period (1500–
1000 BCE).
The decorations on this *dogu*
figure are thought to represent
tattoos.

observation, yet one that may be more subtle than it first
appears. The implication is that the marking of the body, and
particularly of the face, was not simply an arbitrary sign of
criminality, but something that came to be both recognized
and experienced as a sensual expression of debasement, a
cause or reinforcement of debasement in itself. At the same
time as it appears to have this effect, in and on the body, the
tattoo acquires an explicit and specific meaning. This amounts
to a departure from the expressions and values of tattoo, and
for that matter of scarification, body-painting and other forms
of body modification, that we have thus far considered. Those
forms of body art associated in small-scale societies with
rites and life cycles may have symbolic meanings, but, more
conspicuously, they have graphic and visual effects: although
they have commonly been misread as straightforward signs

of role or rank, it is patently reductive to interpret them in those terms, as language-like markers of a particular social affiliation or status. In contrast, the canonical criminal tattoo *is* the word 'criminal', 'thief' or 'murderer', or a motif that has one of these meanings. Yet if penal tattooing is distinguished by this literal discrimination, what makes it effective as a form of punishment is paradoxically not identification or naming, but an effect that precedes or supersedes language, that is, how the tattoo makes the stigmatized individual feel.

The fragmented historical record suggests that penal tattooing was practised in Japan up to 645 CE but then abolished with the changes known as the Taika Reforms, which consolidated the power of the emperor and the state. It may have reappeared as early as the thirteenth century, but was certainly officially reintroduced in the late seventeenth, together with legislation that provided for the penal amputation of the ear and the nose, as well as various other forms of corporal punishment. By this period, however, other changes of fundamental importance were taking place in Japanese society. As the cities grew, and while society officially retained its strict hierarchy and order despite the emergence of an urban affluent merchant population, licensed pleasure quarters featuring teahouses, bathhouses and brothels emerged, not only as scenes for male recreation, but also as scenes that were culturally celebrated.

In this context a form of *irezumi* emerged that was totally different to the old penal type. It was engendered by the bonds between particular women of the pleasure district and their clients and keepers. Some women began to wear small marks that represented a form of pledge or commitment. Sometimes men and women bore corresponding marks between the thumb and first finger that would come together when their hands joined, notionally a celebration of their sentimental tie. Tattoos of this kind in turn gave rise to 'vow tattoos', inscriptions that might include the names of lovers, religious commitments or proverbial expressions. It is said that during the eighteenth century tattoos also began to feature motifs and pictures, but the chronology of this development and the character of the motifs are unclear.

During the later eighteenth century, an old art form, the woodblock print, enjoyed a wave of new popularity. The trend was closely associated with the ascendancy of the merchant classes and the emergence of a bourgeois culture, in which

136 Utagawa Kuniyoshi, woodblock print from the series *The 108 Heroes of the Popular Suikoden*, Japan, 1827–30. This is the left sheet of a triptych featuring a fight between the Chinese warriors Lui Tang, Lu Junyi and (shown here) Li Ying and Mu Hong, whose back is heavily tattooed.

137 Utagawa Kunisada I (Toyokuni III), *Actor Bando Kamezo I as Hinotama Kozo Oni Keisuke*, from the series *A Modern Shuihuzhuan (Kinsei suikoden)*, Japan, 1862. The actor Bando Kamezo is shown in the character of a villain wielding a knife; his tattoos depict thistle flowers and leaves.

printed books and printed images became very popular. The hedonistic lifestyle of the period, referred to as the 'floating world', was celebrated in both popular literature and *ukiyo-e*, or 'pictures of the floating world'. Such prints, by Utamaro, Hokusai and others, were regarded as part of the canon of Japanese art by Europeans, but were in fact a popular art form analogous to *manga* comics; indeed, they are still considered as a somewhat vulgar genre by conservative Japanese today. The *ukiyo-e* pictures would eventually supply templates for a singular style of imagery, unlike any other form of tattooing hitherto documented. Complex, multiple, polychrome images came to constitute an integrated tattoo, embracing the back, upper arms and often also the chest. This transposition of imagery and style from popular woodblock print to the body itself gave rise to the celebrated and instantly recognizable art of modern Japanese tattoo.

Among the most popular Japanese printed works of the late eighteenth and early nineteenth centuries were adaptations of a fourteenth-century Chinese adventure series known as *Suikoden* ('The Water Margin') in Japan and best known in the West through a twentieth-century translation, *All Men Are*

Brothers (1933). Loosely set in the twelfth century, it related the exploits of a gang of bandit heroes, organized into a group marked by a code of honour and mutual loyalty, who struggled against the oppressive and corrupt officials of the Northern Song dynasty (960–1126). This text was not only popular in itself; it also sparked various imitations, defining a genre and an aesthetic that was soon expressed in printed images as well as through the printed word [136–38]. Its particular significance in the context of this book is that several of the *Suikoden* heroes were said to be tattooed. In fact, the apparently florid tattooing, which extended across their backs, arms and chests, was as important to their characters as their talents in various branches of the martial arts.

The motif of the tattooed bandit hero was, however, most powerfully exploited by Utagawa Kuniyoshi (1797–1861) [136, 138]. More than any other *ukiyo-e* artist, Kuniyoshi produced fantastic images and scenes of frenetic action. His breakthrough came with the series *The 108 Heroes of the Popular Suikoden*, which was said to have 'taken Edo by storm'. While in the text itself just four of the bandits are described as bearing tattoos, in Kuniyoshi's rendering a whole host display conspicuous and complex imagery. In such prints as *The Chinese Warriors Mu Chun and Xue Yong Fighting* (1827–30) [138], there is a bewildering visual continuity between the intense struggle of the two protagonists and Mu Chun's tattoo, which has been fully exposed, his robe lost and trampled beneath his feet in the fray. The tattoo spectacularly depicts a dragon rising out of the sea and disgorging an entire scene, a mini-landscape featuring a fort or walled mansion. No allusion is made to any tattoo in the narrative, so this extraordinary body image was presumably Kuniyoshi's invention. The tattoo is replete with images of breaking water, and it is no surprise to discover that the print is contemporary with Hokusai's iconic *Great Wave of Kanagawa* (1829–33). The sea of foam compounds the difficulty of visually deciphering the tattoo, its contorted dynamism a counterpart to the irascible energy of the combatants (who, incidentally, are later reconciled, and in due course join forces to fight others). For Kuniyoshi, in other words, a tattoo was not just an appropriate motif or a way of telling us that these wild characters were more than ordinary ruffians. Rather, it was a vital part of his visual toolkit; it enabled him to supercharge his images.

138 Utagawa Kuniyoshi, *The Chinese Warriors Mu Chun and Xue Yong Fighting*, from the series *The 108 Heroes of the Popular Suikoden*, Japan, 1827–30.

In the early nineteenth century, before these prints were published, lower-class urban workers and members of criminal or semi-criminal gangs may well have been tattooed. But this population's propensity to obtain *irezumi* appears to have been fuelled by the printed image. *Irezumi* gained a following, in particular, among casual workers, artisans, unemployed soldiers, former vassals let loose by impoverished aristocrats and others attracted to urban gangs, in the growing cities of Kyoto, Osaka and especially Edo, which was becoming a modern metropolis, with the rough and sleazy neighbourhoods that that implies. In Edo in particular, lower-class workers, as well as members of these various gangs, fashioned a new sense of themselves as hard and brazen characters, and tattooing became a powerful expression of this outlaw identity, apt for men who actually were fighters or criminals, as well as those who were hangers-on or merely sympathetic to the criminal milieu. Firemen, palanquin carriers, porters, messengers,

right:
139 Felice Beato (attr.), two tattooed men, c. 1879–90. Beato produced many fine studio images of Japanese characters and scenes, which were delicately hand-coloured and bound into lacquered albums for sale, to European visitors as well as Japanese buyers. These images played a key role in making Japan, and Japanese tattooing in particular, known in the West.

opposite:
140 A Japanese academic in front of a flayed, tattooed skin, c. 1950. Some Japanese individuals sold their tattooed skins to collectors and museums, to be removed and preserved after their deaths. This photograph was likely taken in the University of Tokyo pathology museum, which holds the largest such collection of tattooed human skins.

stablemates and grooms (*betto*) were among the occupational groups commonly tattooed, as were *geisha*.

Nineteenth-century photographers in Japan, such as the British-Italian Felice Beato (1832–1909) **[139]** and his Japanese protégé, Kusakabe Kimbei (1841–1934), who went on to establish his own practice, included compelling images of tattooed *betto* among their anthologies of characters and scenes. Subsequently, although such diverse groups as firemen continued to bear tattoos, which for them were practically an emblem of guild membership, *yakuza* (gangsters) and *irezumi* became almost indissociable. And this strong association between tattooing, sleaze and criminality persists right up to the present. Indeed, although the tattoo renaissance of recent decades has certainly reached Japan – and *irezumi* is deservedly considered one of the most refined of the various tattoo traditions, by connoisseurs for whom such judgments are meaningful – it remains the case that most Japanese parents would fear for their daughter's chances of securing a suitable husband were she foolish enough to get a tattoo of any kind.

In the West, too, and over approximately the same period, tattoos came to be emphatically associated with an urban underclass, although there was no counterpart to the Japanese dialogue between popular illustration and actual urban body art. The history of modern tattoo's emergence in Europe is in fact complex, obscure and controversial. It has repeatedly been suggested in scholarly and popular works alike that modern Western tattooing originated in Polynesia, with the voyages of Captain James Cook to the Pacific. It is indeed the case, as was mentioned in Chapter 1, that the Tahitian word *tatau* was recorded at this time, and that through publications about Cook's voyages it soon afterwards entered English and other European languages. It is also the case that a good many participants in the voyages, most of them common seamen, had themselves tattooed, as did many of those on succeeding voyages, including notoriously the *Bounty* mutineers, whose tattoos were minutely described by the deposed commander, William Bligh, so that the naval mission that went in pursuit of them could precisely identify the various offenders. The understanding has been that these particular encounters sparked off a fashion for tattooing, leading both to its stereotypical popularity among sailors, and to the wider awareness of the practice in modern Europe.

In fact, the history of tattooing in Europe has many strands, marked by continuities and discontinuities. Despite the prohibition in Leviticus, 'You shall not make any cuttings in your flesh for the dead, nor print any marks upon you' (19: 28), tattoos carried an association with the wounds of Christ, and both branding and tattooing were recognized as devotional practices during various epochs. In particular, it was common throughout the medieval period for those who had undertaken a pilgrimage to Jerusalem to be tattooed there [141] (or in Bethlehem, which seems to have been a tattoo centre) with the

141 Tattoo stamp, Jerusalem, seventeenth or eighteenth century.
This tattoo stamp featuring the resurrection of Christ belonged to members of the Razzouk family, originally of Coptic descent, who have been tattooing pilgrims in the old city of Jerusalem for several hundred years; the business remains active today. The studio maintained a collection of some hundreds of blocks of this kind, from which a pilgrim could choose a design, which would then be inked and stamped onto the skin as a guide to the tattooist.

names of various pilgrims, such as Jesus and Maria, or the coats of arms of pilgrimage sites. Some travellers, such as William Lithgow, a courtier of James I, supplemented his tattoo of the arms of Jerusalem with James's crown and a motto. While these marks, obtained in 1612, indicate that some Englishmen were obtaining pilgrim tattoos as late as the onset of the seventeenth century, there is little evidence that more than a few individuals continued to do so. This no doubt has much to do with the growing centrality of Protestantism to British identity – which was certainly reinforced over the decades of war with Continental Catholic nations, notably France, during the eighteenth century. Yet other pilgrims to the Holy Land from Catholic countries such as France and Spain, and Christians from elsewhere, certainly continued to be tattooed, and the tradition of pilgrim tattooing has remained alive to this day.

Yet tattooing carried on not only in Palestine but also around much of the Mediterranean, among the Copts and other Egyptian communities, as well as more generally. The French geographer Claret de Fleurieu introduced into his edition (1797–1801) of the Pacific-voyage journal of Etienne Marchand, who like so many other explorers of his era was fascinated by the full-body tattoos of Marquesan men, the caveat that tattooing was hardly peculiar to 'half-savage' nations. 'De tout temps' (since forever), he claimed, Mediterranean sailors – French, Catalan, Italian, Maltese – had been in the habit of inscribing into their skin figures of the Crucifixion and of the Madonna, as well as their own names or those of their lovers. They did so, Claret de Fleurieu understood, not by impregnating the skin with ink, but by dusting the cuts with gunpowder which was then set alight, leaving a bluish, indelible residue.

There are, however, few indications that British sailors were more than very rarely tattooed prior to the 1770s (those who were, the evidence suggests, were marked with gunpowder rather than ink). Muster books that record distinguishing marks note only a handful of individuals before the Cook expeditions who bore any tattoos. The practice had been observed by travellers in the Americas, the Middle East and various parts of Asia, but encountering tattooing did not mean that individuals in any numbers emulated it (although some men who crossed cultural boundaries and became integrated into indigenous communities were tattooed, notably in North America). The Pacific encounters were in fact exceptional, not because

Europeans discovered tattooing there, but because Europeans and the indigenous peoples engaged with one another in an unusually open manner.

The visits to Tahiti, in particular, were marked by curiosity and something of an idealization of the exotic, by both parties. While the stimulus that the peoples of Oceania gave to Enlightenment discourses on the 'noble savage', most famously those penned by Jean-Jacques Rousseau and Denis Diderot, has been widely cited, a demotic counterpart to this, an interest among common seamen in engaging with Polynesian ways of life that was practical and personal rather than literary or philosophical, has been less well understood. The seamen were there, on the edges of islanders' communities, among islanders, for sometimes extended periods; they often entered into the institutionalized Polynesian exchange-partnerships or friendship-contracts known as *tayo*, which Europeans understood as a kind of blood-brotherhood. Gifts and sexual intimacies were exchanged. Polynesians were keen to experience European practices of various kinds (they lined up on the ships' decks to be shaved, for example), while sailors were avidly interested in getting tattooed. The tattoo appears to have been cited and experienced as a novelty. Claret de Fleurieu was very likely right when he claimed that there was a well-established tradition among sailors of the Mediterranean, but it may not have been quite as common or visible as he implies. Perhaps those sailors who bore tattoos were typically engaged in coastal trade, rather than longer voyages, that brought them into contact with the sailors of Atlantic ports. At any rate, mariners in the Atlantic and the seas of northern Europe appear to have been unfamiliar with the Mediterranean practice — which was precisely why the French geographer felt he had to correct those who assumed that tattooing was found above all among less civilized peoples.

Although the number of ordinary seamen on Cook's three voyages was relatively small — a few hundred — the maritime population was nothing if not mobile. These men were soon in circulation on other ships, in port communities in England and in the many other harbours and cities that British ships frequented in various parts of the world. And Cook's voyages were one of the great, talked-about phenomena of the age. Men who had sailed with him would have been admired and eagerly listened to by other mariners, wherever they went.

It would not be surprising if the tattoos of a few were soon adopted by the many.

Yet what sailors borrowed from the Pacific was the tattoo technique, not the motifs or the design systems. While a few deserters, castaways and beachcombers did receive extensive, traditional-style Marquesan, Maori and other Pacific tattoos – later, in the first half of the nineteenth century, a few went on to exhibit themselves when they eventually returned to Europe – those sailors who merely passed through the region had indigenous tattooists imprint motifs chosen by the sailors themselves, who soon picked up the technique and tattooed not only their own bodies but those of others [144, 145]. However, Claret de Fleurieu's observation remains interesting because the types of image he cites, conventional religious figures or emblems, together with the name of the individual or a lover, are characteristic of the sailor-style tattoo that was certainly well established by the early nineteenth century. In other words, there appears to have been a convergence between a long tradition, primarily among Mediterranean sailors, and a fashion that spread rapidly in the wake of the Pacific encounters [142].

But why should sailors, whether in the Mediterranean, the Pacific or the Atlantic, be drawn to this practice? It has often been noted that sailors, especially at this time, suffered a chronic paucity of privacy and possessions. Whether or not they had suffered the form of legal abduction effected by the press gang, without which neither the British nor any other major navy could have maintained anything like sufficient numbers of common seamen, severance from family and community was integral to their lives. Both at sea and in port, they were more or less homeless and had little or no opportunity to shape an intimate environment of objects and relationships that they could call their own, one that defined them as a person. If a sense of self was not easy to fashion or express, it could be achieved, to some extent, through body decoration, through the inscription on the skin of insignia and names that commemorated certain voyages and periods of rest, or which marked relationships and perhaps religious affiliations too.

This state of deprivation was of course shared with itinerant populations of various kinds, although importantly not with such peoples as so-called Gypsies or Travellers,

142 George Scharf, sketch of a sailor with a tattoo of a ship (detail), 1833.
Scharf was a German-born artist who lived in London from 1816, and who illustrated metropolitan life extensively.

Ship Sails
on his Skin
tatooed
with Blue

who formed tight and coherent communities. For centuries and generations, port towns and harbourside quarters within bigger cities were notorious for being milieux in which criminality, dissidence and vice of all kinds thrived. In such locales, marked by uncertain social bonds, poverty, risk to the person and a will to grasp whatever excitement or pleasure might be available on the spur of a moment, it is not hard to imagine an interest in, indeed a certain addiction to, tattoo passing swiftly from maritime men to the wider underclass of victims, occasional and outright criminals, prostitutes, and women who lived intermittently with sailors **[143]**.

Such people typically had limited life expectancies and limited expectations of life. The tattoos they bore represented

opposite:
143 Tattoo on human skin taken from an executed criminal, France, 1830–1900.

right:
144, 145 A tattooist's designs, showing both old and modern patterns, Kobe, Japan, late nineteenth century.

an effort to affirm themselves and their lives, against the odds. The emblems and names that they adopted were of course varied. They might entail identification with the church, faith and the suffering of Christ. They might feature ships and anchors, declaring solidarity with maritime men. Yet – and this was so particularly of the motifs and mottoes adopted by criminals – they might be positively fatalistic, imaging a knife through the heart, 'born to die', or some similar anticipation of premature but inevitable fatality **[146]**.

To make these observations is to risk affirming a stereotype that associates tattooing with degeneracy, and native peoples with Western criminals and prostitutes – the savage without and the savage within Western civilization, so to speak. Such associations were notoriously postulated by the Italian criminologist Cesare Lombroso and the German art theorist Adolf Loos, who took the European criminal underclass to be racially or biologically inferior, and tattooing to be a sign of an innate criminality, of a degenerate nature that, conversely, was institutionalized and indeed upheld among 'primitive' peoples. Yet, if there was never any genetic or racial basis for a predisposition to get a tattoo or act criminally, an affinity between tattoo and criminality has long existed and needs to be seriously reflected upon. As Alfred Gell, writing at the end of the 1980s, pointed out, criminals and prostitutes were far more likely to be tattooed than judges, social workers or criminologists. If this is no longer true to the extent that it was twenty years ago, it remains the case that extensive tattooing, tattooing that is visible when one is normally dressed, is seldom encountered among wealthy professionals.

The criminal imprisoned, the prostitute more or less incarcerated within a brothel, the eighteenth-century sailor ship-bound all exist within the environment of their oppression. What they in a sense possess, all that they feel that they possess, is their own body, and it is therefore understandable that they should make that the medium of memory, the form that they may inscribe with aspirations to live honourably and to love their friends, as well as with dates and emblems that commemorate successes and failures, that declare moments of triumph, that acknowledge their fate. More than one television documentary has featured unhappy characters said to be 'addicted' to tattooing, who seemingly cannot help getting poor or inappropriate tattoos, such as swear words, done

146 Christian Schad, *The Journalist Egon Erwin Kisch*, 1928. Egon Erwin Kisch (1885–1948) was a prominent Communist journalist. Born in Prague, he worked as an activist in Berlin from 1919 until being deported in 1933. Schad painted him in the character of a proletarian construction worker; the tattoos may well be shown because the artist thought them appropriate to this identity, rather than because Kisch actually had them.

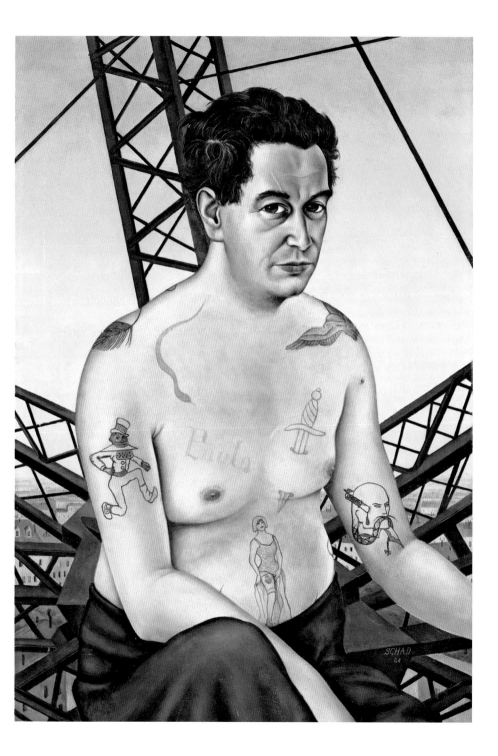

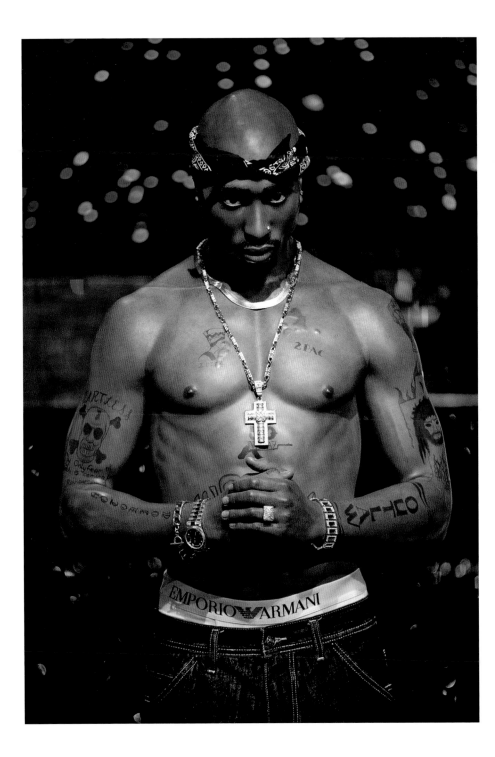

on a whim, or when drunk. Those who mark their body in this way do not simply decide to do such a thing. Rather, they have a deeper need to do it; they do it compulsively and repeatedly.

The issue is also political. The archetypal criminal takes the vandalism of the wayward youth who despoils his own neighbourhood a step further. Said criminal, most especially when in prison, appropriates the stereotypes and accusations that they have been pelted with, and covers their own body with ugly graffiti. Such words and phrases as 'Fuck the world', 'Trust nobody', 'Notorious outlaw', 'Heartless' and 'Thug life', as well as images of guns and violence, were inscribed on the body of the rapper Tupac Shakur, who can hardly be accused of exploiting a narrative of gang villainy in order to succeed as a celebrity singer: he stuck to the script, as it were, getting himself killed in a drive-by shooting at the age of twenty-five [147]. In this sense, criminal tattooing is counter-hegemonic: it expresses the resistance of those regularly dismissed by conservative politicians as society's rubbish. To hear the kinds of tattoo associated with offenders is to offend deliberately, to reassert one's offensiveness in the face of both the state's punitive retaliation and civil society's olive branch of rehabilitation – which, to those who perceive themselves, rightly or wrongly, never to have had the choice or opportunity to lead a different life, no doubt appears almost as bad a joke as governments' investments in expensive yet ineffective projects of social inclusion. Small wonder that, despite the tattoo's fashionability, and all the efforts to celebrate tattoo as art, the practice is yet to shrug off a deep affiliation with delinquency.

There is, of course, much more to the modern history of body art in Europe and North America than this. In the aftermath of Cook's voyages, merchant ships began criss-crossing the Pacific, and castaways and deserters soon entered, or lived on the fringes of, islanders' societies. As we have noted, a good many became tattooed, as had some travellers and settlers, mainly of French descent, in North America during the seventeenth and early eighteenth centuries, and of these various tattooed travellers, a few went on to make a living by exhibiting themselves. The first to do so appears to have been Jean Baptiste Cabri, also known as Joseph Kabris, a native of Bordeaux who went to sea, participated in a Pacific voyage, and in due course spent some years on the island of Nuku Hiva in the northern part of the Marquesas [148].

147 Wax figure of rap star Tupac Shakur unveiled at Madame Tussauds, London, 14 January 2013. The tattoo across the late rap artist's stomach, hidden by his hands, reads 'Thug Life'; the 'i' is replaced by an image of a bullet.

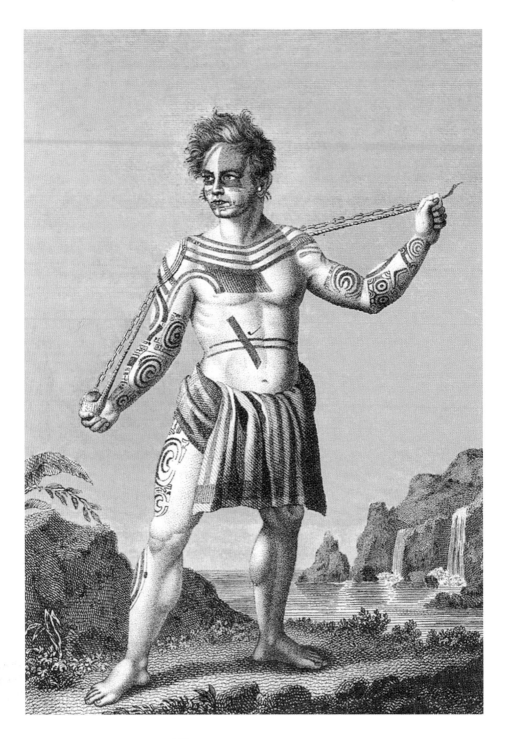

He was married locally, substantially integrated into local society and extensively tattooed, in what would later be considered one of the most remarkable of indigenous Oceanic styles. When the first Russian voyage around the world passed through the islands in 1804, Cabri – who feared ongoing political conflict among the people with whom he lived – took the opportunity to leave, and travelled with the expedition as far as Russia's Pacific coastal settlement of Petropavlovsk before making the long overland trip back to Europe. He supported himself by performing Marquesan dances and relating a no doubt much-embroidered version of his life in theatres in Moscow and St Petersburg, and eventually returned home to France in 1817, where he continued to exhibit himself not only at fairs and market sideshows, but also, more notably, as a star of the 'Cabinet des Illusions' in Paris.

Similarly, John Rutherford and James O'Connell lived among Maori in the 1810s and the Micronesians of Pohnpei in the 1820s and early 1830s respectively. Both were tattooed, and both later toured fairs and performed extensively, Rutherford in England and O'Connell in the United States. By this time, a well-established, sensational narrative had these unhappy sailors kidnapped by savages, indeed cannibals, and involuntarily tattooed. Having been subjected to this ordeal, however, they were supposedly embraced by the tribe, given the hand in marriage of a chief's daughter, and typically went on to fight heroically alongside their adopted kin before fortunately having the opportunity to make their escape back to civilization. In no

opposite:
148 Engraving by R. Cooper after Alexander Orlovsky, *Joseph Kabris*, from G. H. von Langsdorff, *Voyages and Travels in Various Parts of the World* (London, 1813). This engraving of Frenchman Joseph Kabris, one of the first Western travellers to be tattooed extensively, was based on a sketch made during the first Russian voyage around the world, which called at the island of Nuku Hiva in 1804. The tattoos shown are consistent with the classic Marquesan style and are likely to be accurate depictions.

right:
149, 150 Engravings of Barnet Burns, 'the tattooed Pakeha-Maori trader', in Maori costume, from *Weekly Graphic and New Zealand Mail*, 5 July 1911. Burns was an English sailor and trader resident in New Zealand in the early 1830s, during which time he received a full facial tattoo. He returned to England in 1835, began to style himself as a 'New Zealand chief', published a sensational account of his experiences, and exhibited himself and lectured in various parts of Britain and France until shortly before his death in 1860.

BARNET BURNS, THE TATTOOED PAKEHA-MAORI TRADER.

A NEW ZEALAND CHIEF.

case, needless to say, did events actually follow this formula, a subgenre of a larger Western myth of the captive gone native that has had varied manifestations – many of them not involving tattooing – in North African, Native American and Oceanic settings over the last several centuries. In particular, while some may have felt pressured into getting tattooed, there is no credible record of any European having been forcibly tattooed.

From the 1870s onwards, the tattooed man, and in due course the tattooed lady, loomed large in the great shows of the period. The American showman P. T. Barnum, who also exhibited kidnapped Aboriginal Australians, Fijian 'cannibals', including a 'cannibal dwarf', along with sundry other curiosities and 'freaks', is said to have been the first and most successful entrepreneur to exploit public interest in the tattooed body. While indigenous people bearing tattoos were occasionally shown, it is striking that the great majority were of European descent, and were invariably, it appears, said to have been kidnapped, tortured, tattooed, etc. by 'Indians' (that is, Native Americans), barbarians in inner Asia, or whichever other indigenous people appeared most titillating at the time.

The bearer of probably the most extraordinary tattoos of any of these performers was 'Le Capitaine Costentenus', also known, among many other names, as Prince Costentenus, Captain Georgi, Alexandrino and 'The Turk' (although reliably said to have been Greek) [152]. Between the 1870s and the 1890s, he was shown extensively, usually accompanied by a lecturer, as part of Barnum's travelling circus, at many German venues, the Folies-Bergère in Paris, and elsewhere. His remarkable, elegant tattoos were in the Burmese style [151],

Nach der Natur gemalt u. lith. v. J. C. Heinzmann. Lith. Farbendruck aus der k.k. Hof- u. Staatsdruckerei in Wien.

FRED MELBOURNIA,
AUSTRALIAN TATTOOED MAN.

120 MICH. AVE.,
DETROIT, MICH.

C. L. Weed,

although exactly where and by whom they were made is one of the many aspects of his biography that have been obscured by the energetic myth-making that his performance and marketing required. He was to have innumerable imitators and successors, including brother-sister and husband-wife acts. Throughout the early decades of the twentieth century, many individuals were shown at Castans Panoptikum in Berlin, at similar venues across Europe, as part of the Barnum & Bailey Circus (as Barnum's travelling show had become known) across the United States, in Australia [153] and elsewhere.

Although these acts continued to attract a following into the 1930s, at which time there were said to be some three

hundred tattooed performers in and around various American shows, the acts lacked the novelty value they had once possessed. Tattooed ladies, who had once been careful to display a certain degree of modesty, exposed more of their bodies, to the point where they were performing a sort of striptease [154]. On Coney Island in New York, inventive, or desperate, sideshow owners exhibited tattooed dogs, even a tattooed cow. While the tradition continued into the interwar and post-war years in England, the ascendancy of Nazism in Germany brought

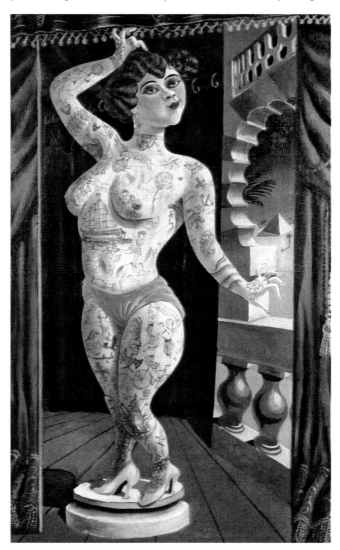

154 Otto Dix, *Suleika, the Tattooed Wonder*, 1920. An etching of 1922 related to this painting indicates that the subject was also called 'Maud Arizona'. She is known to have performed in German port cities in the period, though the tattoos do not match those in photographs purporting to be of this woman.

with it a cult of the pure Aryan body – manifest in mass nude exercise, among other martial exhibitions – that, given the influence of Lombroso and Loos, found tattoo shows anathema. Those performers unable to leave the country very likely died in concentration camps, alongside Jews, Communists, gays and others, in the course of the twentieth century's most extreme and vicious project of bodily and ethnic cleansing.

As these shows flourished and then gradually declined from the 1870s to the 1950s, tattooing among the broader Western population similarly had its ups and downs. While sailors and others continued to be tattooed during this time, throughout both Europe and North America the art does not appear to have been much practised professionally until late in the nineteenth century, although the German-American tattoo artist Martin Hildebrandt claimed to have set up shop as early as 1846. He was succeeded by Samuel O'Reilly, who established his studio in the Bowery in New York in 1875. O'Reilly went on to tattoo a large number of circus performers, and had the distinction of inventing the electrical tattoo apparatus, in about 1890. By the first decade of the twentieth century there were a good many tattooists based in various American cities, and a popular iconography emerged and in due course became an established folk style; it featured patriotic insignia, enticing women, maritime subjects and commemorative motifs ('In memory of mother') **[155, 156]**.

155 'Electrical Tattooing' tattooing kit, American, c. 1920s–30s.

In the 1890s, in both the United States and England, tattoos were briefly fashionable among the upper classes, and for a short period a few tattooists were able to profit from the opportunity to provide wealthy clients with finely executed work done in luxurious surroundings, far from the sleazy neighbourhoods in which tattoo studios were typically found. But the fad was soon over, and although some senior army and navy officers continued to bear regimental arms, among other motifs, beneath their uniforms, the growing associations between tattoos and sexual and criminal underworlds rendered any overt, mainstream engagement with the practice untenable.

In the 1920s and 1930s tattooing became increasingly popular among urban youth, but also began to be considered a moral and hygiene issue. Efforts to regulate it got under way: it became illegal to tattoo minors, and basic methods of sterilizing needles

156 'Joe Clingan, Tattooing Artist', tattoo flash, American, *c.* 1920s–1930s. Clingan (1873–1952) was from Ohio but also worked in Detroit; on his retirement in 1948 he was said to be the last tattooist in the city.

167

157 Reginald Marsh, *Tattoo and Haircut*, 1932.
A number of tattooists and barbers shared premises in the Bowery during the 1920s and 30s. Marsh's painting evokes the sleazy atmosphere of the New York City neighbourhood in this period.

were prescribed. The practice enjoyed renewed, mass popularity during the Second World War, but soon afterwards again fell into disrepute. In the United States, in particular, the political conformism and suburban lifestyles of the baby boomer years (c. 1946–64) were also marked by the decline of the inner-city neighbourhoods in which tattooing had previously flourished [157]. Post-war economic growth then yielded to economic crisis, the exacerbation of inequality, the growth of a new urban underclass and the emergence of a gang culture. In this context the tattoo's long-standing role as a vehicle of criminal identity was revived. Loyalty to the gang, rank and insignia were all, predictably, inscribed on the bodies of gang members, whether in Los Angeles, Sydney, Cape Town or Manila [158–60].

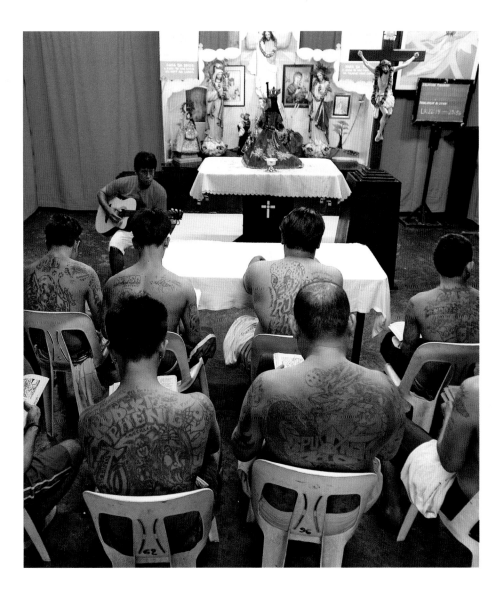

158 Inmates, all heavily tattooed gang members, attend a Catholic worship service inside the jail in Makati City, Manila, 2010.

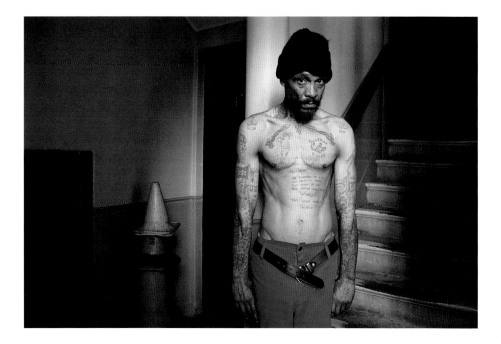

159 Araminta de Clermont,
Ali, 2007.
Ali, now a quiet man who works
as a cleaner and handyman at
St George's Cathedral in Cape
Town, was once a high-ranking
gang member.

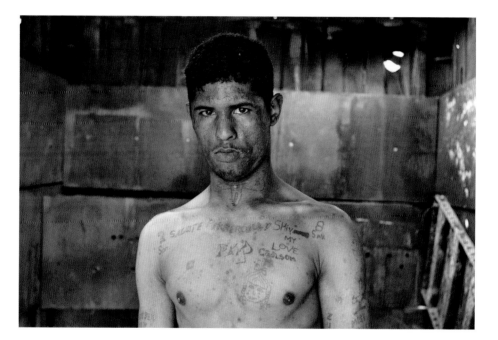

160 Araminta de Clermont,
PKD, 2007.
PKD, 35 when this photograph
was taken, has spent extended
periods in prison. 'Vra my nix'
('Ask me nothing' in Afrikaans)
was tattooed across his forehead;
his gang membership number, 28,
on his neck.

Yet such tattoos were always about much more than the obvious signs of solidarity with fellow outlaws and the familiar expressions of love and loss. The tattoos of prisoners of the post-war Soviet regime are documented through the drawings of Danzig Baldaev (1925–2005), a prison guard who began sketching in Leningrad in 1948; his extraordinary archive has recently been published in the three-volume *Russian Criminal Tattoo Encyclopaedia* (2003–2008) **[161–63]**. He drew the tattoos of men and women – many of whom were officially 'common criminals', yet many also political prisoners, convicted for 'hooliganism' or similar offences against public order – who lamented the seemingly rapacious demands of the regime on their lives and bodies. Both their tattoos and those of the criminals of post-Soviet Russia exhibit an explicit and obscene political iconoclasm that has no counterpart in the West. The heroes and founding values of the Communist state are remorselessly but eloquently excoriated on the emaciated bodies of those exiled to labour camps. Their successors, today's prisoners, bear images of dollar bills, which signify the lies surrounding democracy and liberty that similarly underpin the post-Socialist order. There is no Nobel Prize for tattooing, but in their way these stark and bitter images say as much about a utopian society's war on its own citizens as Aleksandr Solzhenitsyn's novels ever did.

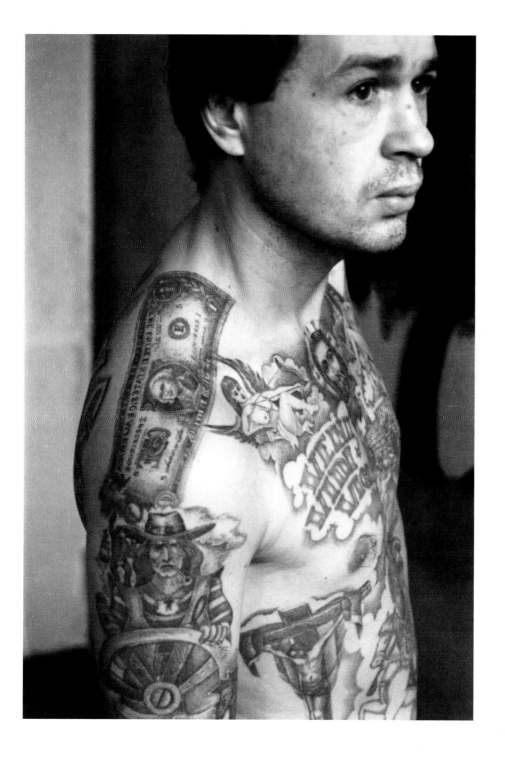

Chapter 6 Identity

Body art, once identified with distant and exotic native peoples on the one hand, and with the underclasses of the West on the other, has migrated across class and ethnic boundaries and become visible in many places in which it would not in the past have been encountered. Yet it would be going too far to say that such practices as piercing and tattooing have become 'mainstream'. What has happened is rather like the gentrification of an inner-city neighbourhood. Through fits and starts, the environment has indeed changed, everything looks different, and there is a lot more money around. But there remain conspicuous residual associations with what still counts as undesirable, with the lifestyles of the poor and infamous.

The transformation has also involved a longer and more uneven history than is commonly imagined. Although the newfound popularity of tattooing among the middle class began to be commonly cited, for example, in the British media, only during the mid-to-late 1990s, art historian Arnold Rubin (1937–1988) had written a history of what he called the 'tattoo renaissance' some fifteen years earlier. He was prescient, or perhaps premature, in celebrating an efflorescence of creativity and experimentation that was only then gaining momentum. It is perhaps telling that *Marks of Civilization* (1988), the book he contributed to and edited shortly before his death, had been planned as the complement to a wide-ranging exhibition project that had, however, failed to garner support. It was not until around 2000 that, almost embarrassingly, every museum seemed to want to host an exhibition on tattooing or body art. At the beginning of the 1980s, the time was not yet ripe, even in southern California.

The twentieth-century 'tattoo renaissance' coincided with associated revivals of scarification, branding and piercing [165, 166]. Scarification and branding have remained niche interests, unorthodox commitments of a subculture interested not only in the finished appearance but also in a deliberate engagement with pain. All four of these practices surfaced as minority pursuits, a strand of the wider interest in counter-cultural experimentation associated with the late 1960s and early 1970s.

164 Richard Todd, Leo Zulueta's back and arm tattoos, 1987. Zulueta, widely seen as the seminal figure of the late twentieth-century tribal tattoo movement, bears an iconic design derived from the Caroline Islands in Micronesia, and particularly from the tattoo tradition of the island of Yap, documented by early twentieth-century German ethnologists and colonial photographers.

165, 166 Front and back covers of *Piercing Fans International Quarterly*, no. 47, 1996. *Piercing Fans International Quarterly* was published by Jim Ward, who had also founded pioneering piercing studio The Gauntlet in Hollywood in 1975. Fifty issues were published between 1977 and 1998. Though the magazine occasionally ran into trouble owing to its explicit images of genital piercings, it played a vital role in fostering piercing milieux, and featured tribal traditions as well as the contemporary practitioners of the period.

Rubin's history is centred on the West Coast of the United States and the interests and work of a number of practitioners who sought to distance themselves from the generic and standardized motifs of American tattoo, a folk tradition that had had its counterparts in Europe and elsewhere. Although not the first of these tattooists, Don Ed Hardy (born 1945) was a key figure. Said to have been fascinated by tattooing since his childhood, he studied at the San Francisco Art Institute in the early 1960s, and became interested in Pop art and in the Japanese tattooing that other avant-garde tattooists in the Bay Area had begun to emulate. He also encountered the work of the Japanese artist Masami Teraoka (born 1936), who had moved to the United States in the early 1960s, studied art in Los Angeles, and begun creating watercolours inspired at once by Pop art and the *ukiyo-e* print tradition [167]. Hardy also encountered Leo Zulueta (born 1952), who is widely credited with instigating the contemporary interest in tribal tattoo traditions, and was at the time especially interested in insular South East Asian styles and in what became known as 'all-black' work [164]. A world away from not only the emblems, flags, girls and skulls of the folk tradition, but also the multicoloured Japanese-inspired tattoos, tribal designs were solid in their forms and frequently featured curvilinear and involuted motifs,

167 Masami Teraoka, *McDonald's Hamburgers Invading Japan/Geisha and Tattooed Woman*, 1975. Drawing on the erotic strand of the *ukiyo-e* print tradition, Teraoka has addressed cross-cultural encounters, globalization, AIDS and, more recently, issues such as sexual abuse within the Catholic church.

some copied more or less directly from early ethnological publications, others more loosely based on schematized birds, lizards and other such motifs.

This renewed interest in tribal tattoos was not unprecedented. In the 1930s, one Horace Ridler (1892–1969) had received a black, loosely Maori-style tattoo from the well-known English practitioner George Burchett, and had gone on to exhibit himself extensively under the name 'The Great Omi', a direct allusion to the Society Islander known as 'Omai' (properly 'Mai'), who had visited England after Cook's second voyage in the 1770s **[168, 169]**. As had so often been the case, and as has been more conspicuously true since, Ridler's tattoo was a project of re-enactment. But 'Omi' belonged to the tradition of the sideshow, whereas Zulueta and Hardy were working for, and indeed creating, an essentially new practice for a new clientele.

Over the same period, the eccentric figure known as Fakir Musafar (born Roland Loomis, 1930), who had a long history of personal experimentation with various forms of piercing, constriction, suspension and other forms of body modification, began to perform publically. As his adopted name implied, he modelled his practice on the ordeals associated with Middle

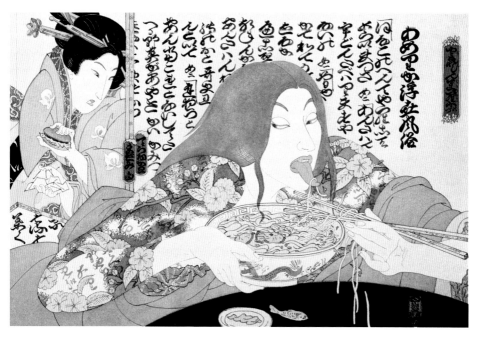

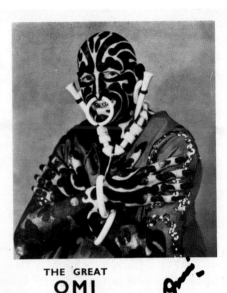

THE GREAT
OMI
STRANGE - FANTASTIC - HUMAN

THE WORLD'S TATOOED WONDER

168, 169 The Great Omi promotional postcards, c. late 1930s–40s.
Horace Ridler is said to have come from a wealthy family in south-eastern England. He began exhibiting himself a few years after serving in the First World War, assumed the Omi personality in the 1930s, and went on to perform and tour in France, the United States, New Zealand and Australia.

Eastern and South Asian ascetics, although like many who emulated non-Western rituals, his interests were eclectic. One of his best-known early 'achievements' was a restaging or adaptation of the Okipa ceremony of the Mandan, a Native American people of North Dakota (South Dakota, as it happened, was Loomis's home state). This gruelling rite entailed the suspension of weighted-down warriors from skewers forced through their chest muscles **[171]**.

An image of Musafar in this position, hanging from hooks through his chest in an outdoor setting, served as the frontispiece to the book *Modern Primitives* (1989) **[170]**, thus granting him, and the particular performance, iconic status. 'Modern primitives' were not members of a coherent community or milieu as such, but there was a sense that a dispersed body-modification subculture did exist, presided over by such senior tattoo artists as Hardy, Zulueta and Lyle Tuttle, and by others engaged in piercing, scarification and related practices that were more or less affiliated with what declared itself to be a 'sexual underground'. Not all the tattoos featured in *Modern Primitives* were tribal or neo-tribal, but the book was marked by opposition to modern society, to mass culture and to the 'colonization' of people's minds by images, in terms

reminiscent of Noam Chomsky's influential critiques. The book's authors were not, however, socialists. On the contrary: for them, the struggle was against the 'de-individualization' that they regarded as the dominant trend of the period. They were for sensual experience, freedom from social constraints, and experimentation with and around 'the only truly precious possession we can ever have and know, and which is *ours* to do with what we will: *the human body*'. It is perhaps ironic that this avowed libertarianism proceeded via an engagement with the institutions and art traditions of so-called primitive cultures, which are typically and stereotypically understood as collectives, groups and societies that do not so much offer freedoms as make claims and demands on people and their bodies.

Coincidentally, during the 1980s a debate had raged around what probably remains the most celebrated and controversial exhibition ever to take place at the Museum of Modern Art in New York. *'Primitivism' in 20th Century Art*, curated by William Rubin in 1984, offered a panorama of modernism's heroes, from Gauguin to Pollock and beyond, from the vantage point of the inspiration they drew from the arts, and particularly the masks and figure sculptures, of Africa, Oceania and Native Americans. The exhibition and accompanying catalogue were subsequently

170 Front cover of V. Vale and A. Juno, *Modern Primitives* (San Francisco: RE/Search, 1989). The alternative San Francisco publisher RE/Search was established in 1980 with the help of Allen Ginsburg and Lawrence Ferlinghetti. *Modern Primitives*, one of its most successful books, remains a key sourcebook for the new tattoo and body modification subcultures that emerged in California during the period.

171 Charles Gatewood, Fakir Musafar, 1982.

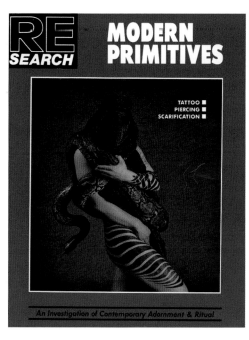

charged by such eminent critics as James Clifford, Hal Foster and Thomas McEvilley with affirming a culture of appropriation. European and American artists were seen to have exploited native art forms and traditions without in any sense acknowledging the creative capacity of indigenous artists, who were themselves participating in modernity and were responsive to the exchanges constitutive of the postmodern world. Focused on fine art, neither the exhibition nor Rubin's rich catalogue considered another sort of stimulus that tribal cultures had provided for the West, one that predated by centuries the arrival of the African masks that famously inspired Picasso, among others, in the years after 1900. Since the eighteenth century, Native American and Oceanic tattoos had been not only of aesthetic interest to Europeans. As we have seen, such body-art practices had been adopted by, and had had a spectacular impact on the bodies of, sailors and others in the West. It is interesting to imagine quite how the great debates concerning influence, affinity and appropriation would have been conducted had the historical examples ranged beyond the modern masters and their sculptural stimuli to embrace the traffic in body art.

Questions of cultural property, appropriation and the politics of primitivism have surfaced around new tribal tattoo practices. When Hardy created an impressive work based on Micronesian designs on Tuttle's back between 1982 and 1983, the question of whether he should have sought permission from indigenous artists or communities did not arise. While the sanctity of tribal tattoos, piercing and other art traditions, and for that matter the ritual significance of the Okipa ceremony, were celebrated in the pages of *Modern Primitives* and in similar publications, little consideration was given to who, if anyone, had the right to emulate, copy or adapt these practices.

As such groups as the Maori of New Zealand, aboriginal Australians and Native Americans, among others, became more conscious of questions of sovereignty and their implications for society as a whole, the issues came to be more overtly politicized. In 2000, when the singer Robbie Williams obtained his shoulder piece from the Maori tattooist Te Rangitu Netana, both the musician and the artist were criticized by Pita Sharples, an eminent Maori academic and political leader, who believed that the specific motifs of the tattoo belonged to his *iwi*, or tribe. Yet given the contemporary ubiquity of

Maori-inspired tattoos, indigenous censure of this kind of borrowing has been relatively muted. Although activists and cultural professionals are certainly uncomfortable with the widespread adoption of customary motifs by persons who not only are not indigenous, but also typically possess only slight knowledge of the relevant cultural traditions, the view may be that there is no point in trying to shut the stable door after the horse has bolted, as it emphatically has. There may also be a sense that, even when such tattoos are applied not by Maori or other indigenous tattooists but by just any commercial artist in the United States, Australia or Europe, the proliferation of the work across the bodies of Westernized youth is an acknowledgement of some kind of the power and prestige of Maori art and culture.

More generally, the 'modern primitives' have been criticized for subscribing to much the same ideas as those adopted by primitivists since Jean-Jacques Rousseau. The criticism is not one, however, that can be applied across the board. Arguably, Leni Riefenstahl's construction of the Nuba did have profoundly damaging consequences for the people, and certainly her many fans around the world were encouraged to understand Nuba body-art traditions, and the communities that sustained them, in terms that diminished the people themselves and reduced them to types. Yet in contrast, the harm done by new expressions of tribal tattoos, which in some cases have had global lives since the eighteenth century, is unclear, although particular groups may certainly be offended by the commoditization of tradition, or the unauthorized use of motifs that they may consider their heritage.

Whatever one's thoughts on the standard primitivist assumptions, they leave us entirely unprepared for the new potency that certain customary body arts have acquired in the West over recent decades. This development is admittedly exceptional. Most forms of customary tattooing and scarification – among Native Americans, for example – have indeed been suppressed or abandoned at one time or another over the last couple of centuries. Yet an extraordinary process of cross-cultural exchange has taken place around Samoan tattooing, and in particular the practice of the *tufuga ta tatau* (priest of tattooing, tattoo artist) Paulo Sulu'ape II and that of his brothers and cousins. The Samoan tradition is almost unique, even within Oceania, in that it has survived European contact, colonialism, independence and globalization. Whereas tattooing elsewhere

was largely abandoned in the wake of conversion to Christianity and colonial modernization, only to be revived a century or more later, the practice in Samoa was never suppressed.

It is not only the customary tattoo technique that has survived in Samoa; the basic forms of the standard male and female tattoos, the *pe'a* and *malu* respectively, have also been maintained, though *tufuga* appear always to have been at liberty to vary details – in the past they may in effect have given their works personal signatures – and occasionally there were more radical innovations, such as the *pe'a* from the Second World War years that incorporate American military emblems.

In the 1970s, after having been quietly sustained for generations on the islands of independent Samoa (formerly known as Western Samoa), the art of Samoan tattoo began an extraordinary voyage. This practice would not be borrowed or pirated by outsiders, but taken abroad by Samoans themselves, at first into migrant Samoan communities beyond the islands, and in due course into

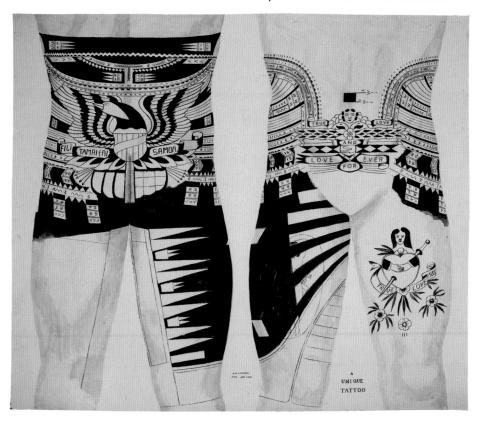

the cosmopolitan spheres of Europe and North America. During the decades of economic growth that followed the Second World War, considerable numbers of Polynesians had settled in New Zealand, most notably in Auckland. There they formed substantial communities, initially in what were then cheap, inner-city neighbourhoods, and later in outer suburbs, where state housing was eventually provided to lower-income families. It was among these people that, in addition to working in a factory, Paulo Sulu'ape began tattooing in the mid-1970s.

In 1978 the New Zealand photographer Mark Adams, who was looking for ways to represent the complexities of his country's cross-cultural history and its ambiguous situation as a European settler-colony in the Pacific, encountered Sulu'ape and his relatives, befriended them, and began to document *tatau* practice and the shifting scenes around it **[173–76]**. Adams drew attention to something that was at once remarkable and ordinary: the day-to-day life of this art in suburban Auckland. Here were the living rooms of bungalows, not dissimilar to those occupied by many working- or lower-middle-class families in many parts of the world, incorporating furnishings typical of the period. Yet these spaces had also been refashioned. The family portraits, the shell necklaces, the plastic-flower lei, the pandanus mats, among other possessions, indicated that wherever this was, it was also the Pacific; it was a space that spoke of the values and memories of kin, culture and community that Polynesian migrants shared. Moreover, it was a space in which a great ritual art could be enacted. And in this context, away from Samoa, that art was at once the same and different. It retained its integrity, yet it was also something that performed a function no one had needed at home: in this multicultural, diasporic setting, it provided a vehicle for cultural and ethnic pride. In the art's male and female forms, it came to be a powerful expression of an identity that only the Samoans could claim.

Sulu'ape wished not only to tattoo individuals, and gain an income from doing so, but also to see *tatau* recognized as a great art, beyond the community and beyond Samoa. He was therefore responsive when the New Zealand painter Tony Fomison (1939–1990), a friend of Adams, expressed his interest in acquiring a full *pe'a*. Fomison was by no means the first non-Samoan to be tattooed, but in almost every case the recipient had taken on small pieces, often in the dense geometric style of the *pe'a* or the *malu*, but of restricted

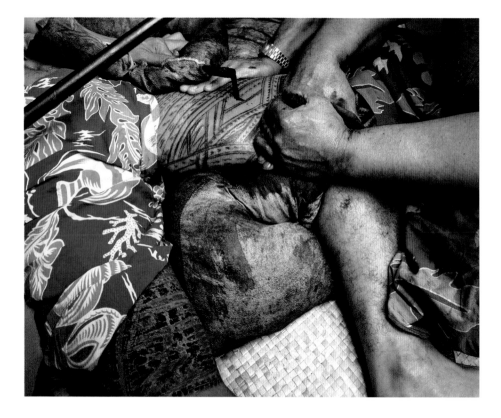

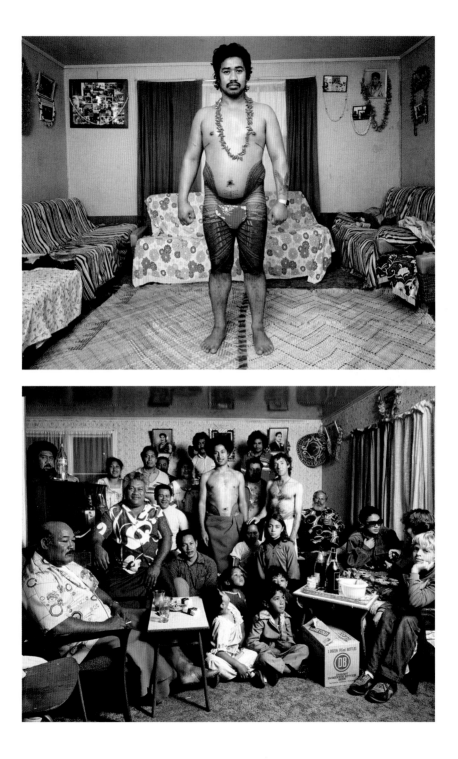

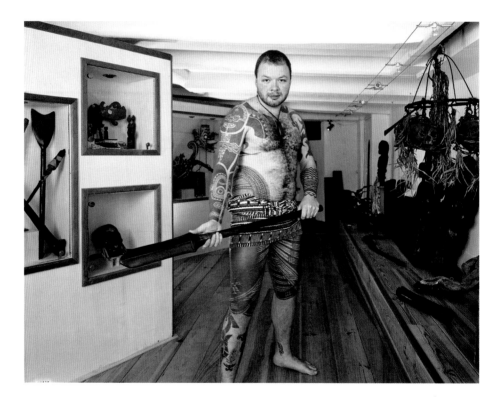

176 Mark Adams, *22.11.2000,
Authentic Tribal Arts, Spiegelgracht,
Amsterdam. Michel Thieme, Su'a
Sulu'ape Paulo II, Tufuga ta Tatau*, 2000.
Photographed in his tribal art gallery,
Thieme staged a parody of the colonial
image of the tattooed savage warrior,
imitating the pose of a nineteenth-
century studio photograph of a
tattooed Marquesan with a club.

extent; bands around the wrist or upper arm were typical. To take on the full tattoo was to undergo an ordeal, and to bear a work of body art that spoke of Samoan myth, culture and ritual. Fomison exhibited extraordinary commitment in making this singular choice, receiving his *pe'a* together with Fuimaono Tuiasau, at the time a Polynesian rights activist and subsequently a highly respected lawyer. One of Adams's most telling photographs is of both men's *umusaga*, the ceremony that marks the completion of the *pe'a*. In one sense Fomison is part of the group, in another he is not. The question of whether, and how far, body art enables a person to change identity and enter another culture is exposed but not resolved.

While Sulu'ape's practice continued to be based in New Zealand throughout the 1980s, he also began to travel overseas, attending tattoo conventions and spending more time in Europe with like-minded individuals. These included one of the tattoo artists featured in *Modern Primitives*, Henk Schiffmacher, also known as 'Hanky Panky', who had set up a tattoo museum in Amsterdam's red-light district. It was a unique institution – part museum, part tattoo parlour – in which singular cross-cultural encounters took place between artists, tattoo artists, Polynesians, Europeans, anthropologists, prostitutes, drug dealers and art dealers. Another of Sulu'ape's friends was Michel Thieme, a tattooist and tribal art dealer also based in Amsterdam [176]. Sulu'ape not only gave Thieme a full *pe'a*, but also taught him how to use the traditional tools of Samoan tattoo. Following Sulu'ape's unexpected death in 1999, Thieme went on to complete tattoos that the former had left unfinished.

The Samoan tradition drew attention to the continued existence of customary tattoo practices elsewhere in the world. In the Philippines, Borneo and Burma, among other places, European and North American tattoo enthusiasts began to seek out artists who, in turn, discovered that outsiders, backpackers among them, were interested in their work [178, 179]. A wider group of cross-cultural tattooists from Asia as well as Polynesia is beginning to emerge and to assume visibility through tattoo conventions as well as in the pages of tattoo magazines and on websites. Yet, while 'traditional' tattoos (that is, those done with hand tools of the kind used customarily in the Pacific and south-east Asia) carry considerable cachet, most of the tattooists attending major European and North American conventions who offer work done in this way are

in fact not of indigenous origin. Among the exceptions is the Marquesan tattoo artist Teikitevaamanihii Robert Huukena, who was born in 1974 and spent nearly twenty years in the French Foreign Legion before establishing a tattoo studio in Nimes, where he works with a Marquesan colleague and visiting artists from elsewhere in the Pacific [177]. Huukena's particular interest is in reclaiming control of the Marquesan tattoo styles that have been widely emulated by Tahitians and others worldwide. He is a committed researcher and has recently published a dictionary of Marquesan tattoo terminology.

Arts that appeared to be on the wane, retreating before the forces of modernization have, in a few places, received fresh stimulus. In place of, or alongside, their long-standing and threatened ritual lives, they have acquired a new mobility on the bodies of tourists and enthusiasts – for better or for worse.

right:
177 Mark Adams, Teikitevaamanihii Robert Huukena examining a nineteenth-century Marquesan carving of a tattooed leg (a sculpted tattoo sample) in the study centre of the Musée du quai Branly, Paris, 2013.

opposite:
178 Analyn Salvador-Amores, *'Manwhatok' (Tattoo Practitioner)*, 2012.

179 Analyn Salvador-Amores, *'Mansikab!' (Painful)*, 2012. Whang-ud, 92 at the time these photographs were taken, has been described as the last traditional tattooist in the Philippines. She is of the Butbut people of southern Kalinga; in recent years enthusiasts and tourists have hiked for hours to reach the remote village in which she practices. Her basic technique is not dissimilar to those customarily employed in the Pacific Islands, although the skin is pierced and inked with a lemon thorn attached to a wand, rather than the fine-toothed Polynesian instrument typically made of shell.

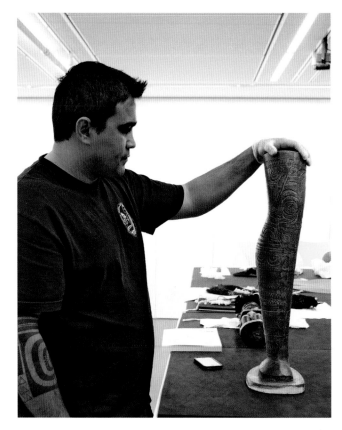

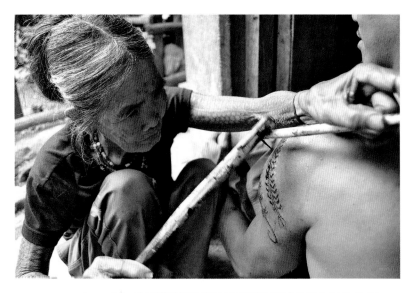

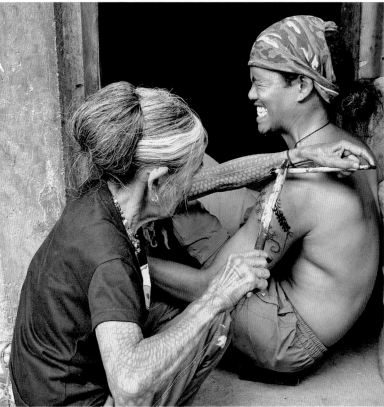

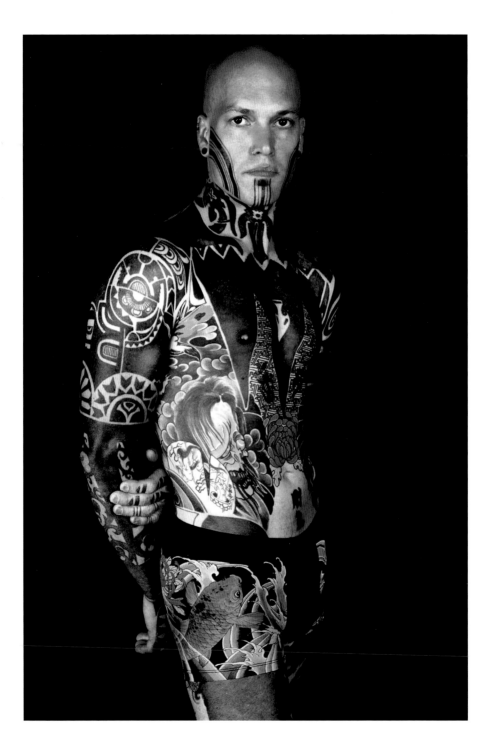

Afterword

In the mid-nineteenth century, the English novelist Wilkie Collins observed that a public bus could be a kind of encyclopaedia of humanity. The hypothetical bus with which I began this book was also an encyclopaedia of body art. If the proliferation of such practices, derived from art traditions of many parts of the world, appears symptomatic of the appropriations of the global cultural order that we all inhabit, *tatau*'s travels, and the transformation of forms of *tatau* into tattoo, exemplify the cross-currents that make up that order [180, 181]. Body art's histories – of henna, piercing and paint, as well as tattoo – demonstrate that modernity has involved less and more than both the conventional and the critical narratives assume. Efforts to civilize, socialize and sanitize the bodies of the underclasses and the colonized had profound, but always partial, effects. Conversely, so-called folk cultures, subcultures and local cultures within and beyond the West have not only proven resilient on their own turf, but also intermittently infected, inflected and even colonized the mainstream. The story of the impact of the late eighteenth-century encounter between Polynesians and Europeans on the body arts of the West – via the skins of Cook's seamen – has certainly suffered exaggeration and simplification. Yet it remains the case that after those meetings on Tahiti's beaches in 1769, nothing would be the same again.

This implies too that the body arts of the world today cannot be mapped. Even in 'traditional' times, customary arts were always exchanged, always travelling forms caught up in histories of trade and conflict. And those histories have left their mark. The bearers of body art have a variety of distinct engagements with the places, cultures and moments in the past that items of adornment, or temporary or permanent body modifications, signal. In some cases these relationships may be profound, the expression of long-standing cross-cultural friendships. In other cases, a young European, American or Australian may indeed have simply acquired a Celtic, Japanese or Maori motif from a shop, much as he or she might acquire

180 Ashley Savage, *Jack Mosher, Tattooist,* 2008.
Savage is a British art photographer who has explored body modification cultures in his work since the 1990s, most prominently through his portaits of heavily tattooed individuals.

a piece of jewelry. The critic of this commoditization of body art assumes that this cross-cultural engagement is no more than skin deep. But how to judge whether 'skin deep' means merely shallow, or in fact profound? Is an ingenuous interest in crossing cultures not better than no interest? And is it not better to travel naively, as all explorers begin by doing, than to stay complacently at home?

If no map can be offered, how then to conclude this book? I do so by considering the work of three artists who each challenge our understanding of the body, and point to the possibilities of body art in the present.

Given its relatively small population in global terms, the Pacific looms disproportionately large in any history or survey of this field, thanks primarily to the fame of its tattoo and body-painting traditions. Yet the region deserves to be celebrated equally for the intricacy and beauty of its arts of personal adornment. Across Oceania, a wonderful variety of pendants, necklaces, ear and nose ornaments, and other objects too numerous to mention, made from fibre, shell, ivory, teeth, bone, feathers, beads, seeds, hair, fur, wood and stone, among other materials, expressed beauty, sexuality, status and genealogy, both before and after the period of European contact. The sensuality of the women of the Pacific islands became, thanks especially to Gauguin and his contemporaries in colonial photo studios, one of the great stereotypes the region was burdened with. In the post-war epoch of Rodgers and Hammerstein's *South Pacific* and Elvis Presley's *Blue Hawaii*, the 'dusky maiden' became an icon of neocolonial kitsch.

In the 1990s a remarkable group of women artists, jewellers and 'fashion activists' in New Zealand audaciously seized on this and related stereotypes and began to explore and parade identities that not only drew on ancestral forms of adornment but also engaged the kitsch imagery with a winning mix of humour, sophistication and politics. Among the most impressive of these practitioners has been Sofia Tekela-Smith (born 1970), of mixed Rotuman and Scottish descent, who spent part of her childhood on the island of Rotuma, to the north of Fiji **[182]**.

Tekela-Smith began by making jewelry, particularly shell and bead pieces, some inspired by visits to the rich collections of northern-hemisphere museums, but went on to produce more ambitious works that addressed the legacy of the 'dusky maiden' and the wider Western fetishization of the native body.

181 Ashley Savage, *Laura Leslie-Campbell*, tattoos by Alex Binnie, 2007.
Binnie is an English avant-garde tattooist and printmaker whose work is increasingly well regarded in the mainstream art world.

Especially striking was her installation *Melodies of Their Honey-Coloured Skin* (2005), which responded to a popular genre of the 1950s and 1960s that consisted of low-relief profile busts of native women and children, including those of Maori, Aboriginal and Afro-Caribbean descent. While these mass-produced, usually ceramic ornaments were of course generic, Tekela-Smith produced painted fibreglass busts that were portraits of herself, her family and her friends, all of whom bore pieces of her jewelry. The intention of the work was to turn the tables, to take control of image-making. At the same time, however, it contained as much nuance as it did cut and sculpted pieces of shell: each individual bust embodied a dialogue between past and present, precedent and innovation,

182 Sofia Tekela-Smith, 2005. Jewelry and tattoo have been vital elements of the new Polynesian fashion and cultural identity.

a passage from museum to the skin and body of a friend, a contemporary bearer. A series of large photographic works similarly featured the contemporary adornment of beautiful but unambiguously self-possessed and challenging women, whose hands and forearms were enigmatically stained deep red [183]. Red is a *tapu* colour, a colour associated with sanctity and power throughout the Pacific; the implication here is not necessarily that some bloody sacrifice has taken place, although it may well have done.

Rebecca Belmore (born 1960) is a Vancouver-based Anishinaabe artist, whose work has addressed such related themes as place, history, absence and memory. In 2005 she became the first Aboriginal Canadian to represent Canada

183 Sofia Tekela-Smith, *You Are Like a Mountain Capable of Building Palaces*, 2004.

at the Venice Biennale, and on that occasion produced an ambitious piece, *Fountain*, that explored the commemorative and place-making work of such familiar features of the civic environment. Her photograph *Fringe* (2007) is at once shocking and absorbing **[184]**. It is a life-sized image that needs to be seen in 'the flesh', but remains powerful in reproduction. Like any reclining woman, it cannot but allude to Western art history, but that is hardly its most arresting aspect. The figure, whose skin colour implies (at least in North America) some native, migrant or mixed ancestry, bears a sutured wound that extends all the way from her right shoulder to her left hip. The thread that has repaired the wound carries strings of blood-red beads, as if this violence has been at once healed and unhealed, as if blood-loss is not an event but an ongoing condition. Said to be 'referencing the abuse of native women and the land', this disturbing image is mysterious and enigmatic. Has the figure suffered a sudden assault, a ritual operation or some radical medical procedure? Does the delicate stitching emulate traditional beadwork, and hence imply shamanistic or some other form of indigenous ritual healing?

Belmore's photograph presents the body as the site of some monumental act of violence, sanctioned or unsanctioned, something disproportionate with any one person yet inflicted on and suffered by this woman in particular. There is a message here that is darker than the one encountered in Tekela-Smith's negotiations of colonial gender politics. While those works celebrate the agency that certain islander women may now confidently possess, Belmore envisages a history with an enduring and injurious legacy. Her vantage point is that of an aboriginal within a settler society, but we do well to remember that colonial and postcolonial violence has profoundly affected many of the peoples whose body arts have been reviewed in

184 Rebecca Belmore, *Fringe*, 2007.

these pages. Both the Nuba of Sudan and the Mende of Sierra Leone were grievously affected by civil war, and in the former case traditions that were potent and extraordinary in living memory have been suppressed or abandoned. While this book has been at pains to draw attention to the continuing viability and vitality of some tribal practices, it does no good to suggest that others have not been destroyed or lost.

Some of the most suggestive contemporary art of, around and about the body has been created over the last twenty years by British artist Marc Quinn (born 1964). One of his most publicized early works was *Self* (1991), a cast of the artist's head made from nine pints of his own blood and then frozen **[185]**. Quinn has since created a new version of the work every five years. Together, the individual casts chronicle his changing body, his ageing, but also confront the viewer with the stuff and substance of which we are made. While portraiture, as a high-art genre, has used physiognomy to reflect social identity and accomplishment – humanity's capacity to rise above nature – here the medium is what is too easily and often spilt. Sitters are said to be immortalized in great portraits, but this work, conceived as a sequence that will at some point be complete, is about nothing if not mortality.

Quite different in nature is Quinn's portrait of the eminent geneticist Sir John Sulston (2001). The work is not 'representational' in any conventional sense of the word, but is in a way a more accurate portrait than any other ever produced. Created for London's National Portrait Gallery, the work consists of a sample of the sitter's DNA suspended in agar jelly and mounted on stainless steel. As the artist has said, 'it carries the actual instructions that led to the creation of John. It is a portrait of his parents, and every ancestor he ever had back to the beginning of Life in the universe.' In another sense, the work is the perfect way to represent this particular scientist, since Sulston has played a leading role in the advancement of DNA studies, and particularly the Cambridge-based project to map the human genome.

Quinn has also created works in the style of classical statuary, but of living individuals either born without limbs or who have suffered an amputation. Made from white Italian marble, these pieces have been shown in the galleries of the Victoria and Albert Museum, alongside the sorts of historic sculpture to which they refer. The most widely discussed of

186 Large-scale replica of Marc Quinn's sculptural work *Alison Lapper Pregnant* shown during the opening ceremony of the Paralympic Games, London, 29 August 2012.

Quinn's works in this mode has been *Alison Lapper Pregnant* (2005), which was exhibited for two years in Trafalgar Square on the 'Fourth Plinth', a plinth left unoccupied by any earlier monument and now used to show contemporary works. Lapper, the subject of the sculpture, is also an artist. Born without arms and with truncated legs, she uses her own body in her paintings and photographic works to address questions of physical normality, ability and disability, which Quinn has been equally concerned to explore.

No genre has been more central to the expression of Western ideals of human beauty than sculpture – think, for example, of Michelangelo's David. Quinn's monument to a friend cuts to the heart of this tradition. It does not simply celebrate an individual who has overcome obstacles that would appear insuperable to many, and neither is it just an affirmation of the worth of all human beings, able or disabled, although such affirmations are of course vital; indeed, Quinn's sculpture featured in the opening ceremony of the London 2012 Paralympic Games in the form of a large-scale replica **[186]**. What *Alison Lapper Pregnant* does, rather, is create a space of discomfort: it compels viewers to question what humanity and beauty look like, or could look like, and it challenges us to consider how we might exist between the ideals given compelling form in great artistic traditions, and the lives we lead through our variously imperfect bodies.

In an essay published at the turn of the millennium, the anthropologist Susan Benson argued that one of the axioms of the 'modern primitives' was sadly false. 'In truth,' she wrote, 'we do not own our own bodies, they own us, and the only thing that is certain about our bodies is that they will let us down, that in the end they cannot be mastered or bent to our will.' The body arts of the world have been, and continue to be, expressions of extraordinary achievement – of maturity, of splendour, of spiritual power, of political triumph. But they have also marked loss, redressed suffering and worked to heal; they have, in short, commemorated and commented on what it is to be human.

Further Reading

All Men Are Brothers, tr. P. S. Buck, New York, 1933

Ashton, S.-A., 6,000 Years of African Combs, Cambridge, 2013

Baldaev, Danzig, Sergei Vasiliev, Alexei Plutser-Sarno (intro), Damon Murray and Stephen Sorrell (eds), Russian Criminal Tattoo Encyclopaedia Volume I, London, 2003

Baldaev, Danzig, Sergei Vasiliev, Anne Applebaum (intro), Damon Murray and Stephen Sorrell (eds), Russian Criminal Tattoo Encyclopaedia Volume II, London, 2006

Baldaev, Danzig, Sergei Vasiliev, Alexander Sidorov (intro), Damon Murray and Stephen Sorrell (eds), Russian Criminal Tattoo Encyclopaedia Volume III, London, 2008

Bateson, G., Naven: A Survey of the Problems Suggested by a Composite Picture of the Culture of a New Guinea Tribe Drawn from Three Points of View, Cambridge, 1936

Beaglehole, J. C. (ed.), The Journals of Captain James Cook on His Voyages of Discovery, Cambridge, 1955–67

—, The Endeavour Journal of Joseph Banks, 1768–1771, Sydney, 1962

Benson, S., 'Inscriptions of the Self: Reflections on Tattooing and Piercing in Contemporary Euro-America', in J. Caplan (ed.), Written on the Body: The Tattoo in European and American History, London/ Princeton, NJ, 2000, 234–54

Berns, M. C., R. Fardon and S. L. Kasfir (eds), Central Nigeria Unmasked: Arts of the Benue River Valley (exh. cat.), Fowler Museum at UCLA, Los Angeles, 2011

Brain, R., The Decorated Body, London/New York, 1979

Brown, P., The Body and Society: Men, Women, and Sexual Renunciation in Early Christianity, New York, 1988

Burchett, G., Memoirs of a Tattooist, ed. P. Leighton, London, 1958

Butler, J., Bodies that Matter: On the Discursive Limits of "Sex", New York/ London, 1993

Caplan, J. (ed.), Written on the Body: The Tattoo in European and American History, London/Princeton, NJ, 2000

Carswell, J., Coptic Tattoo Designs, Jerusalem, 1956

Catlin, G., Catlin's North American Indian Portfolio, New York, 1845

Chapman, A., Hain: Selknam Initiation Ceremony, Santiago, 2002

Claret de Fleurieu, C. P., Voyage autour du monde, pendant les années 1790, 1791 et 1792, par Etienne Marchand, Paris, 1797

Clark, T., Kuniyoshi: From the Arthur R. Miller Collection (exh. cat.), Royal Academy of Arts, London, 2009

Cole, A. (ed.), Fashioning Skin: The Process and Practice of Tattoo, special issue, Fashion Theory, vol. 10, no. 3, 2006

Cook, J., 'Power, Protection and Perfectibility: Aspiration and Materiality in Thailand', in L. Chua, et al. (eds), Southeast Asian Perspectives on Power, Abingdon/New York, 2011, 37–50

Darwin, C., Journal of Researches into the Geology and Natural History of the Various Countries Visited by HMS Beagle, London, 1840

DeMello, M., Bodies of Inscription: A Cultural History of the Modern Tattoo Community, Durham, NC, 2000

—, Encyclopedia of Body Adornment, Westport, CT/London/Oxford, 2007

Ebin, V., The Body Decorated, London/New York, 1979

Einhorn, A., and T. S. Abler, 'Tattooed Bodies and Severed Auricles: Images of the Native American Body Modification in the Art of Benjamin West', American Indian Art Magazine, vol. 23, no. 4, 1998, 42–53

Elliott, M., and N. Thomas (eds), Gifts and Discoveries: The Museum of Archaeology and Anthropology, Cambridge, London, 2011

Ewart, E., and M. O'Hanlon (eds), Body Arts and Modernity, Wantage, 2007

Fardon, R., Fusions: Masquerades and Thought Style East of the Niger-Benue Confluence, West Africa, London, 2007

Faris, J. C., Nuba Personal Art, London/ Toronto, 1972

—, 'From Form to Content in the Structural Study of Aesthetic Systems', in D. K. Washburn (ed.), Structure and Cognition in Art, Cambridge, 1983, 90–112

Fleming, J., 'The Renaissance Tattoo', in Caplan, Written on the Body, 61–82

Foelsche, P., 'Notes on the Aborigines of North Australia', Transactions and Proceedings and Report of the Royal Society of South Australia, vol. 5, 1881–82, 1–18

Forster, J. R., Observations Made during a Voyage Round the World [1778], ed. N. Thomas, H. Guest and M. Dettelbach, Honolulu, 1996

Foucault, M., Discipline and Punish: The Birth of the Prison, New York, 1975

Gadsden, R., et al., Unlimited Global Alchemy, Cambridge, 2012

Geismar, H., and A. Herle, Moving Images: John Layard, Fieldwork and Photography on Malakula Since 1914, Honolulu/Cambridge, 2010

Gell, A., Wrapping in Images: Tattooing in Polynesia, Oxford, 1993

Govenar, A., 'The Changing Image of Tattooing in American Culture, 1846–1966', in Caplan, Written on the Body, 212–33

Guest, H., 'Curiously Marked: Tattooing and Gender Difference in Eighteenth-Century British Perceptions of the South Pacific', in Caplan, Written on the Body, 83–101

Gulik, W. R. van, Irezumi: The Pattern of Dermatography in Japan, Leiden, 1982

Gusinde, M., Die Feuerland-Indianer, Mödling bei Wien, 1931

Hall, S., The Electric Michelangelo, London, 2004

Hardy, D. E., Ed Hardy's TattooTime [reprint of magazines published 1982–91], San Francisco, 2012

Hawkesworth, J., An Account of the Voyages ... for Making Discoveries in the Southern Hemisphere, London, 1773

Hereniko, V., Woven Gods: Female Clowns and Power in Rotuma, Honolulu, 1995

Herle, A., M. Elliott and R. Empson (eds), Assembling Bodies: Art, Science and Imagination (exh. cat.), Museum of Archaeology and Anthropology, Cambridge, 2009

Herlihy, A. F., 'Tattooed Transculturalities: Western Expatriates among Amerindian and Pacific Islander Societies, 1500–1800', PhD dissertation, University of Chicago, 2012

Hose, C., and W. McDougall, The Pagan Tribes of Borneo, London, 1912

Jones, G. I., The Art of Eastern Nigeria, Cambridge, 1984

Joppien, R., and B. Smith, *The Art of Captain Cook's Voyages*, 3 vols, Melbourne, 1985–87

Klanten, R., and F. E. Schulze (eds), *Forever: The New Tattoo*, Berlin, 2012

Ko, D., *Every Step a Lotus: Shoes for Bound Feet*, Berkeley, CA, 2001

—, *Cinderella's Sisters: A Revisionist History of Footbinding*, Berkeley, CA, 2007

Kristeva, J., *Powers of Horror: An Essay on Abjection*, tr. Leon S. Roudiez, New York, 1982

Kuwahara, M., *Tattoo: An Anthropology*, Oxford/New York, 2005

Lamunière, M., *You Look Beautiful Like That: The Portrait Photographs of Seydou Keïta and Malick Sidibé* (exh. cat.), Fogg Art Museum, Cambridge, MA, 2001

Lombroso, C., *Criminal Man* [1876], tr. M. Gibson and N. H. Rafter, Durham, NC, 2006

Loos, A., *Ornament and Crime: Selected Essays*, tr. M. Mitchell, Riverside, CA, 1998

Mack, J. (ed.), *Masks: The Art of Expression*, London, 1994

Mallon, S., P. Brunt and N. Thomas, *Tatau: Samoan Tattoo, New Zealand Art, Global Culture*, Wellington, NZ, 2010

Marquardt, C., *Die Tätowierung beider Geschlechter in Samoa*, Berlin, 1899

Moore, F., *Travels into the Inland Parts of Africa*, London, 1738

Morphy, H., *Aboriginal Art*, London, 1998

Oettermann, S., 'On Display: Tattooed Entertainers in America and Germany', in Caplan, *Written on the Body*, 193–233

O'Hanlon, M., *Reading the Skin: Adornment, Display and Society among the Wahgi*, London, 1989

Park, M., *Travels in the Interior Districts of Africa*, London, 1799

Phillips, R. B., *Representing Woman: Sande Masquerades of the Mende of Sierra Leone*, Los Angeles, 1995

Regnault, C., *Voguing and the House Ballroom Scene of New York City 1989–92*, intro. T. Lawrence, ed. S. Baker, London, 2011

Riefenstahl, L., *The People of Kau*, tr. J. M. Brownjohn, London, 1976

Robley, H. G., *Moko; or, Maori Tattooing*, London, 1896

Rosenblatt, D., 'The Antisocial Skin: Structure, Resistance, and "Modern Primitive" Adornment in the United States', *Cultural Anthropology*, vol. 12, no. 3, 1997, 287–334

Rubin, A. (ed.), *Marks of Civilization: Artistic Transformations of the Human Body*, Los Angeles, 1988

Rubin, W., *"Primitivism" in 20th Century Art* (exh. cat.), 2 vols, Museum of Modern Art, New York, 1984

Schiffmacher, H., *1000 Tattoos*, Cologne/London, 1996

Sontag, S., 'Fascinating Fascism', in *New York Review of Books*, 6 February 1975

Spencer, B., and F. J. Gillen, *The Native Tribes of Central Australia*, London/New York, 1899

—, *The Northern Tribes of Central Australia*, London/New York, 1904

Stair, J. B., *Old Samoa; or, Flotsam and Jetsam from the Pacific Ocean*, London, 1897

Strathern, A., and M. Strathern, *Self-Decoration in Mount Hagen*, London, 1971

Strathern, M., 'The Self in Self-Decoration', *Oceania*, vol. 49, no. 4, 1979, 241–57

Te Awekotuku, N., et al., *Mau Moko: The World of Maori Tattoo*, Auckland, 2007

Terrell, J., 'Joseph Kabris and His Notes on the Marquesas', *Journal of Pacific History*, vol. 17, no. 2, 1982, 101–12

Thomas, N., *Discoveries: The Voyages of Captain Cook*, London, 2003

Thomas, N., A. Cole and B. Douglas (eds), *Tattoo: Bodies, Art and Exchange in the Pacific and the West*, London, 2005

Turner, T., 'The Social Skin' [1980], *HAU: Journal of Ethnographic Theory*, vol. 2, no. 2, 2012, 486–504

Vale, V., and A. Juno, *Modern Primitives*, San Francisco/London, 1989

Sources of Quotations

Introduction

p. 16, caption – Lieutenant Edgar, quoted in Beaglehole, *The Journals of Captain James Cook*, vol. III, p. 351, n. 1.

p. 36 – 'fancy' (Foelsche) Folsche, 'Notes on the Aborigines of North Australia', p. 7.

p. 36 – 'the scapular region' (Spencer and Gillen) *The Native Tribes of Central Australia*, p. 42.

p. 36 – 'no special meaning' (Spencer and Gillen) Ibid.

Chapter 1: Humanity

pp. 49–51 – 'The colour they use ...' (Banks) *The Endeavour Journals*, vol. I, p. 336.

p. 51 – 'Arabians', 'Greenlanders' and 'ancient Huns' (Forster) *Observations* (1996 ed.), p. 347.

p. 63 – 'All painted white ...' (Darwin) C. Darwin, *Beagle diary*, 23 January 1833, available at: <http://darwin-online.org.uk/converted/manuscripts/Darwin_C_R_BeagleDiary_EHBeagleDiary.html> (accessed 19 March 2014).

p. 67, caption – 'On my picture, I drew the virus ...' (Nondumiso Hlwele) 'Body Map of Nondumiso Hlwele', The Memory Box project website, http://www.memorybox.co.za/index.php?option=com_content&task=view&id=30&Itemid=42 (accessed 19 March 2014).

p. 70 – 'have some form of disability ...' (Gadsden) *Unlimited Global Alchemy*, p. 30.

Chapter 2: Society

p. 77 – 'Great preparations were made' (Stair) Stair, *Old Samoa*, p. 158.

p. 83, caption – 'men present a row...' M. Strathern, *Learning to See in Melanesia: Lectures Given in the Department of Social Anthropology, Cambridge University, 1993–2008*, HAU Masterclass series 2, Manchester, 2013 p. 41.

p. 89 – 'an external reflection ...' (O'Hanlon) O'Hanlon, *Reading the Skin*, p. 124.

p. 94, caption – 'At 7:45 p.m., I was shot...' (Burden) Artist's statement to the author.

p. 94 – 'In this instant I was sculpture' (Burden) interview in D. Aitken, *Broken Screen: Expanding the Image, Breaking the Narrative* (New York, 2005), p. 76.

pp. 94–95 – 'So, what does it mean ...' (Burden), Ibid.

Chapter 3: Theatricality

p. 96 – 'a Mumbo-Jumbo' to 'Wild Man' (Moore), Moore, *Travels Into the Interior Parts of Africa*, p. 116.

p. 96 – 'a sort of masquerade habit ...' (Park) Ibid., p. 92.

pp. 98–99 – 'An elephant tusk ...' (Jones) Jones, *The Art of Eastern Nigeria*, p. 59.

p. 99 – 'a supercilious white-faced ...' (Jones) Ibid.

Chapter 4: Beauty

p. 125 – 'fascist aesthetics' (Sontag) S. Sontag, 'Fascinating Fascism', *New York Review of Books*, 6 February 1975, available at: <http://www.nybooks.com/articles/archives/1975/feb/06/fascinating-fascism/> (accessed 19 March 2014).

Chapter 5: Criminality

p. 145 – 'taken Edo by storm' (unattributed) B. W. Robinson, *Drawings by Utagawa Kuniyoshi*, Groningen 1953, p, 5, quoted in van Gulik, *Irezumi*, p. 50.

p. 150 – 'De tout temps' (Claret de Fleurieu) *Voyage autour du monde*, vol. I, p. 156.

Chapter 6: Identity

p. 179 – 'the only truly precious possession ...' (Vale and Juno) *Modern Primitives*, p. 5.

Afterword

p. 196 – 'referencing the abuse of native women and the land' A. Baez, 'Shapeshifting: Transformations in Native American Art at the Peabody Essex Museum', *The Evolving Critic*, 19 January 2012 <https://exploringvenustas.wordpress.com/tag/rebecca-belmore/> (accessed 19 March 2014).

p. 197 – 'it carries the actual ...' (Quinn) Artist's statement from a press release on the National Portrait Gallery's website, available at: <http://www.npg.org.uk/about/press/genomic-portrait.php> (accessed 19 March 2014).

p. 198 – 'In truth ...' (Benson) Benson, 'Inscriptions of the self', p. 250.

Picture Credits

Dimensions are in centimetres followed by inches, and height followed by width and depth unless specified as follows: h. = height, d. = diameter, l. = length

1 © Michael O'Hanlon c/o Pitt Rivers Museum, University of Oxford. 2 © Giuseppe Aresu/Rex. 3 Ace Harlyn, 'Homeward Bound' tattooing flash, 1936. 4 Sikh officer and Woman with Henna Painting on Her Hand (detail), nineteenth century; watercolour, pen and ink, 18.7 x 23 (7 ⅜ x 9 ¹/₁₆); The Trustees of the British Museum, London (1984,0124,0.1.27). 5 George Catlin, The White Cloud, Head Chief of the Iowas, 1844–45; oil on canvas, 71 x 58 (27 ¹⁵/₁₆ x 22 ¹³/₁₆); Paul Mellon Collection, National Gallery of Art, Washington, D.C. (1965. 16.347). 6 Lalla Ghawa, Hands of Fatima, 1989; acrylic on canvas, 102 x 76 (40 ³/₁₆ x 29 ¹⁵/₁₆); British Museum, London (1992,0414,0.1). courtesy the artist 7 Vessel, painted pottery, 17.1 x 13 (6 ¾ x 5 ⅛; National Museum of the American Indian, Smithsonian Institution, Washington, D.C. (24/4326), Photo Ernesto Amoroso. 8 Wellcome Library, London. 9 Cosmetic palettes; slate, l. 7 (2 ¾) and 23.5 (9 ¼); Museum of Archaeology and Anthropology, University of Cambridge (1951.533 A/Z 45743). 10 Museum of Archaeology and Anthropology, University of Cambridge (P.7170.ACH1). 11 Museum of Archaeology and Anthropology, University of Cambridge (P.48850.ACH2). 12 Red deer frontlet; bone and antler, h. 32 (12 ⅝); Museum of Archaeology and Anthropology, University of Cambridge (1953.61A). 13 Armoured shirt; wood, h. 53 (20 ⅞); Museum of Archaeology and Anthropology, University of Cambridge (1922.950B). 14 Body-painting pigment container; bamboo, l. 19 (7 ½), d. 3 (1 ³/₁₆); Pitt Rivers Museum, University of Oxford (1901.57.2). 15 Head of a woman wearing neck rings; painted wood and brass; Pitt Rivers Museum, University of Oxford (1929.92.3.1 & 2). 16 Set of girl's girdle-plates; l. 11 (4 ⁵/₁₆) (each plate); Pitt Rivers Museum, University of Oxford (1928.69. 1461.1-7). 17–19 Stamps used for printing designs onto the body; rubber, l. 10.3 (4 ¹/₁₆), 10.5 (4 ⅛) and 12 (4 ¾); Pitt Rivers Museum, University of Oxford (2000.13.1). 20, 21 Female shaman's costume; embroidery, cowrie shells, brass mirrors and bells, l. 140 (55 ⅛); Museum of Archaeology and Anthropology, University of Cambridge (1933.377-379). 22 Funerary mask; red-coloured ceramic, 13 x 19 x 5.7 (5 ⅛ x 7 ½ x 2 ¼); Musée du quai Branly, Paris (Inv. 71.1891.57.269); Musée du quai Branly, photo Patrick Gries/Benoit Jeanneton/Scala, Florence. 23 Rambaramp

effigy; mixed media, h. 168 (66 ⅛); Museum of Archaeology and Anthropology, University of Cambridge (1927.2174). 24 Marc Quinn, Mirage, 2009; patinated bronze, 228 x 145 x 56 (89 ¾ x 57 ¹/₁₆ x 22 ¹/₁₆); photo Todd-White Art Photography; courtesy White Cube; © Marc Quinn/White Cube. 25 Portrait bust; bronze, h. 42 (16 ⁹/₁₆); Museum of Archaeology and Anthropology, University of Cambridge (E.1902.94). 26 Rajesh Kumar Singh/AP/ Press Association Images. 27 © Frobenius-Institut, Frankfurt am Main. 28 Brian Kersey/ AP/Press Association Images. 29 Startraks Photo/Rex. 30 Woman's skull, elongated by head-binding; 17 x 12 (6 11/16 x 4 ¾); Institut Royal des Sciences Naturelles de Belgique (Inv. IG 13.199); 31 Ceramic vessel; clay, paint, 13 x 18 (5 ⅛ x 7 ¹/₁₆); National Museum of the American Indian, Smithsonian Institution, Washington, D.C. (20/7605); photo Walter Larrimore. 32 Photo Oxford Archaeology. 33 Tattooed skin, 60 x 28 (23 ⅝ x 11); The State Hermitage Museum, St. Petersburg (inv. no. 1684/298); photo The State Hermitage Museum/Vladimir Terebenin, Leonard Kheifets, Yuri Molodkovets. 34 National Anthropological Archives, Smithsonian Institution, Washington, D.C. (NAA 0445900); photo Verrier Elwin. 35 National Anthropological Archives, Smithsonian Institution, Washington, D.C. (NAA 04429200). 36 Museum of Archaeology and Anthropology, University of Cambridge (P.502.ACH1). 37 Museum of Archaeology and Anthropology, University of Cambridge (P.507.ACH1). 38 Museum of Archaeology and Anthropology, University of Cambridge (P.501.ACH1). 39 Museum of Archaeology and Anthropology, University of Cambridge (P.529. ACH1). 40 Arm ornament; bark, paint, resin and feathers, 9 x 28 (3 ⁹/₁₆ x 11); Pitt Rivers Museum, University of Oxford (1915.10.21). 41 Arm ornament; bark, paint, hair and string, 8 x 27.5 (3 ⅛ x 10 1³/₁₆); Pitt Rivers Museum, University of Oxford (1917.6.30). 42 E. Hattorf, studio portrait of Tom Henry, a Nuxalk man wearing a fur hat, chilkat blanket, and face paint, Hamburg, Germany, 1885. 10.5 x 6.4 (4 ⅛ x 2 ½) (mounted); The Trustees of the British Museum, London (Am,B59.2). 43 Brook Andrew, Sexy and Dangerous, 1996; colour transparency on transparent synthetic polymer resin, 145.9 x 96 (57 ⁷/₁₆ x 37 1³/₁₆); courtesy the artist and Galerie Nathalie Obadia, Paris and Tolarno Galleries, Melbourne. 44 Marguerite Milward, Portrait of Bendiri, A Tattooed Khond Woman, c. 1938; plaster of Paris, h. 38 (14 ¹⁵/₁₆); Museum of Archaeology and Anthropology, University of Cambridge (1949.116). 45 Fiona Pardington, Portrait of a Life-Cast of Matua Tawai, Aotearoa/New Zealand from the series Ahia: A Beautiful Hesitation, 2010; photograph, 146 x 110 (57 ½ x 43 ⁵/₁₆) (ed. 1/10); Courtesy the Musée de l'Homme/ Muséum national d'Histoire naturelle, Paris; University of Auckland Art Collection; © Fiona Pardington. 46 After Sydney

Parkinson, The head of a New Zealander, from James Cook and John Hawksworth, Account of the voyages undertaken by the order of His present Majesty, for making discoveries in the Southern Hemisphere, Vol. 2, pl. 13 (London, 1773); engraving, 21 x 17 (8 ¼ x 6 1¹/₁₆); David Rumsey Map Collection, www. davidrumsey.com. 47 Parfait Augrand after Jacques Arago, Îles Sandwich, femme de l'île Mowi dansant, from Louis de Freycinet, Voyage autour du monde. Atlas historique, pl. 88 (Paris, 1822); engraving, 32 x 23.8 (12 ⅝ x 9 ⅜); National Library of Australia, Canberra (an9032027). 48 John Record after John Frederick Miller, Instruments des insulaires de Mer du Sud, from James Cook and John Hawksworth, Account of the voyages undertaken by the order of His present Majesty, for making discoveries in the Southern Hemisphere, Vol. 2, pl.10 (London, 1773); engraving, 21 x 17 (8 ¼ x 6 1¹/₁₆); David Rumsey Map Collection, www.davidrumsey.com. 49 Sydney Parkinson, studies of Tahitian tattoos, 1771; pencil, ink, and watercolour, 29.7 x 42 (11 11/16 x 16 ⁹/₁₆); British Library, London akg-images. 50 Arnaqu Ashevak, Tattooed Women, 2008; Etching and aquatint, 94.5 x 73.5 (37 ³/₁₆ x 28 ¹⁵/₁₆); Canadian Museum of Civilisation, Gatineau Quebec (IV-C-6338); reproduced with the permission of Dorset Fine Arts. 51 Jessie Oonark, Tattooed Faces, 1960; Museum of Archaeology and Anthropology, Cambridge; Public Trustee for Nunavut, Estate of Jessie Oonark. 52 Museum of Archaeology and Anthropology, University of Cambridge (N88451.PAT). 53 Benjamin West, The Death of General Wolfe (detail), 1770; oil on canvas, 152.6 x 214.5 (60 ¹/₁₆ x 84 ⁷/₁₆); National Gallery of Canada, Ottowa (no. 8007). 54 Jan Verelst, Sagayenkwaraton (baptized Brant), Named Sa Ga Yeath Qua Pieth Tow, King of the Maquas (Mohawk), 1710; oil on canvas, 91.5 x 64.3 (36 x 25 ⁵/₁₆); acquired with a special grant from the Canadian government in 1977; Library and Archives Canada, Ottawa (acc. no. 1977-35-2). 55 After John White, The Wife of a 'Werowance' or Chief of Secotan, 1585–93; drawing on paper, 35 x 22.2 (13 ¾ x 8 ¾); The Trustees of the British Museum, London (SL,5270.5). 56 Augustus Earle, A native of the Island of Tucopea (Tikopia), c. 1827; watercolour, 24.8 x 22.2 (9 ¾ x 8 ¾); National Library of Australia, Canberra (an2822563). 57 Louis Choris, Larik, Chef du groupe des îles Romanzoff, from Louis Choris, Voyage pittoresque autour du monde, pl. 56 (Paris, 1822); lithograph, 41 x 25.7 (16 ⅛ x 10 ⅛); National Library of Australia, Canberra (an10465524). 58 Louis Choris, Femme du groupe des îles Saltikoff arik, from Louis Choris, Voyage pittoresque autour du monde, pl. 60 (Paris, 1822); lithograph, 40.9 x 25.8 (16 ⅛ x 10 ³/₁₆); National Library of Australia, Canberra (an10465532). 59 Charles Rodius, Edanghe from Long Island, 1834–35; pencil on paper, 22.8 x 15.4 (9 x 6 ¹/₁₆); The Trustees of the British Museum, London (1840,1114.78).

60 Tattoo template or signboard, wood, 87 x 26 x 1.5 (34 ¼ x 10 ¼ x 9/16); Musée du quai Branly, Paris (Inv. 71.1894.77.1); Musée du quai Branly, photo Patrick Gries/Bruno Descoings/Scala, Florence. **61** Alfred Gell, *The Flaying of Iotete*, c.1990; ink on paper, 30 x 30 (11 ¹³/₁₆ x 11 ¹³/₁₆); private collection; courtesy Simeran Gell. **62** Raymond Amisongmeli, Luke Kamangari, James Lanjinmeli, Albert Lumutbange, Ben Mafa and David Yamanafi, sculpture depicting an initiate during the process of scarification, 2001–2; wood, paint, l. 146 (57 ½); Museum of Archaeology and Anthropology, University of Cambridge (2002.89). **63** Museum of Archaeology and Anthropology, University of Cambridge (P.16626); **64–67** Anthropos Institut, St Augustin, Germany. **68** Headdress; cowrie shells, wool, beads, metal pendants, bells and buttons, 68 x 32 (26 ¾ x 12 ⅝), made before 1983; Pitt Rivers Museum, University of Oxford (1983.20.5). **69** Chief's seat (detail); wood and skin, 94 x 56 x 61 (94 x 22 ¹/₁₆ x 24); Musée royal d'Afrique centrale, Tervuren (Inv. EO.0.0.15995). **70** Courtesy Susan Vogel. **71** Nondumiso Hlwele, *Body Map*, 2008; customised print commissioned by Museum of Archaeology and Anthropology, University of Cambridge, from the original acrylic painting, South Africa, 2003; h. 178 (70 ¹/₁₆); Museum of Archaeology and Anthropology, University of Cambridge (2008.20). **72** Babalwa Cekiso, *Body Map*, 2008; customised print commissioned by Museum of Archaeology and Anthropology, University of Cambridge, from the original acrylic painting, South Africa, 2003, h. 178 (70 ¹/₁₆); Museum of Archaeology and Anthropology, University of Cambridge (2008.22). **73, 74** © Hamish Roberts. **75, 76** Photo courtesy Marla C. Berns. **77** From Charles Wilkes's *Narrative of the United States Exploring Expedition, 1838–42* (Philadelphia, 1844); engraving. **78** Museum of Archaeology and Anthropology, University of Cambridge (P.4696.ACH1). **79** Museum of Archaeology and Anthropology, University of Cambridge (P.111315.GTN). **80** Museum of Archaeology and Anthropology, University of Cambridge (P.111321.GTN). **81** Museum of Archaeology and Anthropology, University of Cambridge (P.111320. GTN). **82** N. Maurin after Jacques Arago, *Guerrier sandwichien*; engraving, from Jacques Arago, *Promenades autour du monde* (Paris, 1822). **83** Museum of Archaeology and Anthropology, University of Cambridge (T.120434). **84** Photo courtesy Marilyn Strathern. **85–90** © Michael O'Hanlon c/o Pitt Rivers Museum, University of Oxford. **91** From Hans Surén, *Mensch und Sonne*, Hans Scherl, 1936; Interfoto/akg-images. **92** © Joe Penney/Reuters/Corbis. **93, 94** Chris Burden, *Shoot*, F Space, Santa Ana, CA, 19 November, 1971. © Chris Burden. Courtesy of the artist and Gagosian Gallery. **95** Museum of Archaeology and Anthropology, University of Cambridge (N.13024.GIJ). **96** Museum of Archaeology and Anthropology, University of Cambridge

(P.71603.GIJ). **97** Museum of Archaeology and Anthropology, University of Cambridge (P.71616.GIJ). **98** Juju mask; wood, metal, fibre, h. 98 (38 9/16) (including raffia); 72 x 40.5 x 30 (28 ⅜ x 15 ¹⁵/₁₆ x 11 ¹³/₁₆) (mask only); The Trustees of the British Museum, London (Af1922,0610.1). **99** Photo courtesy Richard Fardon. **100–105** Lansana Jo, drawings of Mende masks, 1972; felt-tip pen on paper, each drawing 28 x 35.5 (11 x 14); courtesy Ruth Phillips. **106** Sande society mask; wood, h. 43 (16 ¹⁵/₁₆); Museum of Archaeology and Anthropology, University of Cambridge (Z.20496). **107** Photo courtesy Henrietta Cosentino. **108** Melissa Farlow/National Geographic Creative. **109** Mask for Noh theatre; painted wood, 20.8 x 13 (8 ³/₁₆ x 5 ⅛); The Trustees of the British Museum, London (OA+.7111). **110** Steve Vidler/Iberfoto/AISA. **111, 112** From Chantal Regnault, *Voguing and the House Ballroom Scene of New York* (New York: Soul Jazz Books, 2011); photo © Chantal Regnault. **113** Ronald Grant Archive. **114, 115** © William Yang. **116** Labret (lip-plug); ivory, 4 x 1.2 (1 9/16 x ½); Pitt Rivers Museum, University of Oxford (1884.84.78). **117** Mask; wood, 22 x 19 (8 ¹¹/₁₆ x 7 ½); Pitt Rivers Museum, University of Oxford (1884.84.76). **118–121** Photo James Faris, 1966–69; © James Faris. **122** James Barnor, *Eva*, London, c. 1965; courtesy Autograph ABP; © James Barnor. **123** Museum of Archaeology and Anthropology, University of Cambridge (P.119601.NWT). **124** Comb with a bird crest; ivory, h. 8.3 (3 ¼); Museum of Archaeology and Anthropology, University of Cambridge (Z.17754). **125** Asante comb; wood, h. 23.5 (9 ¼); Museum of Archaeology and Anthropology, University of Cambridge (1935.225). **126** Museum of Archaeology and Anthropology, University of Cambridge (P.118092–P.118100). **127** Library of Congress Prints and Photographs Division, Washington, D.C. (LC-USZ62-49139). **128** Jodi Cobb/National Geographic Creative. **129** Embroidered shoes with green band, white insert at throat, and heel tab lined in red, l. 13 (5 ⅛); Bata Shoe Museum, Toronto (BSM P96-108-AB).**130** Seydou Keïta, *Untitled*, 1949–51; gelatin silver print, 60 x 50 (23 x 19); courtesy CAAC The Pigozzi Collection © Seydou Keïta/SKPEAC. **131** Malick Sidibé, *Tresse Kassonke, circa 1974*, 2001; gelatin silver print on board, 61 x 50.2 (24 x 19 ¾); courtesy the artist and Jack Shainman Gallery, New York. **132** Malick Sidibé, *Taximan avec Voiture, 1973*, 2008; gelatin silver print, 61 x 50.8 (24 x 20); courtesy the artist and Jack Shainman Gallery, New York. **133** Philipp Franz von Siebold, Japanese penal tattoo marks, from *Nippon*, Vol. 2, pl. XXXI (Leiden, 1832). **134** Museum of Archaeology and Anthropology, University of Cambridge (P.6050.ACH1). **135** Hollow *dogu* figure; clay, h. 41.5 (16 ⅜); Hakodate City Board of Education, Hokkaido, National Treasure. **136** Utagawa Kuniyoshi, Li Ying wielding a mace, from the series *The 108*

Heroes of the Popular Suikoden, Japan, 1827–30; woodblock print, 38.7 x 26.3 (15 ¼ x 10 6/16); Ashmolean Museum, Oxford/The Art Archive. **137** Utagawa Kunisada I (Toyokuni III), Actor Bandô Kamezô I as Hinotama Kozô Oni Keisuke, from the series *A Modern Shuihuzhuan (Kinsei suikoden)*, Japan, 1862; woodblock print, ink and colour on paper, 36.2 x 24.6 (14 ¼ x 9 ¹¹/₁₆); Museum of Fine Arts, Boston (11.42759). **138** Utagawa Kuniyoshi, *The Chinese Warriors Mu Chun and Xue Yong Fighting*, from the series *The 108 Heroes of the Popular Suikoden*, Japan, 1827–30; woodblock print, 38.7 x 26.3 (15 ¼ x 10 ⅜); The Trustees of the British Museum, London (2008,3037.10008). **139** Felice Beato (attr.), two tattooed men, c. 1879–90; hand-coloured photographic print, 25.6 x 20.4 (10 ¹/₁₆ x 8 ¹/₁₆) (unmounted); Henry and Nancy Rosin Collection of Early Photography of Japan, Freer Gallery of Art and Arthur M. Sackler Gallery Archives, Smithsonian Institution, Washington, D.C. (FSA A1999.35.218). **140** Photo by Horace Bristol, Camera Press London. **141** Tattoo stamp; 10.5 x 4.8 x 1.2 (4 ¼ x 1 ⅞ x ½); Musée du quai Branly, Paris (inv. 71.1970.23.3); Musée du quai Branly, photo Thierry Ollivier/Michel Urtado/Scala, Florence. **142** George Scharf, sketch of a sailor with a tattoo of a ship (detail), 1833; graphite drawing, 12.7 x 17.5 (5 x 6 ⅞); The Trustees of the British Museum, London (1862,0614.979). **143** Tattoo on human skin; Wellcome Library, London (Science Museum A526). **144, 145** A tattooist's designs; ink on paper, 35 x 22.1 (13 ¾ x 8 ¹¹/₁₆); Pitt Rivers Museum, University of Oxford (1906.18.8.1). **146** Christian Schad, *The Journalist Egon Erwin Kisch*, 1928; oil on canvas, 90 x 61 (35 ⁷/₁₆ x 24); Hamburger Kunsthalle, Hamburg/Bridgeman Art Library; © Christian Schad Stiftung Aschaffenburg/VG Bild-Kunst, Bonn and DACS, London 2014. **147** John Phillips/UK Press via Getty Images. **148** R. Cooper after Alexander Orlovsky, *Joseph Kabris*, from G. H. von Langsdorff, *Voyages and Travels in Various Parts of the World* (London, 1813); engraving. **149, 150** Barnet Burns, 'the tattooed Pakeha-Maori trader'; engraving, 39 x 28.5 (15 ⅜ x 11 ¼); National Library of Australia, Canberra (Rex Nan Kivell Collection, an10457773). **151** Page of a tattoo manuscript; paper, 43 x 29 (16 ¹⁵/₁₆ x 11 ⁷/₁₆); The Trustees of the British Museum, London (2005,0623,0.4). **152** After C. Heitzmann, *Le Capitaine Costentenus*, from Ferdinand Hebra, *Atlas der Hautkrankeiten* (Vienna, 1856); engraving. **153** C. L. Weed, *Fred Melbournia, Australian Tattooed Man*, c.1888–89; albumen print on cabinet mount, 16.5 x 10.7 (6 ½ x 4 ³/₁₆); National Library of Australia, Canberra (an21731878). **154** Otto Dix, *Suleika, the Tattooed Wonder*, 1920; oil on canvas, 162 x 100 (63 ¾ x 39 ⅜); Private Collection; © DACS 2014. **155** 'Electrical Tattooing' kit; painted wood with iron and brass trim and electrical fittings, tattooing needles and

ink, paper card, labels, metal box, and glass bottles, overall 55.9 x 43.2 x 17.7 (22 x 17 x 7); box 52.9 x 36.4 x 17.7 (20 ⅞ x 14 ⅜ x 7); Smithsonian American Art Museum, Washington, D.C., Gift of Herbert Waide Hemphill, Jr. and museum purchase made possible by Ralph Cross Johnson (1986. 65.379); Photo Smithsonian American Art Museum/Art Resource/Scala, Florence. **156** Tattoo flash; pen and ink and ink wash on paperboard, 35.7 x 27.0 (14 x 10 ⅝); Smithsonian American Art Museum, Washington, D.C., Gift of Herbert Waide Hemphill, Jr. and museum purchase made possible by Ralph Cross Johnson (1986. 65.68); Photo Smithsonian American Art Museum/Art Resource/Scala, Florence. **157** Reginald Marsh, *Tattoo and Haircut*, 1932; egg tempera on masonite, 118.1 x 121.6 (46 ½ x 47 ⅞); Art Institute of Chicago, Gift of Mr. and Mrs. Earle Ludgin (1947.39); © ARS, NY and DACS, London 2014. **158** © Romeo Ranoco/Reuters/ Corbis. **159** Araminta de Clermont, *Ali*, 2007; © Araminta de Clermont (www. aramintadeclermont.com). **160** Araminta de Clermont, *PKD*, 2007; © Araminta de Clermont (www.aramintadeclermont.com). **161** Danzig Baldaev, *Corrective Prison Camp No. 9*, 1989, from *Russian Criminal Tattoo Encyclopaedia Volume III* (London: FUEL Publishing, 2008); © Danzig Baldaev/FUEL, drawing © Danzig Baldaev/FUEL, *Russian Criminal Tattoo Encyclopaedia*. **162** Danzig Baldaev, *Morgue, 47 Zagorodny Lane, Leningrad*, 1960, from *Russian Criminal Tattoo Encyclopaedia Volume I* (London: FUEL Publishing, 2003); © Danzig Baldaev/FUEL; drawing © Danzig Baldaev/FUEL, *Russian Criminal Tattoo Encyclopaedia*. **163** Sergei Vasiliev, *Strict Regime Corrective Colony No. 12, Nizhny Tagil, Sverdlovsk Region*, 1992, from *Russian Criminal Tattoo Encyclopaedia Volume III* (London: FUEL Publishing, 2008); © Sergei Vasiliev/FUEL; photograph © Sergei Vasiliev/ FUEL, *Russian Criminal Tattoo Encyclopaedia*. **164** © 1987 The Fowler Museum of Cultural History at UCLA; photo Richard Todd. **165, 166** Front and back covers of *Piercing Fans International Quarterly*, no. 47, 1996. **167** Masami Teraoka, *McDonald's Hamburgers Invading Japan/Geisha and Tattooed Woman*, 1975; watercolour on BFK Rives, 36.2 x 54.61 (14 ¼ x 21 ½); Private Collection; courtesy Catharine Clark Gallery, San Francisco. **168, 169** From the collection of Ashley Savage (www.savageskin.co.uk). **170** Front cover of V. Vale and A. Juno *Modern Primitives* (San Francisco: RE/Search, 1989); courtesy RE/Search Publications (www.researchpubs.com). **171** © Charles Gatewood. **172** Jack W. Groves, *A Unique Tattoo*, 1952; pigment ink and watercolour on cardboard, 75.5 x 89.9 (29 ¾ x 35 ⅜); The Trustees of the British Museum, London (Oc2008,Drg.148). **173** Mark Adams, *5.3.1982. Farwood Drive, Henderson, West Auckland. Su'a Pasina Sefo, Tufuga ta Tatau. Uli*, 1982; Cibachrome print; © Mark Adams.

174 Mark Adams, *30.6.1985. Chalfont Crescent, Mangere, South Auckland. Jim Taofinu'u. Su'a Sulu'ape Paulo II, Tufuga ta Tatau*, 1985; Cibachrome print; ©Mark Adams. **175** Mark Adams, *10.5.1980. Grotto Rd, Onehunga, Auckland. The Tuiasau family, Tony Fomison and friends on the occasion of the Umusga for Fuimaono Tuiasau. Su'a Sulu'ape Paulo II, Tufuga ta Tatau*, 1980; Cibachrome print; © Mark Adams. **176** Mark Adams, *22.11.2000. Authentic Tribal Arts, Spiegelgracht, Amsterdam. Michel Thieme. Su'a Sulu'ape Paulo II, Tufuga ta Tatau*, 2000; C-type photograph; © Mark Adams. **177** © Mark Adams. **178** Analyn Salvador-Amores, *'Manwhatok' (Tattoo Practitioner)*, 2012; photo Analyn Salvador-Amores. **179** Analyn Salvador-Amores, *'Mansikab!' (Painful)*, 2012; photo Analyn Salvador-Amores. **180** Ashley Savage, *Jack Mosher, Tattooist*, 2008; photo © Ashley Savage (www.savageskin.co.uk).**181** Ashley Savage, *Laura Leslie-Campbell*, tattoos by Alex Binnie, 2007; photo © Ashley Savage (www.savageskin.co.uk). **182** Photo © Marti Friedlander. **183** Sofia Tekela-Smith, *You Are Like a Mountain Capable of Building Palaces*, 2004; photograph, 160 x 126 (63 x 49 ⅝); © Sofia Tekela-Smith. **184** Rebecca Belmore, *Fringe*, 2007; media and dimensions variable; photo Henri Robideau, courtesy the Artist. **185** Marc Quinn, *Self*, 1991; blood (artist's), liquid silicone, stainless steel, perspex and refrigeration equipment, 208 x 63 x 63 (81 ⅞ x 24 ¹³/₁₆ x 24 ¹³/₁₆); photo Marc Quinn Studio, courtesy White Cube; © Marc Quinn/White Cube. **186** Yoichi Hayashi/ AP/Press Association Images.vw

Index

References in *italic* indicate pages on which illustrations appear